AMERICAN FOLK ART

WILLIAM C. KETCHUM, JR.

NEW LINE BOOKS

Copyright © MMIX by New Line Books Limited All rights reserved.

No part of this publication may be reproduced, stored in a retrieval system or transmitted in any form by any means electronic, mechanical, photocopying or otherwise, without first obtaining written permission of the copyright holder.

Fax: (888) 719-7723

E-mail: info @ newlinebooks.com

Printed and bound in China

ISBN 978-1-59764-271-2

Visit us on the web! www.newlinebooks.com

Author: William C. Ketchum, Jr.

Producer: Robert Tod

Book Designer: Mark Weinberg

Production Coordinator: Heather Weigel

Photo Editor: Edward Douglas

Editor: Linda Greer

Typesetting: Command-O, NYC

PHOTO CREDITS

All photographs supplied by ESTO Photographics Including:

Chun Y. Lai/ESTO 30, 32, 34 (top), 40-41, 130 (left), 132, 136-137, 139, 142 (bottom), 143

Schecter Lee/ESTO 12 (left), 24-25, 27 (bottom), 31 (top), 35, 42 (top), 48, 61, (left & right), 64, 68, 69 (top), 72, (left), 75, 79, 81, 85 (top), 88-89, 94, 96, 103, 104, 110, 112-113, 114 (left), 118, 120-121, 122, 123 (top & bottom), 124-125, 126, 127, 128, 129, 130 (right), 134, 135, 140, 142 (top)

Additional photograph, page 85 bottom, supplied by the Museum of American Folk Art, New York City

CONTENTS

INTRODUCTION

REMEMBERING THE FAMILY
7

FOLK ART AROUND THE HOUSE
25

PASSING TIME: FOLK ART AS HOBBY
49

BLOWING IN THE WIND
65

PUBLIC FOLK ART

NAUTICAL ART

THE WORLD IN MINIATURE

105

FOLKY FABRICS: TEXTILE ART

INDEX 144

INTRODUCTION

Folk art, the art of the "common man" (as opposed to the formal art commissioned and appreciated by the wealthy and well-educated), is by no means unique to the United States. However, it is here that it thrived, encouraged by the emergence of the world's first sizable middle class and a nearly universal belief that art, like all else, should be open and available to everyone.

This belief encouraged the proliferation during the 18th and 19th centuries of a group of carvers and painters whose range of skills differed substantially from that of their European counterparts. Many had no formal artistic training, and in their failure to follow traditional rules of perspective, proportion, and color blending they produced an abstract style which often seems shockingly modern to 20th-century eyes.

Moreover, unlike the European academics, they were jacks-of-all-trades. American portrait painters also regularly painted wagons, coaches, tavern signs, or even houses. Sculptors shifted readily from classical human forms to tobacconists' figures and ships' figureheads. In a widespread and sparsely settled society, each man (or woman) did what was required.

Much of this work was certainly not viewed by its creators or consumers as "art." Indeed, most of them adhered to the same traditional view held by their self-anointed social and economic superiors: "art" was limited to Greek and Roman sculpture, academic paintings, bronzes, prints, engravings, and the like. What they produced, on the other hand, was what was needed by their emerging communities.

It is writers, museum curators, collectors, and antique dealers who have, in this century, defined (and continue to define) these practical objects as folk art. The earliest folk art collectors, themselves artists or wealthy art patrons, were drawn to what they knew, traditional painting and sculpture. Others, more sensitive to the broader definitions of these mediums, discovered the folk-art qualities of such utilitarian items as weathervanes, shop signs, carved utensils, and figural ceramics.

Today, as reflected in this book, such diverse objects as factory-made cast iron doorstops, architectural fragments, and molded carnival chalkware are embraced as folk art. There is no reason to believe that the process of inclusion will be reversed. New items or categories (such as "wacky wood") are continually being embraced; nothing once included is later rejected. This, too, is part of the American way. As the more traditional folk forms have been priced out of most collectors' range, tastemakers and dealers have obligingly discovered new and less costly types or, as with 20th-century folk art, a whole century of new material. All, in the belief, of course, that "art, like all else, should be open and available to everyone."

BIRTH AND BAPTISMAL CERTIFICATE c. 1806; watercolor on paper fractur, attributed to Barbara Becker Haman (b.1774), Shennadoah County, Virginia. Related to European illuminated manuscripts, fractur drawings were created primarily by American aritsts of Germanic background. Courtesy Sotheby's.

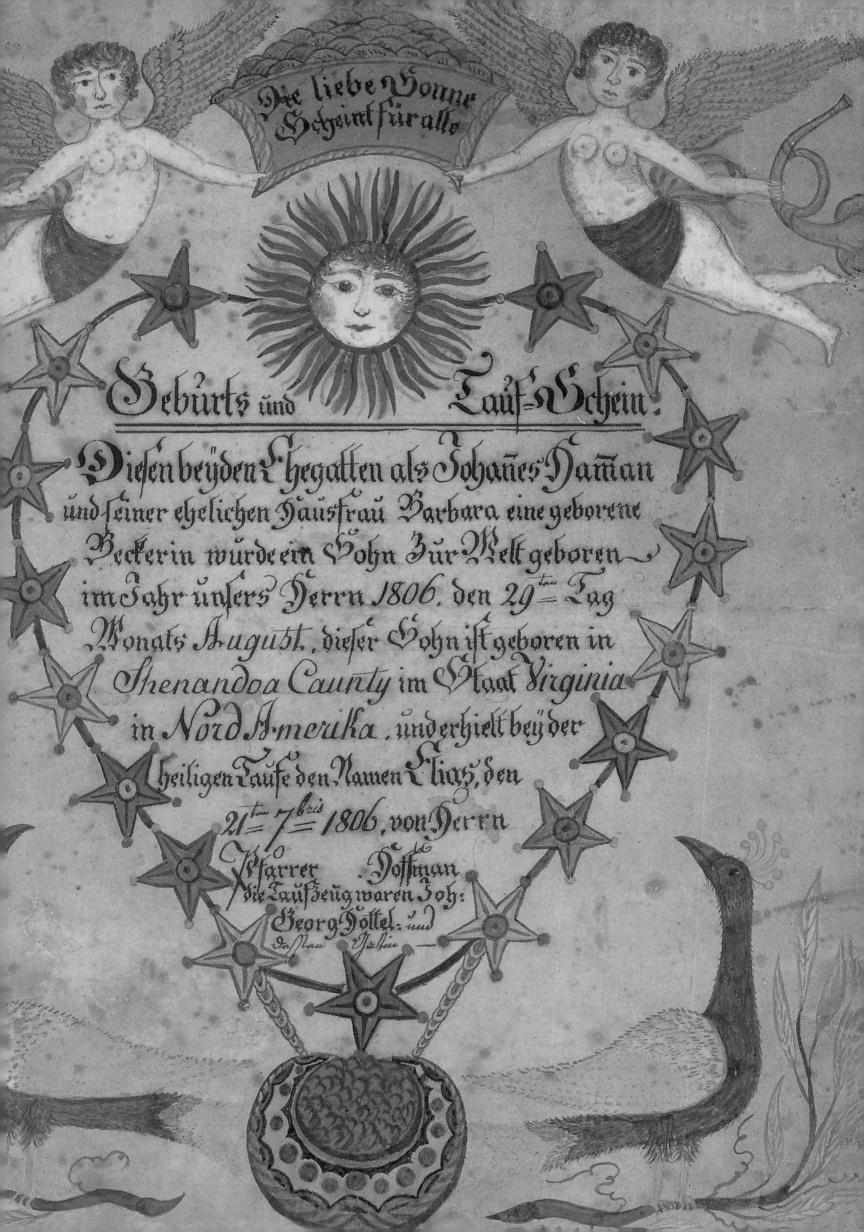

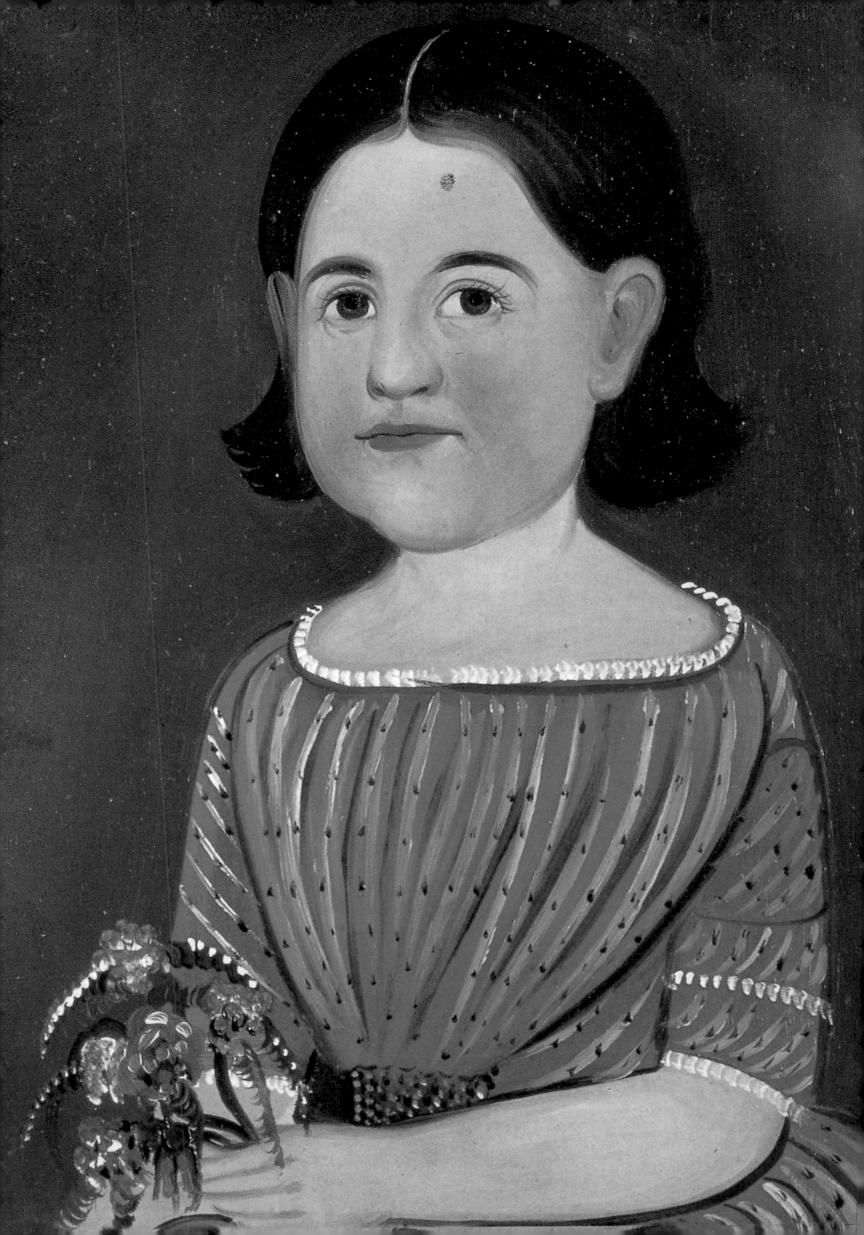

CHAPTER 1

REMEMBERING THE FAMILY

Folk art is, above all else, family art, carried out in a variety of mediums and with a multitude of purposes. Oil and watercolor portraits, silhouettes, memorial paintings, and gravestone art serve to perpetuate the memory of the living and the dead, while their surroundings, homes, and community are preserved through genre or "memory" painting. As with most folk art, the creators might have been professionals working for a fee or talented amateurs creating for their own satisfaction.

Portraits

It is difficult for us, in this age of still and video cameras and home movies, to imagine the importance of the portrait artist in memorializing the family. Yet until 1839, when Louis Jacques Mande' Daguerre (1787-1851) invented the daguerreotype, only the artist and the silhouette cutter could render a likeness.

Portrait painting had in Europe long been the prerogative of the royal and the rich; in the American colonies those who could afford it had their likenesses painted by academy-trained artists, usually of English origin. However, this was a "New World" with new ideas. The rising merchant, artisan, and farmer classes also wanted portraits, and if they could not afford the best professionals, they could afford home-grown portraitists. These might not have been academy-trained, but they were professionals in that they worked for a fee.

Referred to as limners (from the French *luminare*, to light up or illuminate, as in the fraktur decorations which embellished early religious tracts), these artists worked in both city and country.

In fact, many spent their winters in large cities like New York or Baltimore and their summers wandering from town to town across the countryside. Typically, they would take rooms at the local inn or board with a farmer (often paying with a family portrait) and would advertise for patrons in the local paper.

PORTRAIT OF A YOUNG
WOMAN c. 1830-1850;
oil on canvas; attributed to
William Matthew Prior
(1806-1873), active in Maine
and Massachusetts. Images
of children are among the
most popular of all folk art
subjects. Private Collection.

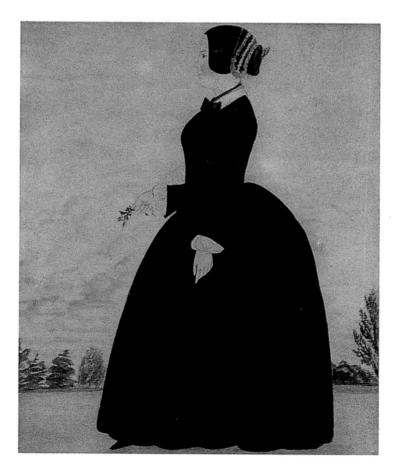

PORTRAIT OF A YOUNG
WOMAN c. 1825-1840;
watercolor on paper; attributed
to J. Evans, New Hampshire.
Background details enhance
the worth of this charming
picture. *Author's Collection*.

Following Page:
WATERMELON PARTY
1975; oil on canvas; by
Mattie Lou O'Kelley (1908-),
Maysville, Georgia.
O'Kelley, who created
this genre painting, is one
of the best known 20th
century folk artists and has
documented life in the rural
South. Private Collection.

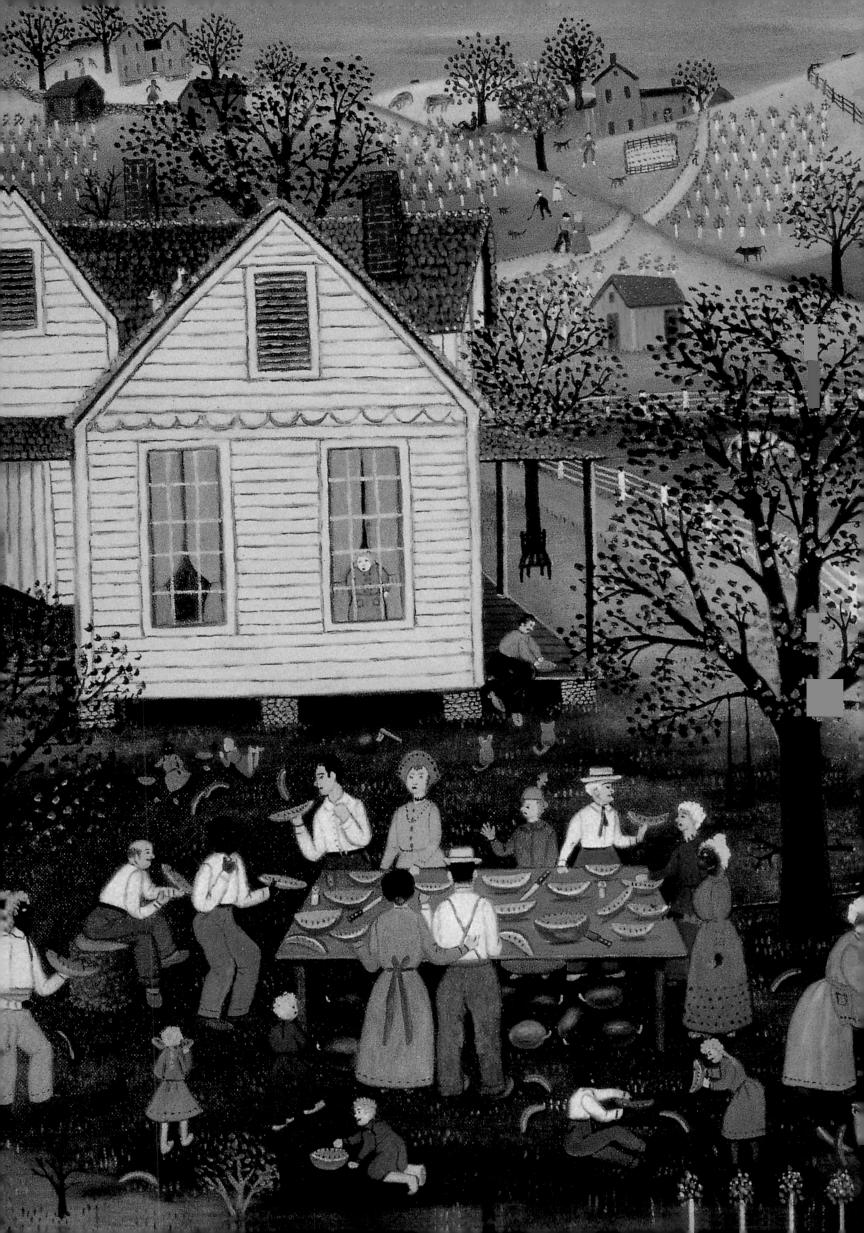

These ads, like the one placed by George Mason in the *Boston News-Letter* of January 7, 1768, often reflected the artist's sensitivity to the economic realities of his profession:

GEORGE MASON, Limner, begs leave to inform the Public That (with a view to more constant Employ) he now draws Faces in Crayons for Two Guineas each, Glass and Frame included, as the above-mentioned Terms are extremely moderate, he flatters himself with meeting some Encouragement.

Indeed, it was not unusual for the portrait painter to offer several grades of work, ranging from a fully-developed piece with extensive background details, to what was little more than a bare colored outline of the sitter. The New England artist Matthew Prior (1806-1873) noted in his advertising that "persons wishing for a flat picture can have a likeness without shade or shadow at one quarter price."

Although they seldom had much professional training, these itinerant artists often developed high degrees of facility and idiosyncratic styles which must have appealed to their customers (some produced hundreds of paintings) and certainly appeals to the contemporary collector. Though often lacking in techniques such as the use of shading or spatial relationships, they were skilled at hiding their shortcomings (hard-to-render hands and ears would be concealed within vests or beneath hats) and maximizing their strengths, such as the ability to execute

elaborate decorative details.

Since many also worked as sign, coach, or wall painters, these artist-craftsmen gloried in planes of bold, flat colors and the jewel-like details of earrings, hair combs, and shawls. Customers admiring the rich sheen of a new green velvet dress or the status reflected by the presence in the portrait of a newspaper or bible (it meant the sitter could read!) were likely to overlook slightly misplaced features.

Moreover, despite any defects in their own technique the limners were much aware of the academic art world. They employed as forms English portrait prints or "heads" and regularly perused how-to books such as *The School of Wisdom or Repository of the Most Valuable Curiosities of Art*, published in New Brunswick, New Jersey in 1787.

This did not, however, always help. The revealingly frank diary of the artist James Guild (1797-1844) notes that on the way to Bloomfield, New York he

put up at a tavern and told a Young Lady that if she would wash my shirt, I would draw her likeness....The poor Girl sat niped up so prim and looked so smileing...while I was daubing on a piece of paper, it could not be called painting, for it looked more like a strangle cat than it did like her. However, I told her it looked like her and she believed it.

PORTRAIT OF
ARCHER PAYNE, JR. c. 1791;
oil on canvas; attributed to
the Payne Limner, Virginia.
The use here of guns, dogs,
and hunting trophies reflects
the mannerisms of traditional
English portraiture.
Courtesy Sotheby's.

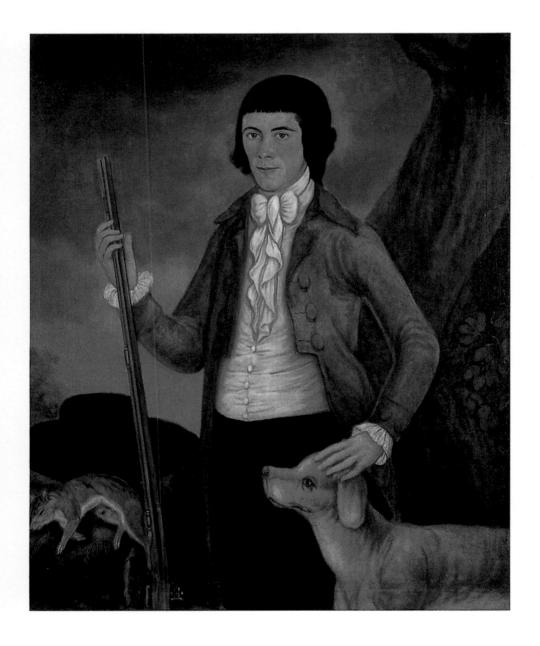

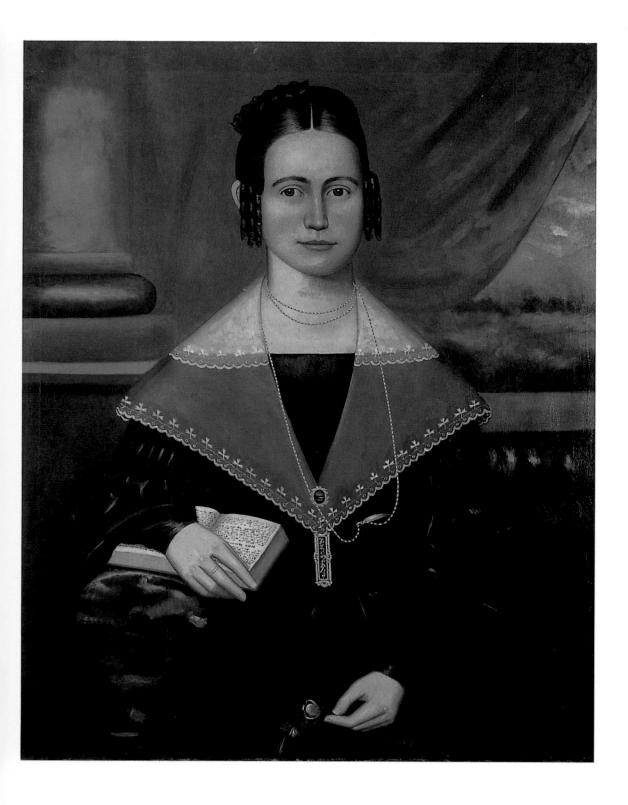

PORTRAIT OF LAURIETTE ASHLEY ADAMS PECK

c. 1840; oil on canvas; attributed to Erastus Salisbury Field (1805-1900), New York City or the Connecticut River valley. Field was one of America's most prolific folk painters, producing over a thousand paintings. Courtesy Museum of American Folk Art.

Like the European portraitists they mimicked, the American limners were overwhelmingly male and generally worked in oils. There were, however, a few women such as Ruth Henshaw Bascom (1772-1848) and quite a few, men and women, who worked in watercolors, pastels, or other mediums. One of the most interesting watercolorists was Lewis Miller (1796-1882) of York, Pennsylvania who devoted much of his long life to meticulously chronicling the faces, figures, and scenes of his native community.

By the mid-19th century most professional painters of folk portraits had turned to other trades (including photography). However, amateurs continued in the field throughout the Victorian era, and in the present century the rebirth of folk painting has spawned a new generation, including such important figures as John Kane (1870-1934) and Larry Zingale, who continues to contribute to this fine tradition.

GEORGE WASHINGTON
ON HORSEBACK c. 1830-1850;
watercolor, ink, and pencil
on paper; Pennsylvania.
This historical painting in the
fraktur manner presents one
of the most popular subjects
of patriotic folk art. Courtesy
Museum of American Folk Art.

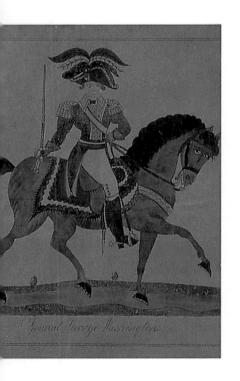

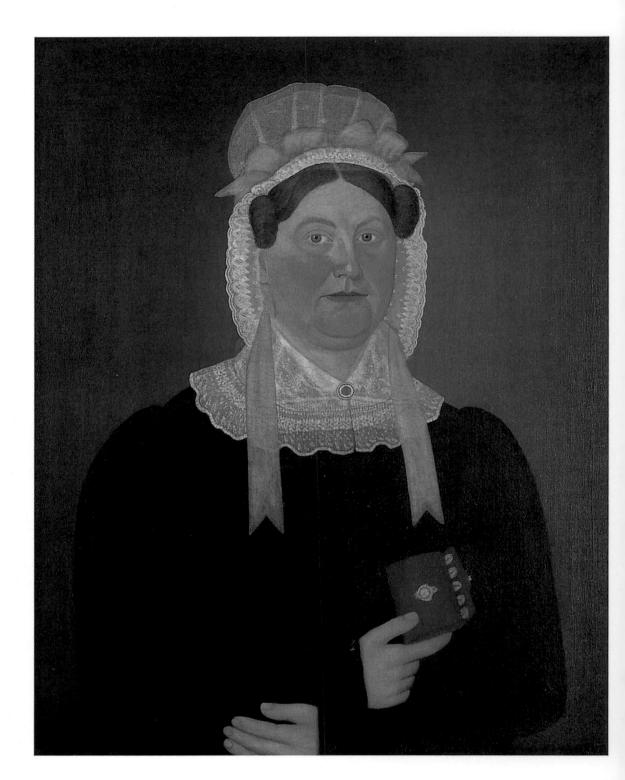

PORTRAIT OF A WOMAN c. 1820; oil on canvas, by John Brewster, Jr. (1766-1854), Maine. Brewster, a deaf mute, was a widely traveled artist working throughout New England for almost half a century. *Courtesy Sotheby's*.

PORTRAIT OF MARY KINGMAN
c. 1845; oil on canvas; by Susan C. Waters
(1823-1900), New York or New Jersey.
Waters was one of the very few recognized
female portrait artists of the 19th century, and
her work is in great demand. Courtesy Sotheby's.

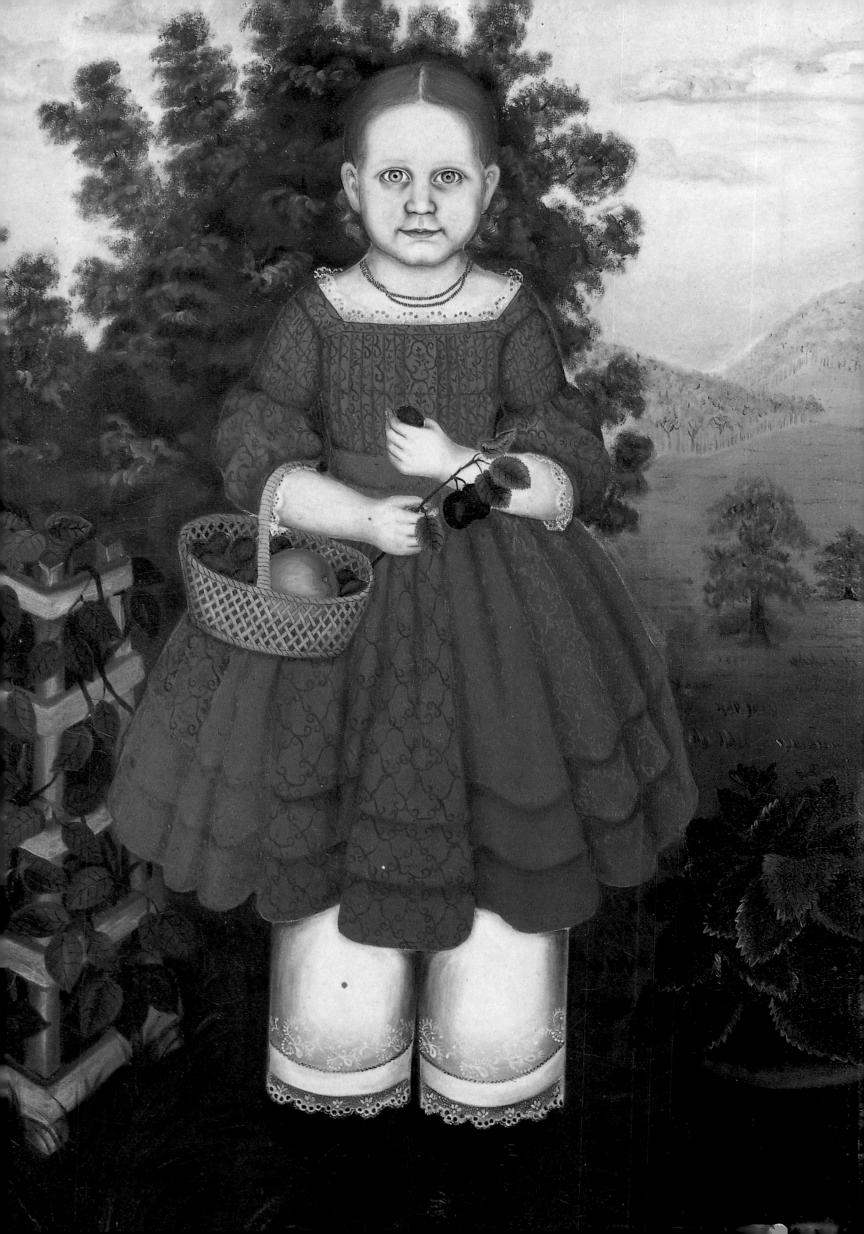

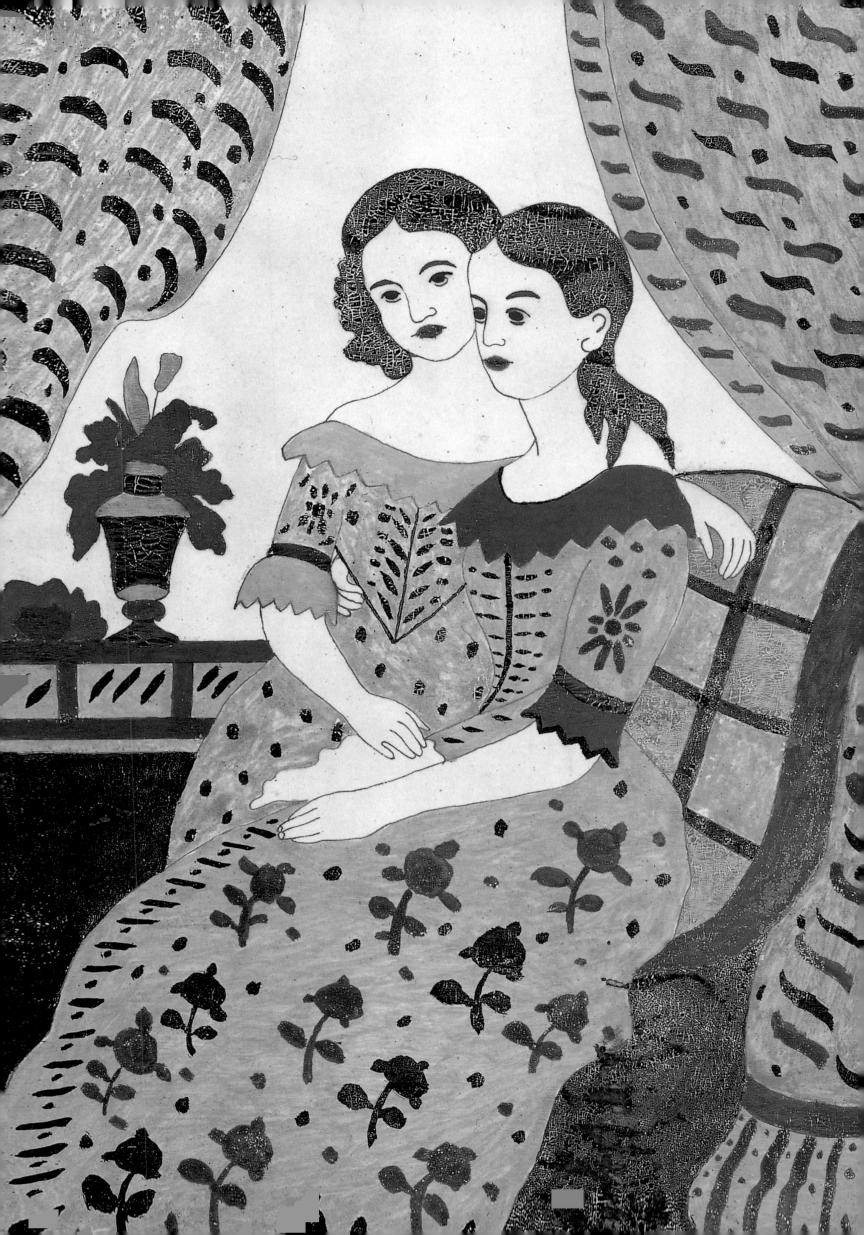

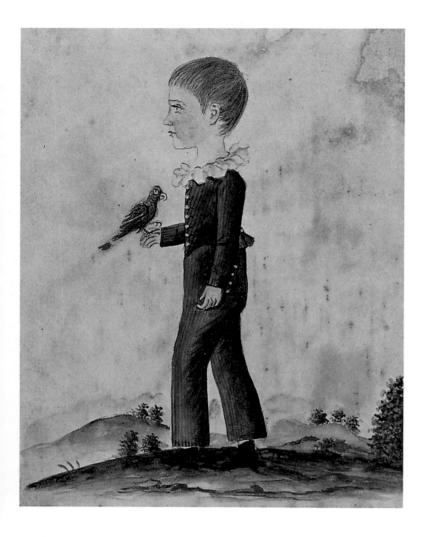

PORTRAIT OF WOMAN WITH WATERING CAN c. 1830; watercolor on paper; attributed to Elizabeth Glazer, Baltimore, Maryland. Glazer, a prolific artist, is known also for her poetry and needlework. *Courtesy Sotheby's*.

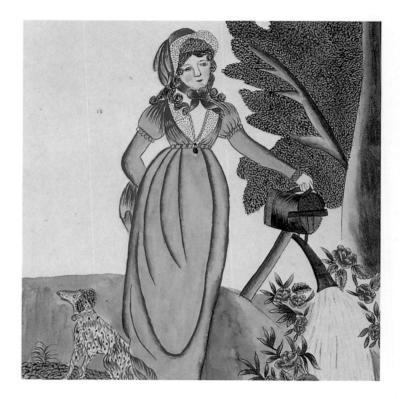

PORTRAIT OF BOY WITH PARROT

c. 1815; watercolor and ink on paper; attributed to Jacob Maentel (c.1763-1863), Pennsylvania. Maentel, one of the most important American folk watercolorists, produced dozens of small portraits. *Courtesy Sotheby's*.

PORTRAIT OF BOY WITH RABBITS

1831; oil on canvas; by John Bradley (d. 1874); New York or Connecticut. Bradley, like many American folk painters, embellished his work with images taken from European prints, such as the castle seen here. Courtesy Sotheby's.

PORTRAIT OF THE TOW SISTERS

c. 1854; watercolor on paper; by Mary Ann Smith. Like much early folk painting, this is a rendition of a period lithograph, "The Two Sisters," by an artist more adept at painting than spelling. *Courtesy Sotheby's*.

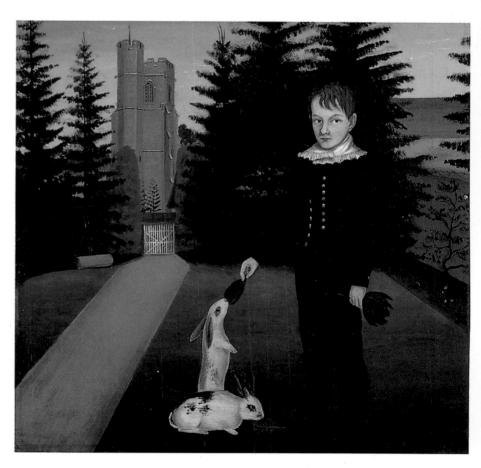

Silhouettes

For those who could not afford even Matthew Prior's bargain- basement price of \$2.92 for a "flat picture," there was always the silhouette cutter. The origin of the term tells much about the medium: the word is supposed to have been taken from the name of an 18th-century French minister of finance, Etienne de Silhouette, notorious for his frugality. Requiring only paper and scissors to create and selling for as little as twenty-five cents, the silhouette was indeed the thrifty alternative to a portrait.

There are three basic silhouette types: the hollow-cut, which consists of a profile cut from white paper and placed over a piece of darker paper or fabric; the cut-and-paste type in which a silhouette cut from darker material is glued to a lighter ground; and the painted silhouette which is not cut. All three types might be embellished with details in pencil, watercolor, or bronze powder.

While some silhouette artists cut their work freehand, most employed one of several patented mechanical devices called Pantographs which allowed adjustment of image size. Dexterity increased rapidity of production; one silhouettist, William King (1754-) of Salem, Massachusetts claimed to have cut twenty thousand profiles or "shades" at a rate of one every six minutes. King's advertisement in the *Salem Gazette* for July 27, 1804, stated that

he flatters himself, from the exactness of his profiles and the moderateness of the price (only twenty-five cents for two likenesses of one person) he shall give a pleasing satisfaction to those who favor him with a call.

Although some portrait painters also cut silhouettes, most were done by specialists. Like limners, they often were itinerants; however, there was frequently an element of theatre involved as well. Some silhouette cutters such as Charles Wilson Peale of Philadelphia (1741-1826) had their own studios or "museums" in which their work was displayed. Others turned handicaps to their advantage. Miss M.A. Honeywell (active 1806-1848), having been born without hands or feet, cut with scissors gripped between her teeth and signed her work, "Cut without hands by M.A. Honeywell." Another, the armless Master Sanders K.G. Nellis, is pictured in the *Salem Advertiser* of January 29, 1836 cutting silhouettes with his toes. He also played the cello and shot a bow and arrow with the same extremities. One suspects that the popularity of such artists was achieved more through spectacle

HOLLOW-CUT SILHOUETTES, HUSBAND AND WIFE c. 1820-1840; cut paper with ink; New England. The subjects' collars have been finely dilineated with ink. *Private Collection*.

Even more so than the portrait painter, the silhouette cutter was affected by the coming of the camera, which could provide a more accurate and eventually less expensive image. By 1850 nearly all had ceased to pursue this career.

than through skill.

HOLLOW-CUT SILHOUETTE OF A MAN c. 1820-1840; cut paper embellished with ink on fabric; New York.

The outer contour of the cut-out paper creates the image and is backed with dark fabric. Like most silhouettes, this one is unsigned. *Private Collection*.

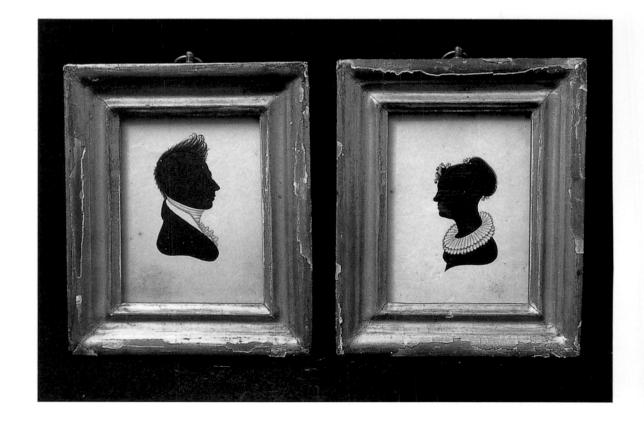

Genre Painting

Genre paintings, scenes of everyday life in home and community, have a long history. Sixteenth-century Flemish artists like Pieter Brueghel the Elder (1525-1569) created genre paintings which hang in every major museum. Similar if less well-known paintings have long been done by American folk artists. These range from simple interior scenes through views of individual farms or factories to larger scale compositions such as those of Joseph H. Hidley (1830-1872), who devoted much of his life to picturing his native Poestenkill, New York.

Many 19th-century American genre paintings were done by professional artists such as Fritz G. Voght (active 1850-1900) whose work was used to illustrate numerous business directories and atlases, so popular during the period. However, there were many who worked for the sheer pleasure of it, including one of our best-known folk artists, Edward Hicks (1780-1849), a Pennsylvanian whose remarkable farm scenes and "Peaceable Kingdoms" are valued in the hundreds of thousands of dollars.

In the present century genre painting has been graced by the presence of the internationally acclaimed Grandma Moses (Anna Mary Robertson, 1860-1961) whose renderings of bucolic scenes were instrumental in the establishment of the "memory painting" school of artists whose work reflects their memory of childhood life in what many seem to have regarded as happier times. Grandma Moses articulated this artistic philosophy best when she remarked that "things now go faster, in olden times things were not so rushed. I think people were more content, more satisfied with life than they are today."

Genre painters often relied heavily on period prints for inspiration. Grandma Moses acknowledged her debt to Currier and Ives lithographs, and a more recent artist who works in the same vein, Mattie Lou O'Kelley of Atlanta, Georgia (1908-) has sometimes taken her cue from illustrations in *The Saturday Evening Post* and similar popular magazines. In all cases, however, the print is but a starting point for the artist, who reworks the theme to produce a unique and personal expression.

An important aspect of the genre field is history painting, or the capturing on canvas or other mediums of important national and world events. Here again there is a long history, dating back

GENRE PAINTING, FARM SCENE c. 1850-1880; reverse painting, oil on glass; Pennsylvania. Images such as this were created to fit mirror or clock panels. Private Collection.

to the Greeks and Romans who described their martial triumphs in clay or on frescoed walls. As early as the 18th century, the American painter John Durand pointed out to readers of his advertise-

ELIZA WITH POOR PUSS
c. 1830-1850; hand-colored
lithograph on paper;
published by B. Bramell,
Philadelphia. Popular
prints such as this were
often copied by aspiring
artists; their works, in
turn, are thought by 20thcentury collectors to be
originals. Author's Collection.

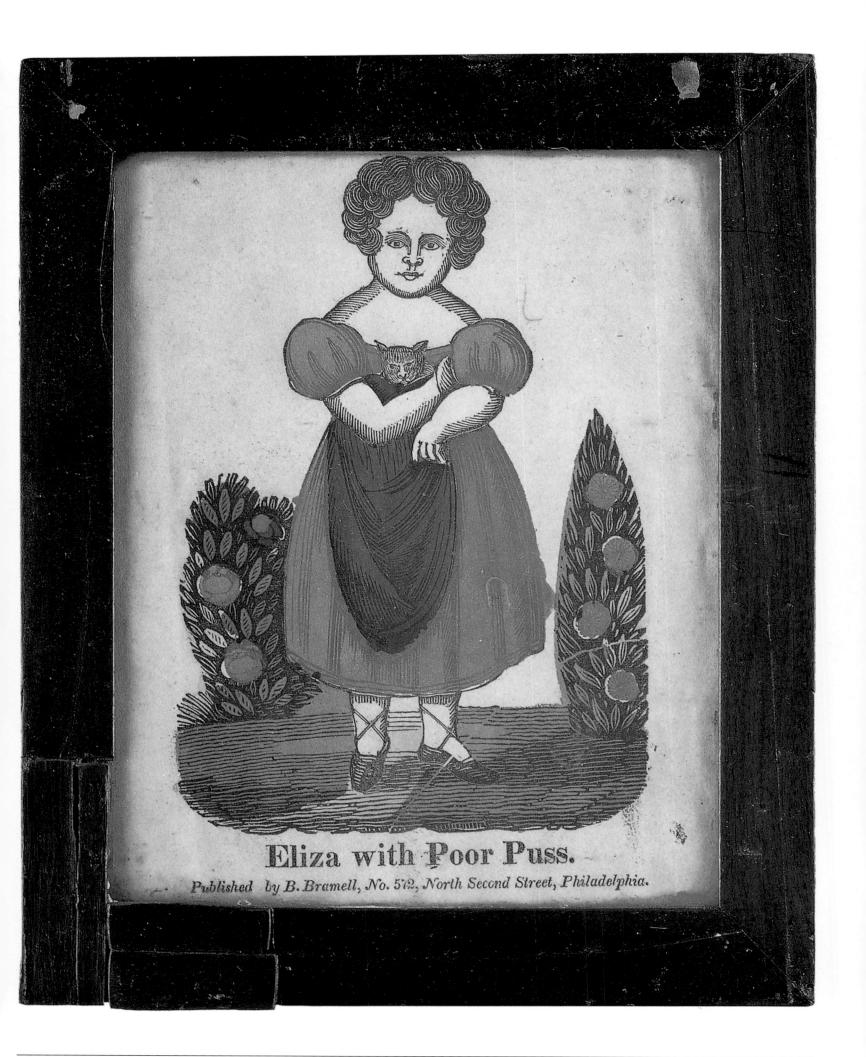

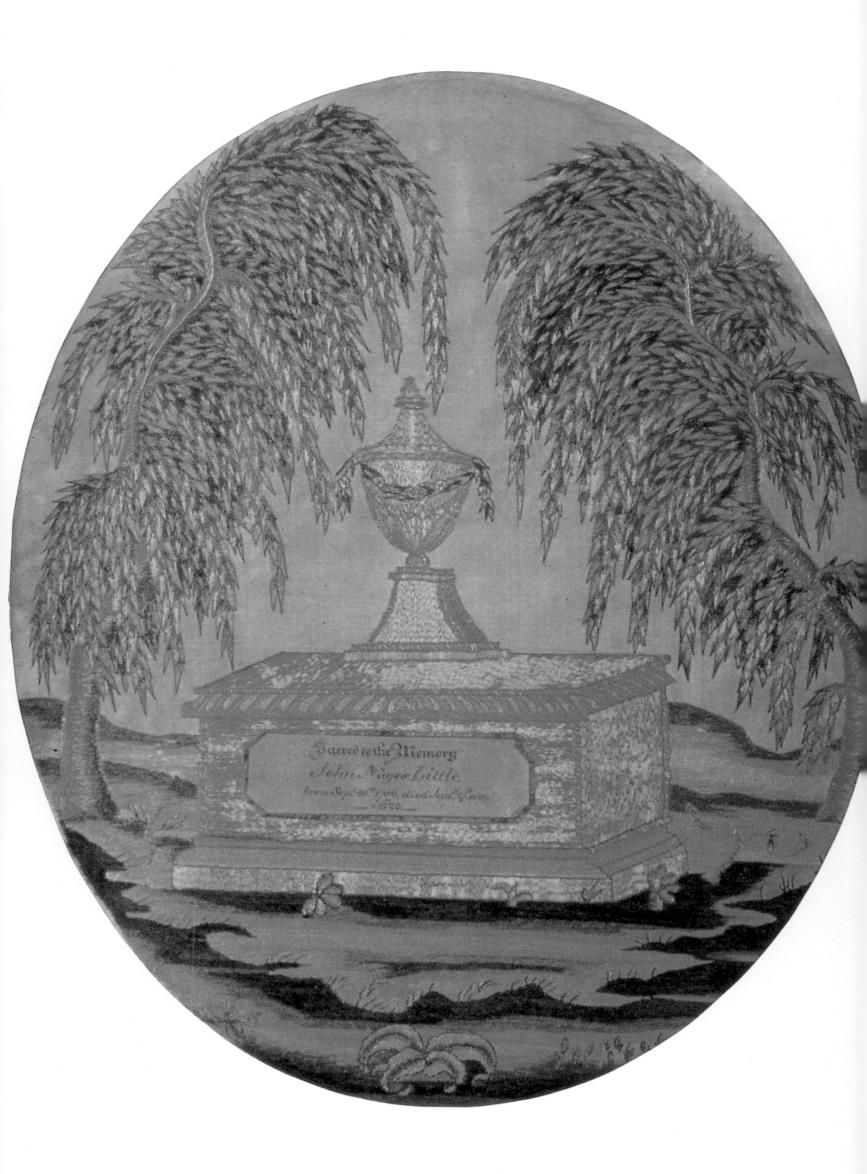

ments in The New-York Gazette or the Weekly Post-Boy (April 11, 1768) that

History-painting, besides being extremely ornamental, has many important uses. It presents to our View, some of the most interesting Scenes recorded in ancient or modern History.

American folk painters have recreated everything from major battles of the Revolution, War of 1812, and Civil War to biblical and mythological events. Among the greatest of these artists was Erastus Salisbury Field (1805-1900), whose gigantic painting, Historical Monument of The American Republic, (c. 1876) is thirteen feet long and incorporates numerous vignettes from the Republic's history, along with miniature portraits of the founding fathers and a bizarre architectural scheme.

Memorial Paintings

Memorial paintings, produced for a relatively brief period in the early 19th century, were largely a reflection of social mores. Women, while denied

access to the trades and professions, were expected not only to supervise the home but also to be the chief mourners of the all-too-common departed. In furtherance of this objective, girls attending boarding or finishing schools were taught to create mourning pictures, watercolor or mixed-media (watercolor and needlework) paintings which typically featured a tomb, weeping willow trees, and one or more despondent (usually female) figures, often dressed in classical garb quite unsuited to the period.

The earliest mourning pictures were based on English prints depicting Washington's tomb (following his death in 1799) and were usually of needlework. By the early 1800s these had been largely replaced by watercolor versions which, while still including the motifs described above, added such embellishments as painted backgrounds (which might include a village or a college), angels, birds, and a variety of flowers and trees. The mourners, rather that being clad in classical gowns as in earlier pictures, were frequently clad in period dress. Evolving attitudes toward death and changes in the roles of women gradually brought an end to mourning pictures; few were produced after 1840.

Since most women made only one or two mourning pictures, these artists are, for the most part, not as well known as those who worked in other fields. One name, however, that of the accomplished Eunice Pinney (1770-1849) of Connecticut, has survived, probably because she left behind a variety of historical watercolors and genre scenes as well as memorials.

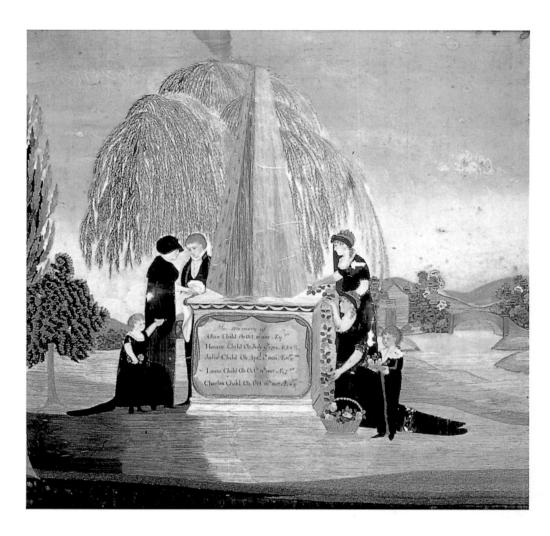

MEMORIAL PICTURE c.1820-1840; needlework and watercolor; New England. Such a sentimental and romantic scene as a tomb with a weeping willow surrounded by mourners in solemn garb makes this a traditional memorial. Courtesy Museum of American Folk Art.

MEMORIAL PICTURE c. 1820-1830; needlework and watercolor; New England. The earlier memorials were done primarily in needlework with watercolor backgrounds. *Private Collection*.

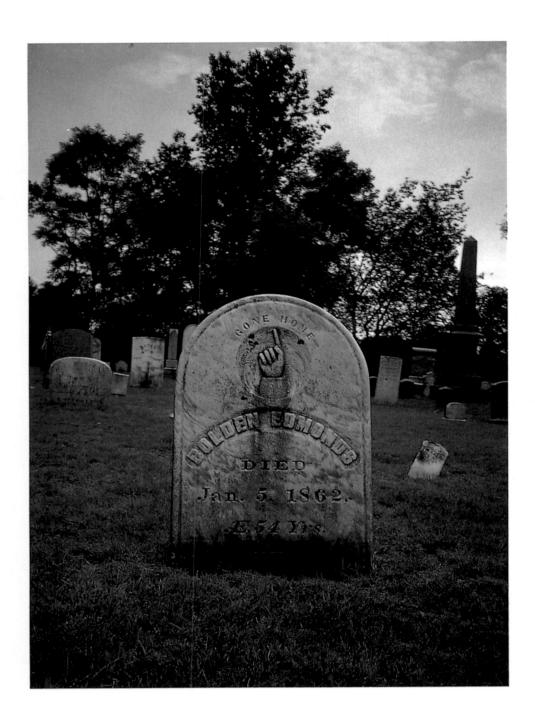

TOMB- OR GRAVESTONE 1862; carved marble. Few funereal symbols are more portentous than the finger pointing heavenward. Graveyard, Fortsville, New York.

Gravestone Art

Much can be learned of a society from the way it treats its dead, and American reverence for the departed is reflected in the finely carved stones used to mark their passing. While the earliest or poorest settlers had to be content with a rude field stone or a wooden cross, by the mid-1600s decorated memorials began to appear in New England's burial grounds.

The earliest carvers were untrained men from allied crafts such as leatherworking, cabinetry, or stonecutting, who found a demand and met it. By the mid-18th century, though, a class of gravestone artists emerged. What they produced reflected what was regarded as suitable in the community. Under the stern gaze of the Puritans, by whom death was regarded as a deserved end, stones were adorned with a death's head, a pair of crossed bones, or a figure of the grim reaper himself.

Benevolence prevailed in the 1700s and the skull became a winged cherub or "soul," often accompanied by a rich floral background, as in the work of Zerubbabel Collins (1733-1797) of Lebanon, Connecticut and Bennington, Vermont.

By 1800 classical motifs such as the funeral urn, tomb, and weeping willow appeared, making apparent a certain similarity between gravestone carving and memorial art of the same period. Indeed, one suspects that the same prints which inspired the schoolgirl artist may well have influenced the rustic stonecutter.

During the 1840s, however, classical

motifs gradually gave way to the romantic and eclectic designs of the Victorian era. Religious symbols, the hand pointing upward to heaven, and the open bible were popular among adult believers, and such varied motifs as the mortar and pestle, quill pen, anchor, gun, or flag indicated the craft or military service of the deceased. Doves and lambs frequently adorned the tombs of children.

While only a few carvers signed their work, most were amazingly consistent in style. As a result it has been possible for researchers to identify a substantial number of artists through secondary evidence such as estate inventories, bills, and church documents.

TOMB- OR GRAVESTONE 1796; carved marble; by Zerubbabel Collins (1733-1797), Bennington, Vermont. Dozens of Collins's stones can be found in Vermont and eastern New York, yet no two are quite alike. *Graveyard, Argyle, New York.*

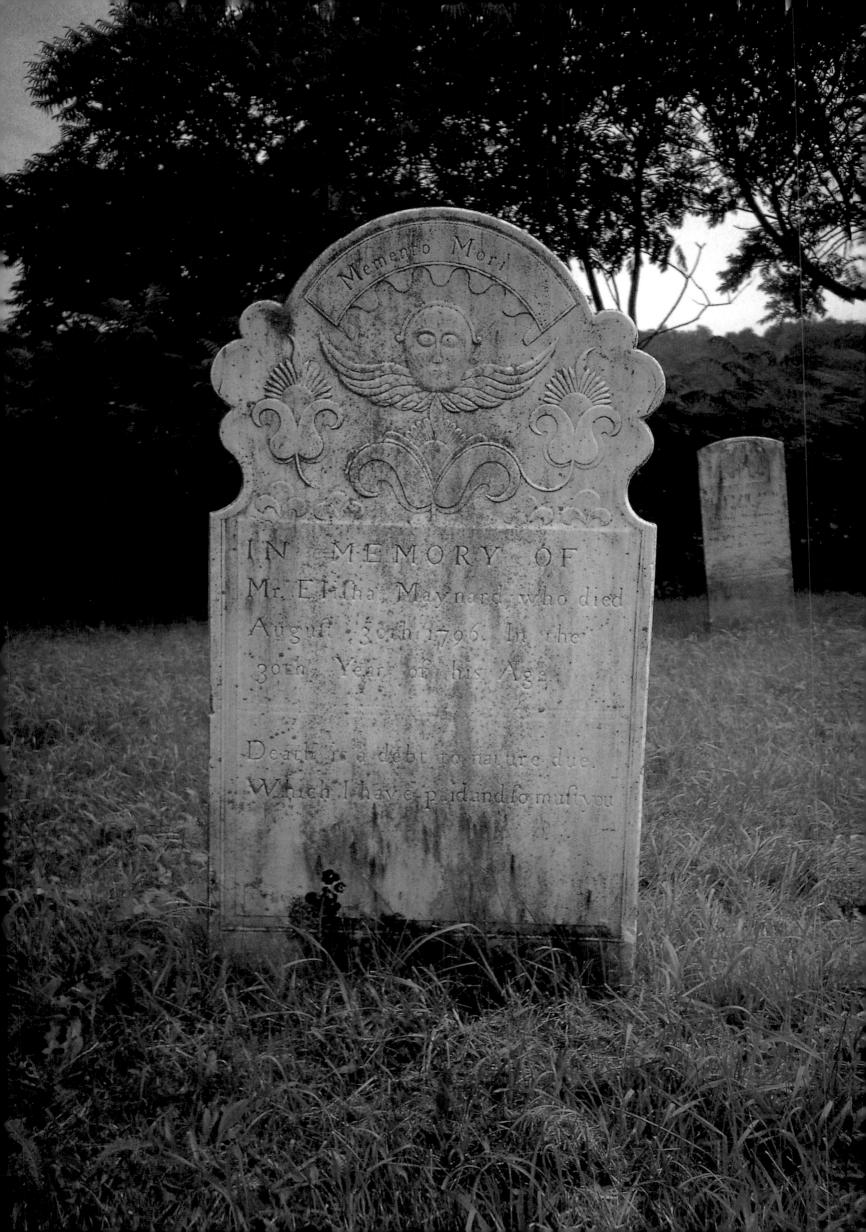

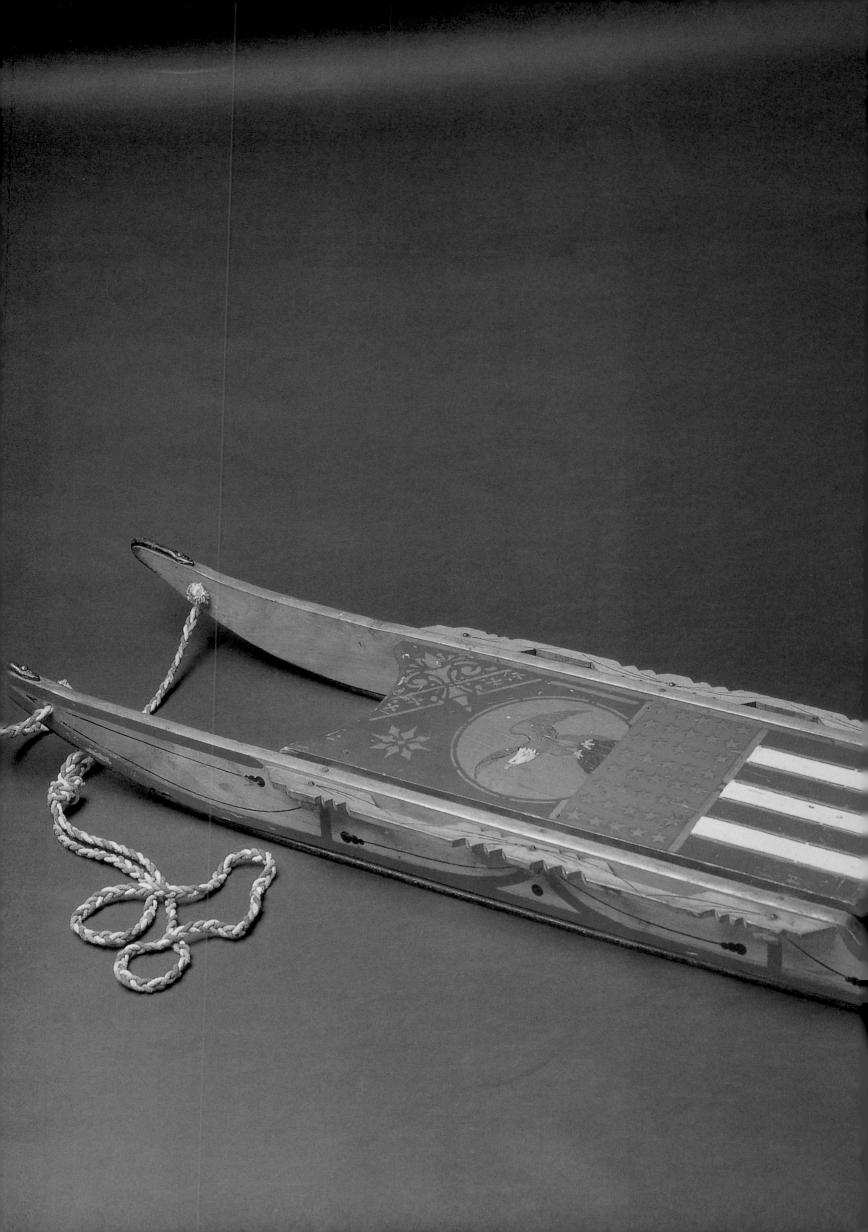

FOLK ART AROUND THE HOUSE

There was a time when historians and antiquarians viewed our ancestors as a group of solemn Puritans who lived in houses with whitewashed walls and rejected all interior decoration. Recent studies, however, have shown that, in general, the first Americans loved color, painting their walls red, yellow, and blue and filling their homes with carved and decorated furniture and accessories. That this was the case is hardly surprising, since these settlers came from European nations where such decorative embellishment was customary.

On the other hand, religious strictures sometimes led to criticism of those who wanted a bit of

color. In her *Home Life In Colonial Days*, Alice Morse Earle notes that a Salem, Massachusetts resident named Archer was thus mocked by a Puritan neighbor for painting a room: "Well! Archer has set us a fine example of expense—he has laid one of his rooms in oil."

One suspects that less objection was made to carved and painted utensils, as these not only were commonly made at home, but were also often gifts expressing affection for loved ones. Even the stern Cotton Mather would allow for that!

What is often surprising is the high artistic quality of the work involved. Most early settlers were, by necessity, jacks-of-all-trades familiar with saw and hammer, paintbrush and anvil. As a result they were often able to create remarkably fine pieces of folk art. And, of course, it was the best that was treasured and has come down to us. Few mediocre pieces have survived the centuries.

CHILD'S SLED c. 1870-1900; saw-cut pine with free-hand and stencil-painted decoration, northeastern United States. Patriotic motifs such as the eagle and the flag were common on 19th-century childrens' toys. Courtesy Joel and Betty Schatzberg.

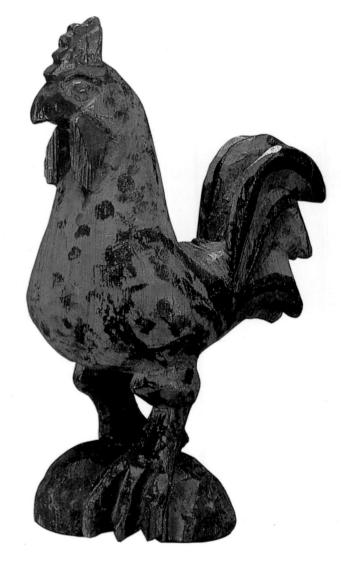

ROOSTER c. 1865-1875; carved and painted pine with gesso; by William Schimmel; Carlisle, Pennsylvania. An itinerant carver, Schimmel often traded his work for room and board. Today it is highly valued. *Courtesy Museum of American Folk Art.*

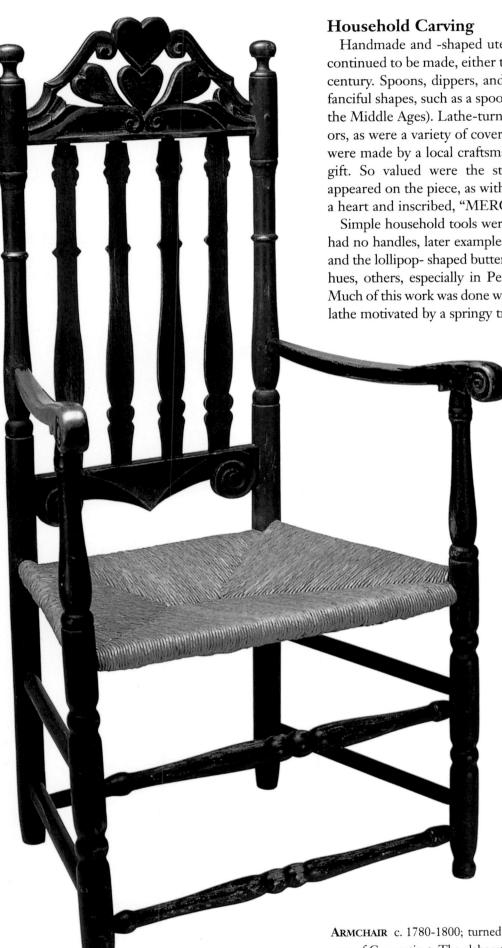

Handmade and -shaped utensils were common in early American houses and continued to be made, either through whim or necessity, until the end of the 19th century. Spoons, dippers, and spatulas of pine, maple, or cherry were carved in fanciful shapes, such as a spoon with a human or animal head (a custom dating to the Middle Ages). Lathe-turned wooden bowls were often painted in bright colors, as were a variety of covered containers used for storage. In some cases these were made by a local craftsman, but often they were produced in the home as a gift. So valued were the storage containers that their owner's name often appeared on the piece, as with a small, round pantry box which is decorated with a heart and inscribed, "MERCY NEEDHAM'S BOX/Sep. 13, 1815."

Simple household tools were also often made at home: rolling pins (the earliest had no handles, later examples one and finally two), mortars and pestles, spatulas, and the lollipop- shaped butter paddles used in the dairy. Some were painted in gay hues, others, especially in Pennsylvania, might have incised names and designs. Much of this work was done with a knife or chisel, though sometimes a simple whip lathe motivated by a springy tree was employed to turn basic forms.

Greater skill was required to shape butter prints and molds which were used to impress designs upon fresh butter. The craftsman would carve a decorative figure such as a cow (most appropriate), swan, eagle, ear of corn, or bundle of wheat on the flat surface of a handled, round wooden "print" with which blocks of butter were stamped. Molds into which butter was pressed were similarly carved. There were even rolling pins covered with figures about their circumference so that they might be rolled across a sheet of butter. All were hand shaped in the most charming manner.

Closely related were Springerle boards and gingerbread prints, oblong blocks of cherry or walnut into which were whittled up to a dozen shallow relief carvings of people, birds, animals, flowers, and fruits. Cookie dough pressed over such a mold would retain the designs. Much larger were the cherry or mahogany New Year's cake boards made for bakery use. Oval in shape and as much as twenty-five inches long, these were adorned with complex composifeaturing sometimes George Washington on horseback, the American eagle, or other patriotic motifs. Best known among the carvers of these is John Conger of New York City (active 1827-1835).

ARMCHAIR c. 1780-1800; turned, carved, and painted hardwood; Framington-Avon-Simsbury area of Connecticut. The elaborate carving of hearts on this chair is one of the more whimsical decorations found in American furniture. *Ex. Lillian Blankley Cogan Collection*.

TRAMP-ART PEDESTAL BOX c. 1900-1920; carved and notched pine

with interior lined in satin, northeastern
United States. Decorative boxes like
this were often used to store jewelry or
keepsakes. Courtesy Kelter-Malcé Antiques.

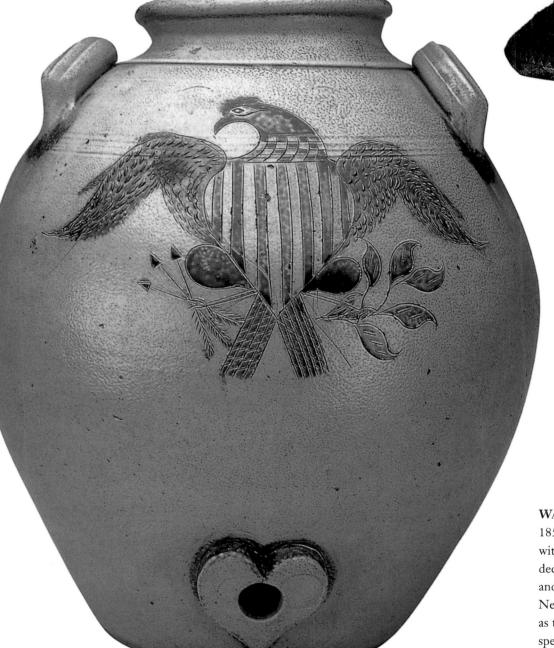

WATER COOLER c. 1830-1850; salt-glazed stoneware with incised, blue-filled eagle decoration; Jacob Van Wickle and James Morgan, Old Bridge, New Jersey. Ornate pieces such as this were usually made on special order or as gifts from the potter. *Private Collection*.

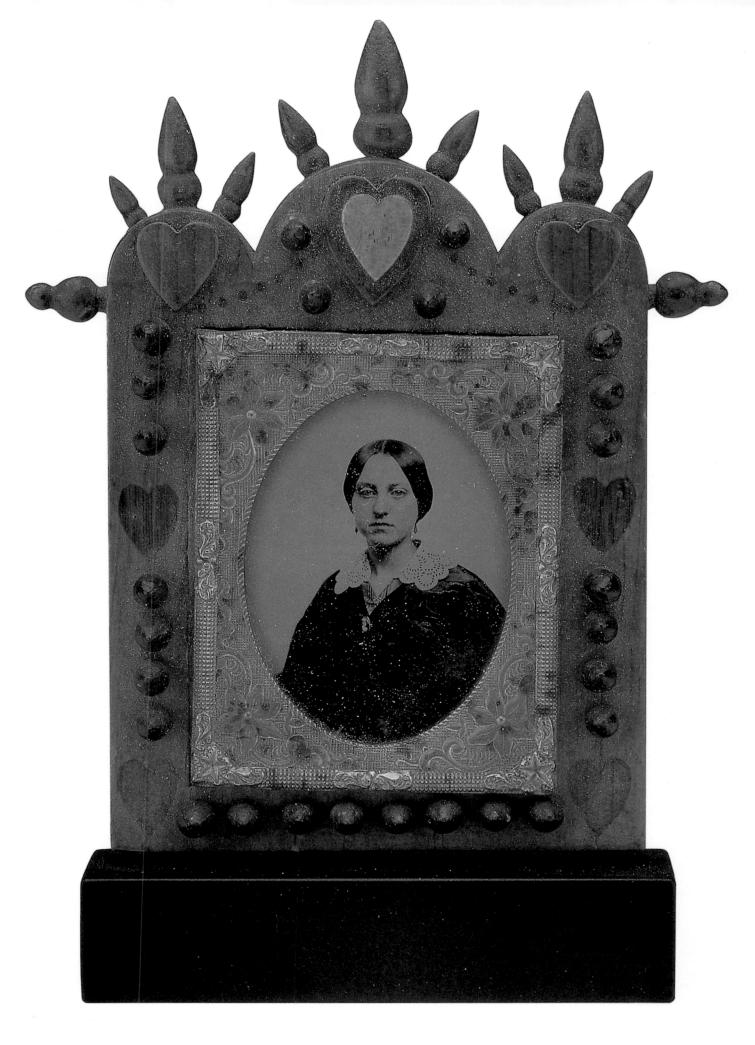

PICTURE FRAME c.1860-1890; carved and painted pine; northeastern United States. The tinted tintype of a beloved family member is set within a one-of-a-kind folk frame. *Private Collection*.

PICTURE FRAME, BACK VIEW The reverse of the picture frame shown (at left) bears inlaid, punch-decorated, and polychrome painted hearts—symbols of love and affection. *Private Collection*.

Painted Furniture and Accessories

Though all early settlers decorated their household furnishings, none did it with more verve than the Germanic settlers of Pennsylvania. From the 17th until the end of the 19th century they produced an unending stream of richly painted chests, cupboards, bureaus, and tables.

Perhaps best known of these are the dower chests in which young women stored quilts and linens to be used after marriage. Given as gifts by parents or swain, these were often dated and bore the name of the woman or couple and that of the manufacturer. Made of pine or poplar and decorated on the front and top with polychrome baskets of tulips, unicorns, pin-wheels, stars, and other traditional motifs, these storage pieces were once found in nearly every Pennsylvania Dutch home. Today, the best examples by makers such as Christian Seltzer (1749-1831) of Jonestown, Pennsylvania, will be found only in museums.

Even as late as the 1870s cabinetmakers in the state's Mahantango Valley were turning out chests of drawers adorned with brightly colored birds and flowers. Even more popular, both in Pennsylvania and in New England, were small storage boxes for sewing materials, handkerchiefs, or other "sundries." These were often the products of young women attending academies, who would decorate boxes (obtained from cabinetmakers) with complex landscapes and classical scenes. This "academy painting" was also applied to the tops of small tables.

Other useful household items such as pipe and salt boxes, looking glass and picture frames, and clock faces were also painted and decorated. Initially this was freehand work in oils, but by the 1820s the availability of stencils and metallic bronze and silver powders resulted in a movement toward more mechanical and less individual designs.

While much painted decoration was pictorial, there was even more that was abstract. Furniture makers regularly covered everything from chairs to beds with a coat of red, blue, or green paint, often designed to disguise the fact that the piece was made from several woods of different colors and grains. More sophisticated decorators even enhanced their work with graining and marbleizing: the application, using sponges, brushes, and metal

DOWER CHEST c. 1790-1810; polychrome painted pine; Pennsylvania. Designed for storage of a young woman's dowry, these chests were elaboratly decorated with flora and fauna. *Courtesy Marna Anderson Gallery*.

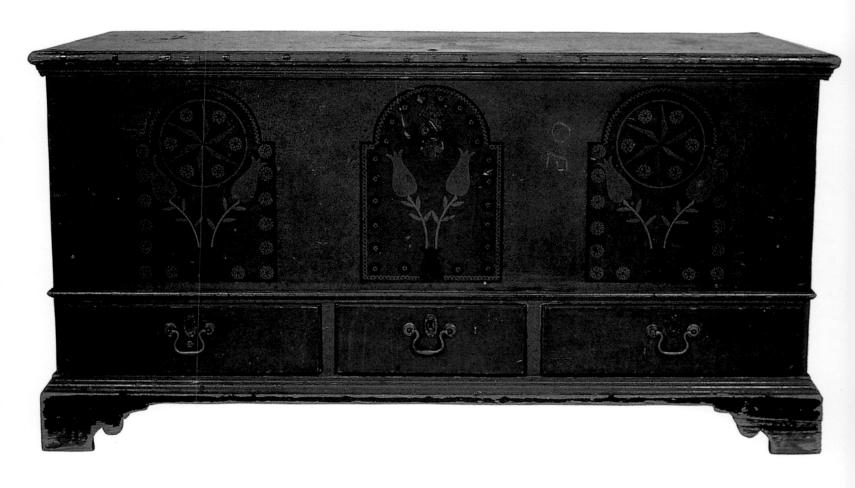

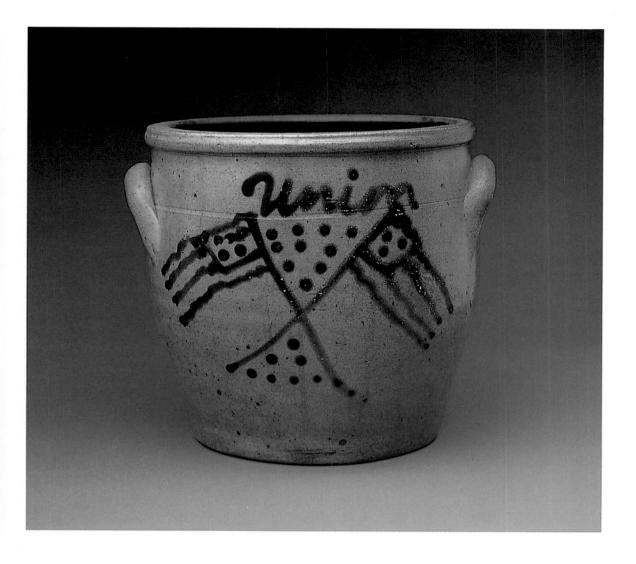

STORAGE POT c. 1860-1870; salt-glazed stoneware with free-hand decoration in cobalt blue; New York or Pennsylvania. The word "Union" suggests that the piece dates to the Civil War era. Courtesy Joel and Betty Schatzberg.

GAMEBOARD c. 1900-1920;
painted pine; New York.
Created for Chinese checkers,
a game played with marbles
within the area of a sixpointed star, this piece exerts
a strong appeal through
its bold design and vivid
coloration. *Private Collection*.

combs, of a surface that imitated woodgrain or marble. Thus, a skilled workman might transform a plain pine dressing table into one that appeared to be of mahogany with a marble top.

Not content with these faux finishes, others plied their tools and colors to create fanciful swirling compositions in bright reds, blues, yellows, and greens that bore no resemblance to anything found in nature, but evoked a most favorable response from their color-conscious customers. In New Jersey and the Hudson Valley area of New York other cabinetmakers produced massive storage pieces called kasten, which were decorated in shades of gray (grisaille) with patterns featuring classical urns, fruit, and flowers.

The extensive repertoire of these craftsmen is reflected in an 1805 advertisement placed by the Baltimore chair makers, John and Hugh Finlay (active c. 1803-1833):

CANE SEAT CHAIRS, SOFAS, RECESS and WINDOW SEATS of every description and all colors, gilt ornamented and varnished in a stile not equalled on the continent—with real Views, Fancy Landscapes, Flowers, Trophies of Music, War, Husbandry, Love, &,&.

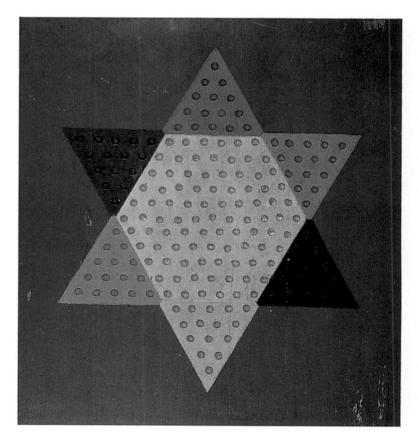

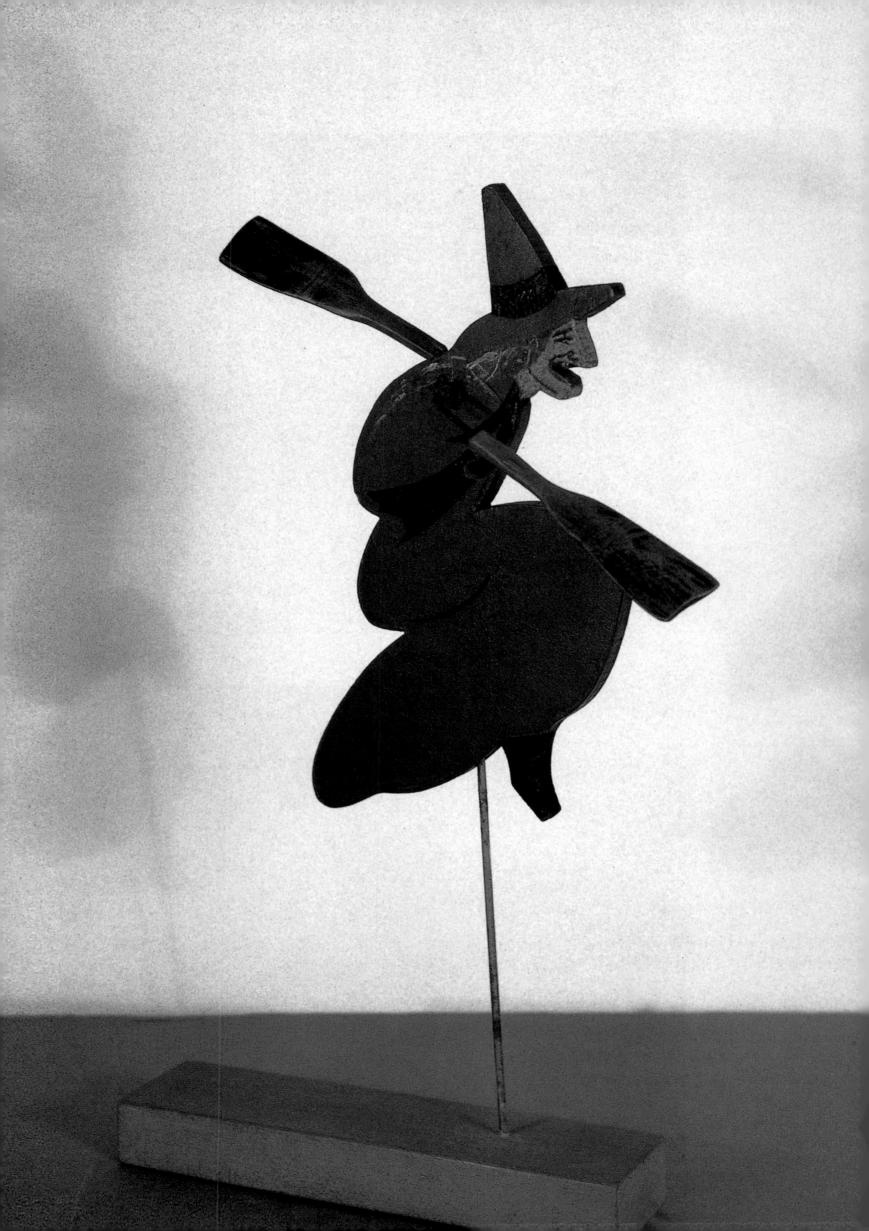

Today the most frequently encountered decorated chairs are those that were made and marked (c. 1818-1843) by the Connecticut turner, Lambert Hitchcock (1795-1852). Hitchcock, who painted his products with a combination of stencil and freehand work, gave his name to a whole category of mass-produced furnishings, many of which were still being made in the last decades of the century.

c. 1800-1820; polychrome painted pine; New England. Many early clock faces became, in effect, minature folk paintings. Author's Collection.

WHIRLIGIG
c. 1930-1940;
painted wood;
Connecticut.
Whirligigs of
this shape, a witch
whose arms spin
in the wind, were
made from plans
printed in *Popular*Mechanics magazine.
Private Collection.

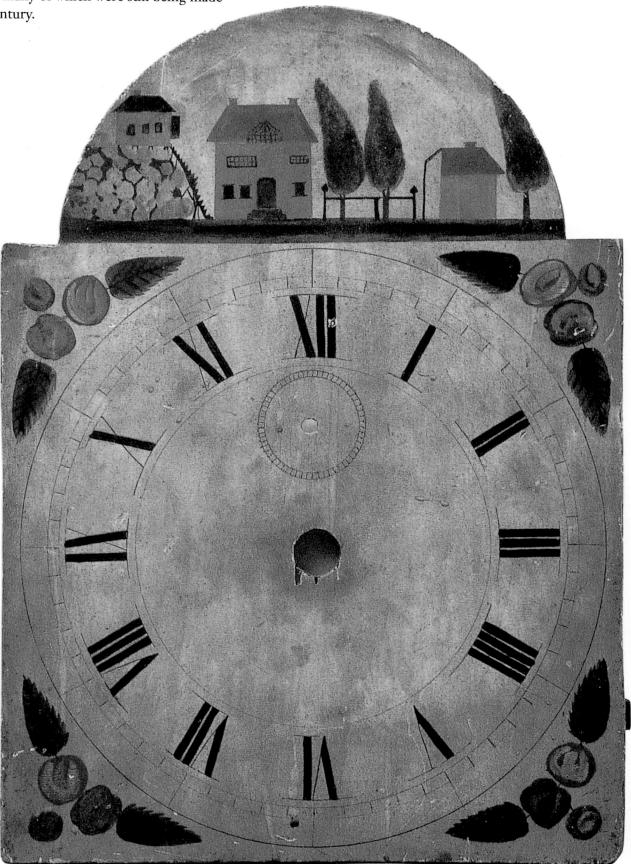

Two CHESTS

c. 1835-1870; smaller example: grain-painted; the larger: sponged in gray on a putty ground; New England. Neither of these fanciful finishes is intended to resemble a natural wood surface. Courtesy Marna Anderson Gallery.

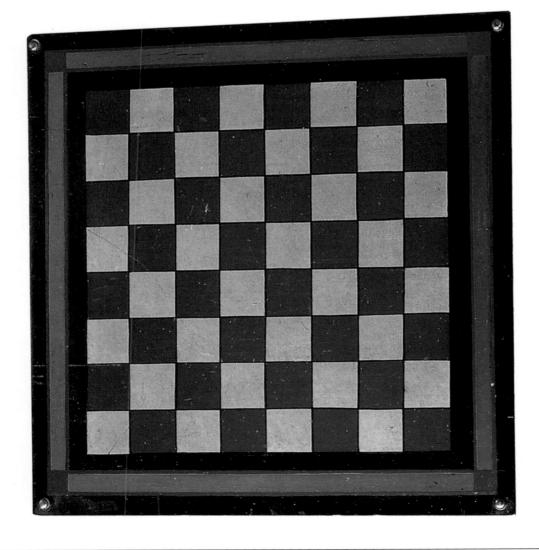

CHECKERBOARD

c. 1900-1925; painted hardwood board with iron feet; Connecticut. A large number of home-made checkers and parcheesi boards exist, made mostly by people unwilling to pay for a factory-produced example. Courtesy Kelter-Malcé Antiques.

INKWELL AND SANDER

1773; salt-glazed stoneware with incised, blue-filled decoration; by William Crolius, New York, New York. This object, in the shape of a heart, is a rare and attractive desk piece. *Private Collection*.

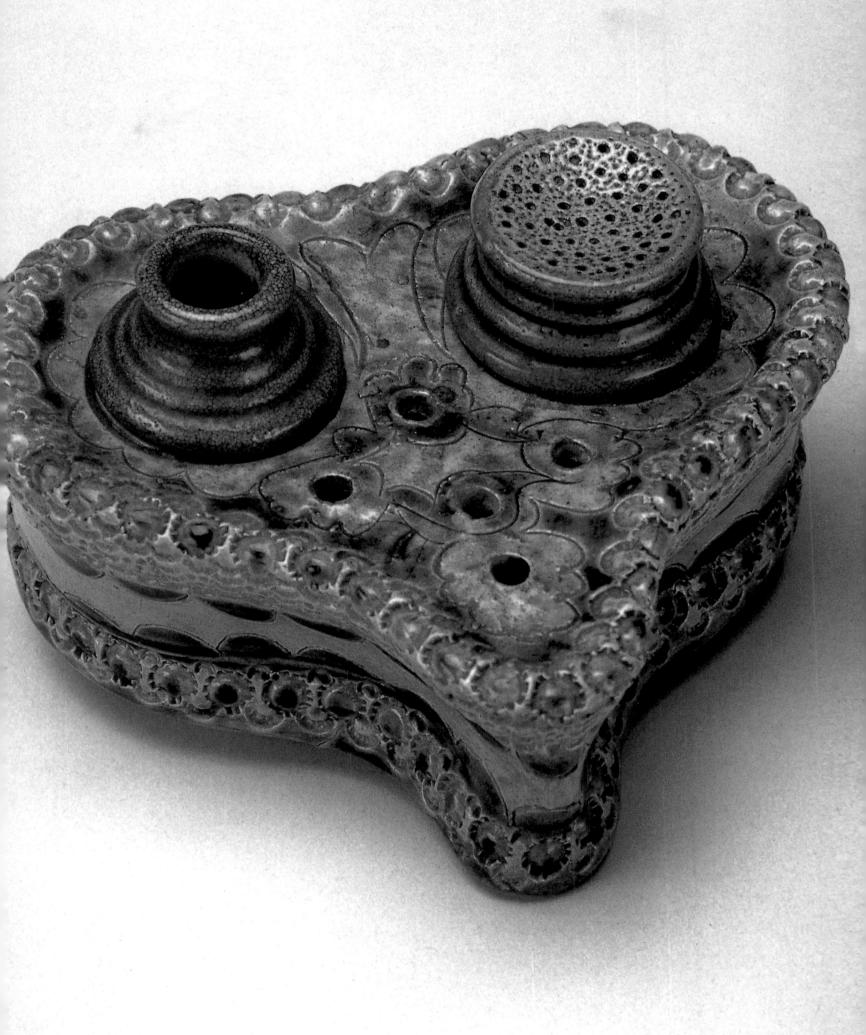

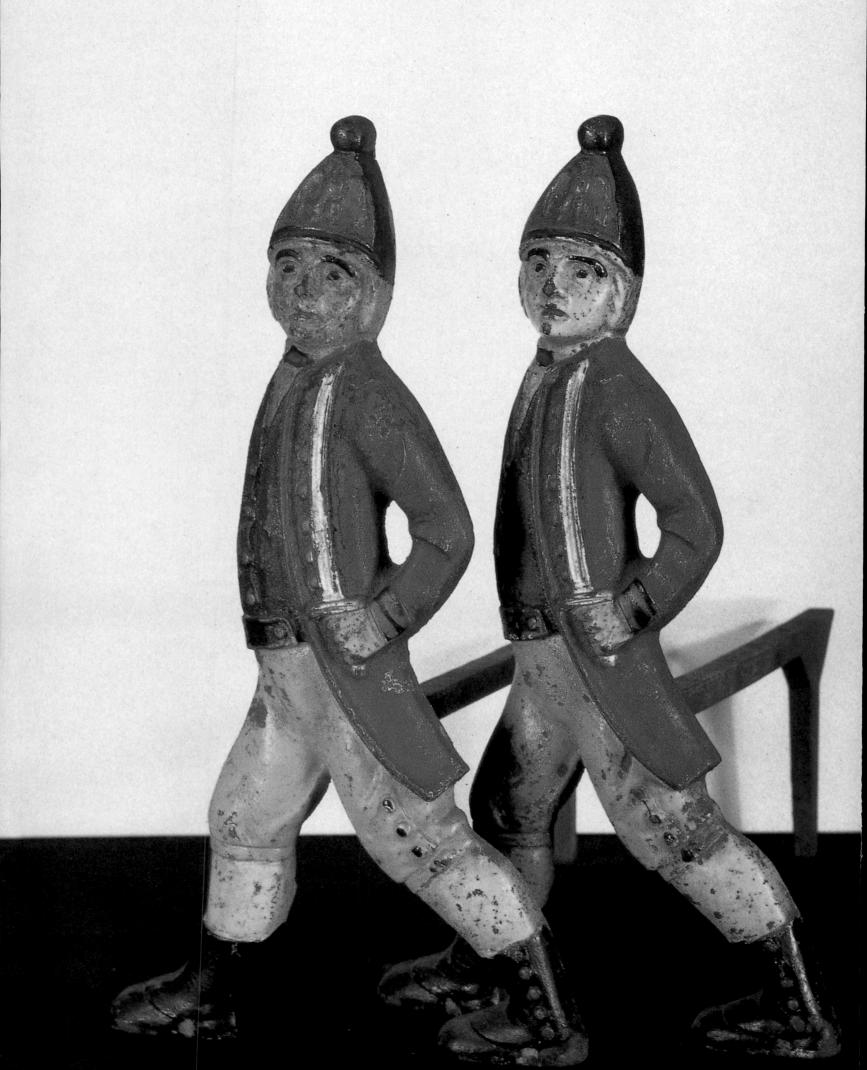

Figural Art in Metal

An impressive variety of folk art forms appear in wrought and cast iron. In some cases, as with doorstops (door porters to the English), the object is a folk form unto itself; one need think only of the numerous doorstops—ships, baskets of flowers, human figures, birds, and animals—produced by American foundries between 1880 and 1940. Typically, these were cast then painted in bright colors. Since they were made to suit popular taste, designs included some highly topical items: baseball players, Mickey Mouse, a young woman dressed as a flapper, nursery rhyme characters like Little Red Riding Hood, and even Uncle Sam. The great popularity of these doorstops has led to numerous reproductions, and collectors must be wary.

Another category, stoves, includes everything from simple six-plate woodburners embossed with representations of sailing ships, Victorian women, or various floral patterns, to large cast iron coal stoves made in the shape of towers or houses, sometimes crowned with representations of George and Martha Washington. Among other popular and readily available examples of folk art in metal are the andirons employed in fireplaces, both early- American and present-day. Andirons come in various shapes: Hessian soldiers, George Washington, blackamoors, sailors, ducks, geese, dogs, cats with glowing green glass eyes, and even leaping trout. Most date c. 1850-1930 and were originally painted, but they have usually lost their color to the flames. The earliest examples have the dogs soldered to the figures or a dovetail attachment. Nuts and bolts join the dogs in most 20th-century andirons.

Hitching posts of cast iron with rings to which a horse's reins might be secured were a standard fixture before most Victorian homes, shops, and public buildings, and they were usually crowned with a finial. As one might suspect, this was customarily a horse head. However, other forms are known, including human and eagle heads, clenched fists, geometric shapes such as stars or octagons, and baskets of flowers. There were also a few hitching posts in fully developed human form, most notably the jockey and the young slave, the latter an extremely fine form, sensitively sculpted.

Mill weights were used to counterbalance the blades of the great windmills which pumped well water to nourish midwestern crops. Weighing from fifteen to fifty pounds, they come in a variety of purely decorative forms: squirrels, ducks, chickens, cats, and birds, as well as moons, stars and abstract shapes. Largely unknown to Eastern collectors until the 1970s, these pieces have, despite their weight and general awkwardness, attracted a faithful following. As with decorative stoves, though, few people have space for a large collection.

Far easier to handle and display are the small cast iron match safes which once hung in every kitchen. Hundreds of different types are known; so many, in fact, that collectors may specialize in a single area such as patriotic, floral, or advertis-

ANDIRONS c. 1900-1920; polychrome painted cast iron, New York or New England. Hessian soldiers are among the most common subjects for figural andirons. Others in the same patriotic vein are eagles, Columbia, and George Washington. *Private Collection*.

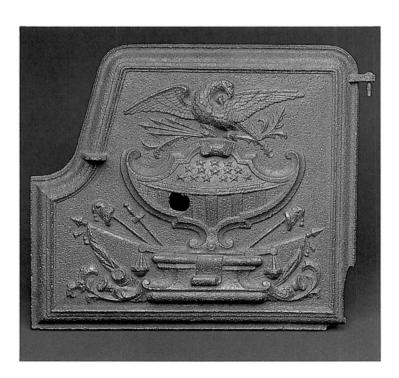

BOOT SCRAPER

c. 1990-1930; sheet iron; midwestern United States. No longer in use, these quaint pieces are now displayed as folk sculpture. *Private Collection*.

STOVE DOOR c. 1830-1850; cast iron with embossed eagle and trophies of war; Troy, New York. Heating and cooking stoves, once the focal point of a room, were often lavishly decorated. Ex. Author's Collection.

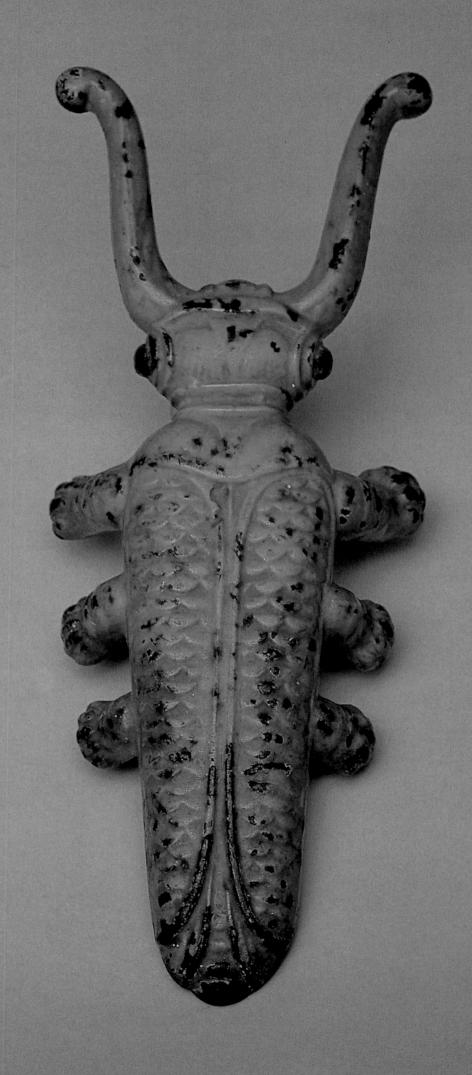

ing (many were promotional give-aways). These are often found in original paint, and most desirable are the rarities: black Americana, political campaign themes, and one-of-a-kind pieces.

The bootjack was another popular device, used to remove boots and shoes. Best known, of course, is the slightly scatological "Naughty Nellie," but other examples include an oversized beetle and a longhorn steer whose horns serve to pry off the recalcitrant footwear.

A variety of iron benches, chairs, and tables used on patios and lawns were also quite common. Rustic examples, with backs, seats, and arms in the shape of leafy branches, are much sought after today, as are a variety of garden urns (some four feet high), flower pots, and even cast iron fish tanks. All were embossed with decorative floral patterns and are greatly favored by contemporary landscape designers and decorators.

Folky metal door knockers shaped like hands, eagles, or flags greeted the visitor to the American home of the past. Within the kitchen were found a multitude of cast iron objects, including figural trivets upon which hot plates might rest, and the stands used for holding flatirons. These latter, like match safes, were frequently business give-aways, incorporating the name or logo of a foundry or a company which manufactured kitchen utensils.

Less common are painted cast iron picture and mirror frames. World War I spurred the manufacture of iron picture frames decorated with cannons and American flags, presumably designed to house an image of a son or husband fighting in Europe. Earlier Victorian frames are in the Art Nouveau manner.

Following Page:
ANDIRONS c. 1870-1900;
New England or southern
United States. These
African forms represent
one of several variations
which include figures clad
as sailors. *Private Collection*.

CIGAR HOLDER

c. 1900-1925; carved and painted wood, incised "Habanas"; eastern United States.

This wall-hung receptacle was used for cigars or matches.

Ex Jay Johnson Collection.

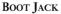

c. 1880-1920; painted cast iron, New York. This object, in the shape of a beetle, was designed to ease the effort of removing one's boots. The boot heel is placed between the beetle's elongated feelers, which hold the boot in place while the foot is withdrawn. *Private Collection*.

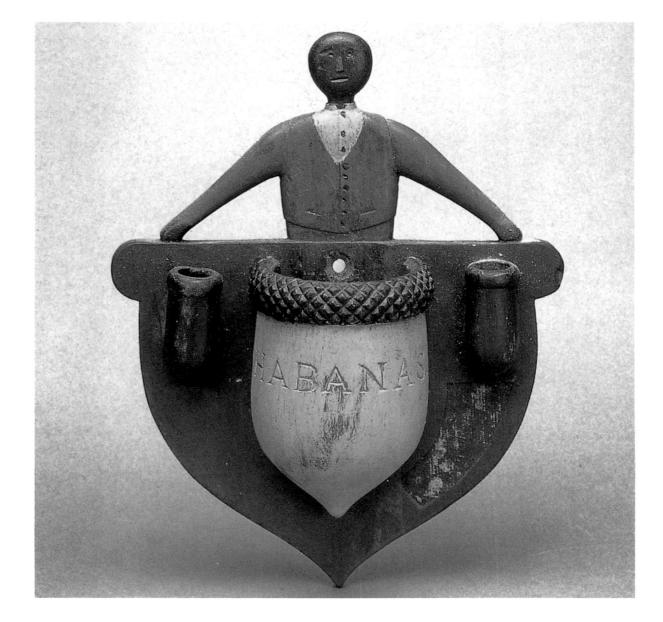

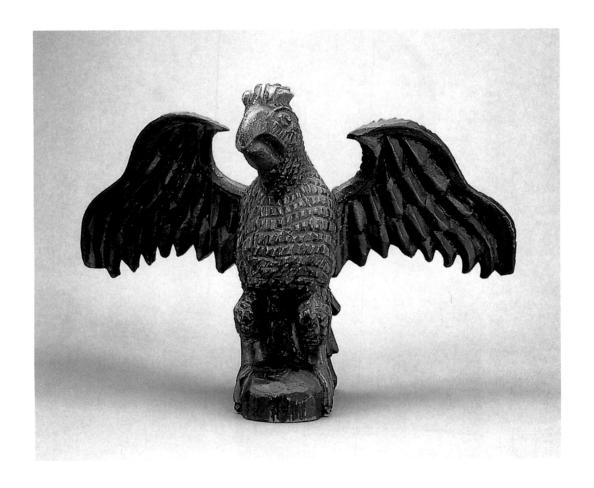

EAGLE c. 1870-1890; carved and painted pine with gesso; by William Schimmel (1817-1890); Carlisle, Pennsylvania. Eagles, with wing spreads up to three feet, were Schimmel's favorite birds. *Private Collection*.

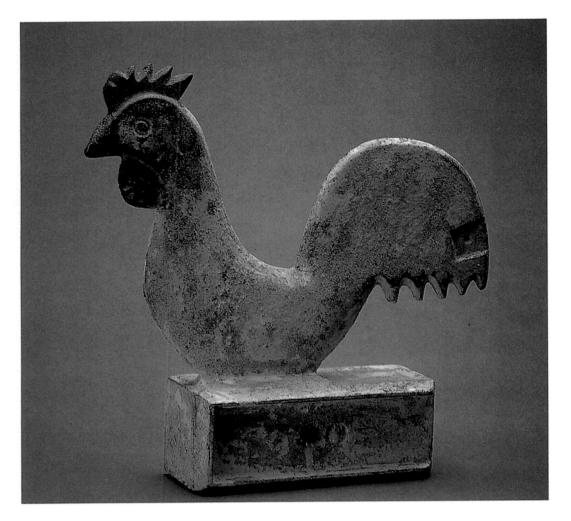

WINDMILL WEIGHT c. 1880-1910; painted cast iron; attributed to Elgin Windmill Power Company, Elgin, Illinois. These heavy pieces were originally mounted high on the windmill to balance the propeller weight. Now, with their prime purpose gone, collectors may examine them at close range for their aesthetic value. Courtesy American Primitive Gallery.

DOORSTOP c. 1930-1940; painted cast iron; Ohio. Cartoon figures and storybook characters, such as Little Red Riding Hood shown here, were popular doorstop subjecs. *Private Collection*.

Religious Painting and Carving

In most areas of the United States religious painting and sculpture is not found in the home or, if present, is largely confined to commercial reproductions. A notable exception is the Southwest, where in states such as New Mexico and Arizona Spanish-Americans have long cherished religious folk art. Local craftsmen known as *santeros* produced three types of art: large, polychromed carved altar screens (*reredos*), paintings on pine or cottonwood panels called *retablos*, and figural carvings, *bultos*. The subjects were saints and the holy family and the inspiration was provided by religious prints or the few classical paintings brought in long ago from Mexico.

With the exception of altar screens which were intended for the adobe churches, these pieces were produced mainly for the small shrines or *nichos* found in every believer's home. Consequently, most were quite small. *Bultos* were generally two feet or less in height, and the typ-

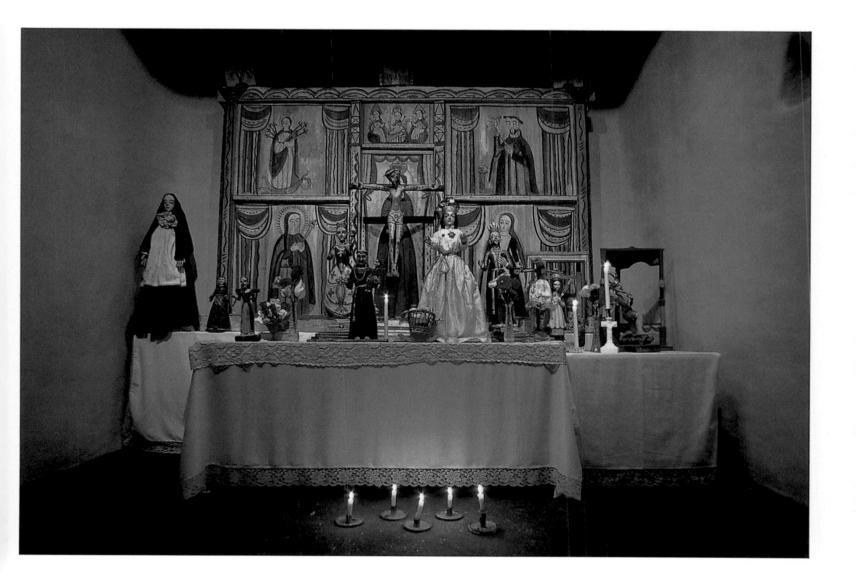

ADAM AND EVE 1965; carved pine; George T. Lopez, Cordoba, New Mexico. Lopez is a member of a family that for six generations has carved *bultos*, or Spanish-American religious figures. Unlike most *santeros*, he often does not paint his figures. *Collection Rubens Teles*. REREDO OR ALTAR SCREEN c. 1840-1890; carved and painted wood; from the chapel of Our Lady of Talpa, Talpa, New Mexico. Courtesy Taylor Museum, Colorado Springs Fine Arts Center:

ical *retablo* measured about eight by twelve inches. An exception was the *bulto a vestir*, a cloth-covered framework with carved head and hands. Often four feet tall, these were primarily church furnishings.

Though long unappreciated outside the Southwest, *bultos* and *retablos* have come to be recognized as among the most powerful and moving of American folk art forms. Artists like Jose Rafael Aragon (active c. 1820-1835) and Fray Andres Garcia (active c. 1748-1778) are now highly regarded.

By the late 1800s the *santeros* had begun to vanish, their work replaced by inexpensive religious prints sold at trading posts. However, in the last few decades a new group of artists has emerged to carry on the age-old tradition. Ironically, though, the work of such 20th-century carvers as Jose Dolores Lopez (1868-1938) of Cordoba, New Mexico is sold mostly to collectors rather than believers. Some of these sculptors, such as Felipe Archuleta (1910-) of Tesuque, New Mexico have expanded their repertoire to include non-religious carvings. His lively animal carvings have been exhibited at several major museums.

Religious carvings and paintings have been made during this century in other areas of the country as well. One of the best known 20th-century folk carvers was John Perates (1895-1970) of Portland, Maine. Perates

SAINT LUKE c. 1935-1945; carved and painted oak bas relief; by John Perates (1894-1970);Portland, Maine. Perates, a skilled cabinetmaker, produced a series of reliefs and an altar for his Greek Orthodox church. Private Collection.

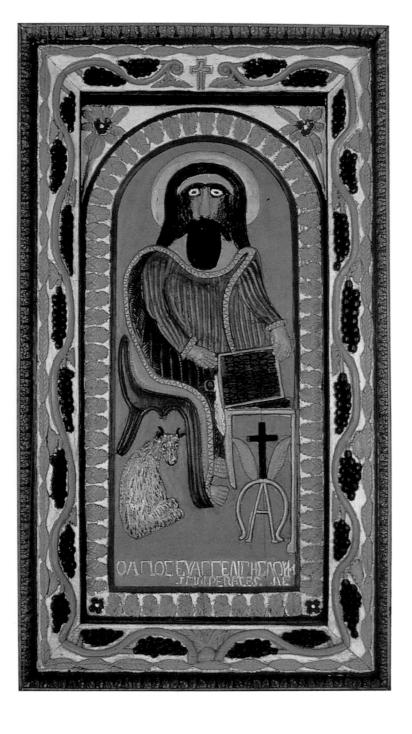

created a monumental grouping of painted relief carvings based on the life of Christ. These were designed for installation in his church, but most pieces have found their way into public and private collections. Perates' work reflects another old country tradition, that of the painted icon.

On a much smaller scale are the biblical carvings of Edgar Tolson (1904-) of Compton, Kentucky. Born in the Appalachians and heir to a long tradition of whittling, Tolson created with knife and chisel a variety of delicate, sparsely-colored pieces based on such themes as the expulsion from paradise and the story of Cain and Abel. His stony-faced figures have the power and frontality of Gothic images.

THE NAZARENE CHRIST

c. 1850-1860; carved and painted cottonwood with cotton robe and horsehair wig; northern New Mexico. A figure of this type, known as a bulto a vestir, would most likely be intended as a devotional object in a small parish church. Courtesy Taylor Museum, Colorado Springs Fine Arts Center.

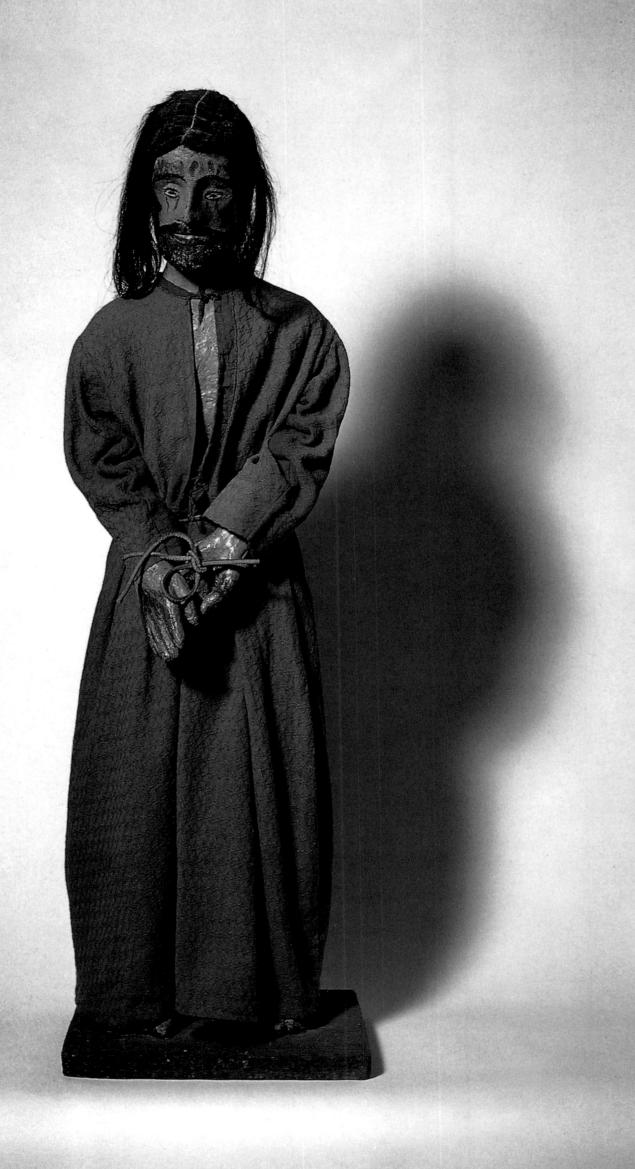

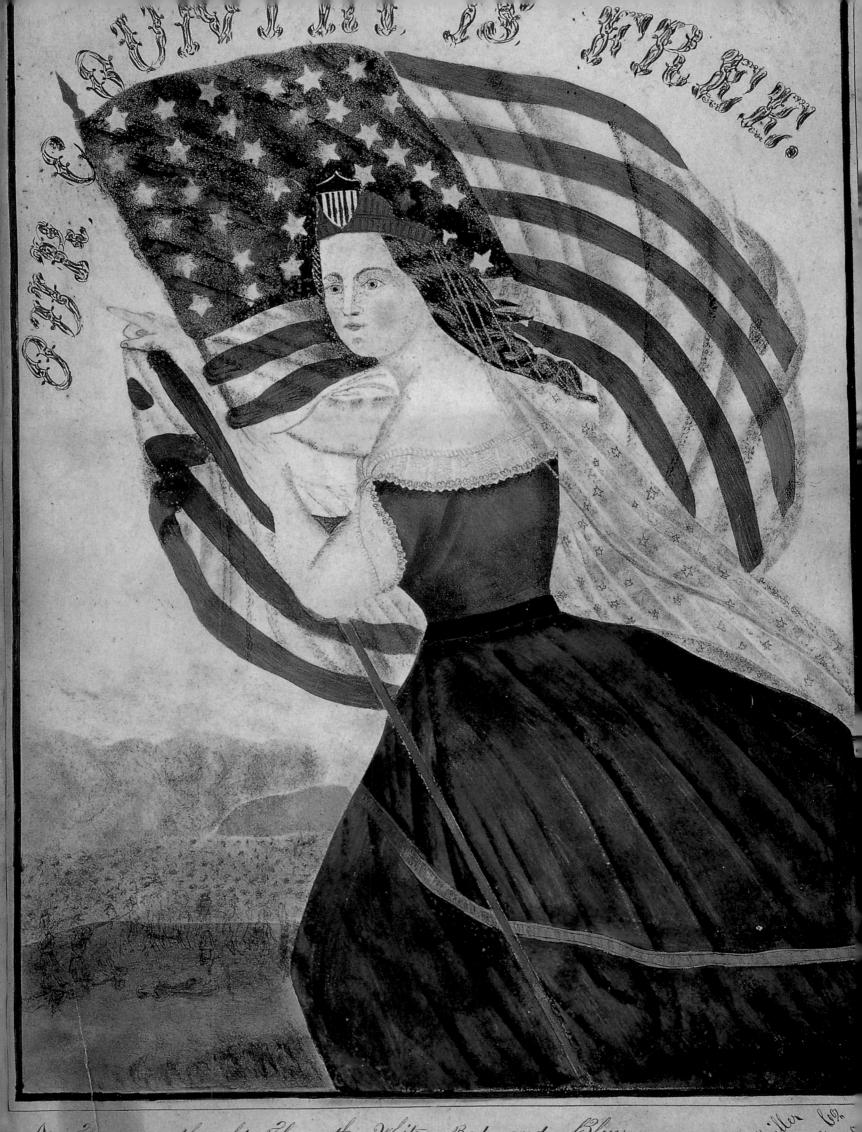

No stag sove the old Blag the White Red and Blue . Shall wave o've a nation unbroken and true . Brise up and defend it ye sons of the Brave. Whose blood bought the Banner wour vair must save.

for Miles for the

CHAPTER 3

PASSING TIME: FOLK ART AS HOBBY

As the 19th century advanced, leisure time became a greater part of American life; labor-saving devices in the home, on the farm, and in the factory allowed more people to have more free time. In the period before movies, radio, and television, this time was often occupied by what one might term creative hobbies, activities that were both interesting and often productive of something useful and attractive. This was especially true in the case of middle- and upper-class women, who were the beneficiaries of both new domestic appliances and an influx of cheap, immigrant domestic labor. To fill her newly acquired spare time the lady of the house often turned to pastimes such as theorem painting and calligraphy.

Such leisure-time undertakings were not confined to women. Games and art activities like sand-paper painting were regarded as acceptable for mixed groups, and many men excelled in calligraphic drawing. None of this would have been regarded as useful by the Puritans, but in the 19th century the belief that "idle hands do the devil's work" was reinterpreted to allow those hands pleasurable as well as pro-

ductive activities.

Crafts indulged in primarily by men, such as cane and whimsey carving and the making of tramp art objects, reflected a general familiarity with the jack-knife at a time when most males had a certain amount of mechanical facility, and gifts were more often handmade than store-bought.

OUR COUNTRY IS FREE c.
1870; watercolor on paper; by
Joe Miller, Illinois. Like many
similar folk paintings, this one
was adapted from a 19th-centu-

ry Currier & Ives lithograph. Courtesy Merle H. Glick.

multi-colored silk thread embroidery on rag paper; by Eda Brown, northeastern United States. The artist has brought freshness and simplicity to a common 19th-century theme. Textile folk art of this sort is both rare and desirable. Courtesy Kelter-Malcé Antiques.

EMBROIDERY ON PAPER 1848:

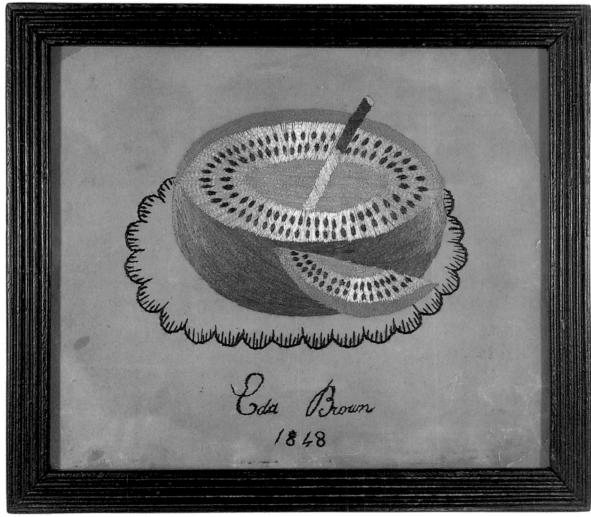

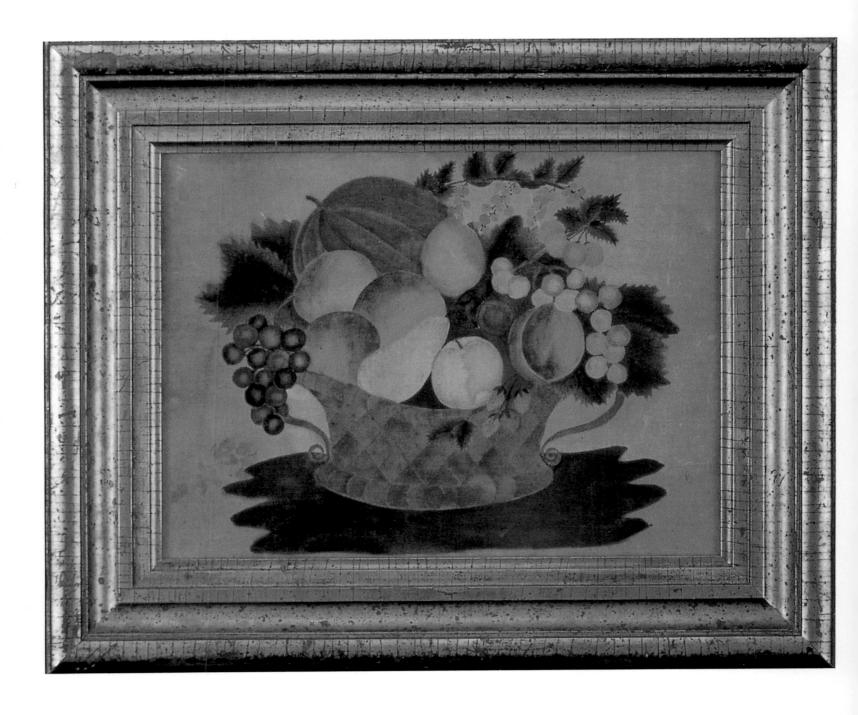

THEOREM c. 1830-1850; watercolor on velvet; New England. The classic theorem form was the basket or bowl of fruit, sometimes embellished with a bird or butterfly. *Private Collection*.

Theorem Painting

One of the most popular arts practiced during the 1800s was theorem painting, a form of composition in which cardboard stencils of individual elements such as leaves, apples, or gourds were combined to a whole. These pictures usually took the form of a compote or basket filled to overflowing with fruit, flowers, and vegetables, above which hovered a bird or butterfly.

Theorem painting was a most democratic process requiring no formal training. Moreover, by midcentury newspapers and women's magazines carried advertisements for complete kits with which to practice the art. Advice such as the following offered in the publication *Art Recreations* in 1868 is typical:

Theorem Painting...is better shaped to fruits, birds and butterflies, than to landscapes and heads. It will enable you to paint on paper, silk, velvet, crepe, and light colored wool. Lay the theorem on the paper on which you intend to paint....Press the theorem firmly down with weights at each corner and proceed to paint. Commence with a leaf; take plenty of paint, a very little moist, on your brush, and paint in the cut leaf of the theorem....If successful with a leaf, try a grape.

Despite the various surfaces suggested, most theorem paintings found today were done on velvet, as the watercolors used were less likely to run on this fabric. However, paper and even tin were used. The earliest theorem examples date to the 1850s, and the art was still being practiced at the turn of this century.

Calligraphy

Calligraphic art was a byproduct of the ornamental handwriting widely practiced throughout the 19th and early 20th centuries. Often referred to as Spencerian script (for a writing master named Spencer who established a chain of secretarial schools), this highly stylized or "flourished" technique enabled the practitioner not only to write a most readable hand, but also to produce charming pen-and-ink drawings. These delicate works are of great interest today, but they were a minor part of calligraphic training. A typical period text, *Tarble's SELF-INSTRUCTOR IN WRIT-ING AND ITS USES* (1856), devoted only a single example and one paragraph to such illustration, pointedly stating that "no attention should be paid to these, until the other copies are well mastered."

Nevertheless, much of the finest calligraphy extant is in the form of large drawings, typically of birds (eagles were a great favorite), lions, horses, and human figures, done by writing masters as advertisements of their skills. Most are in black and white, though blue and red inks as well as watercolor embellishments were sometimes employed. Few students attained this level of competence, though many learned to produce a nice bluebird as evidenced by the number of such drawings which grace the small autograph books popular among Victorian girls and boys. Removed and mounted, these four-by-seven-inch sketches are often seen in antique shops and shows.

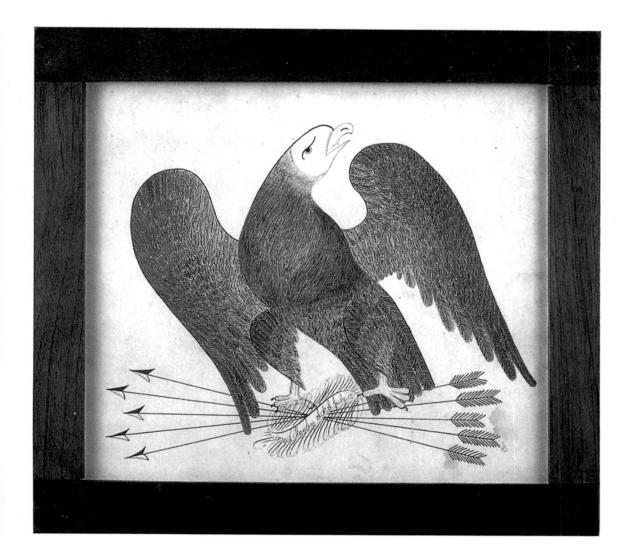

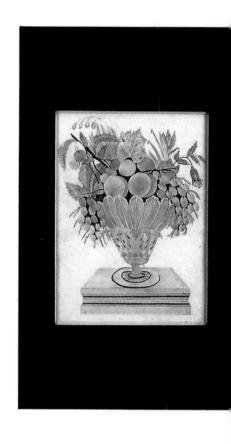

GRISAILLE THEOREM c. 1830-1840; gray wash and pencil on paper; New England. Most theorems were done in bright colors. Examples in shades of gray are rare. Courtesy Museum of American Folk Art.

American Eagle, Calligraphy Drawings

1872; brown ink on paper; by S. Fagley, New York or Pennsylvania. Eagles were a particularly popular subject for calligraphers as well as for artists working in other media during the 19th century.

Courtesy Museum of American Folk Art.

STAG, CALLIGRAPHY DRAWING c. 1830-1870; ink and gray wash on paper; by S.R. Baldwin, northeastern United States.

Larger drawings like this one (19 x 15 1/2 inches), were often done by writing masters.

Sometimes, needlework design books served as a source for the composition. *Courtesy Museum of American Folk Art*.

Sandpaper Paintings

Sandpaper paintings are so named because they were done on a piece of paper covered with adhesive and marble dust, little different from modern sandpaper. These works weren't painted at all, but were executed in charcoal or chalk. The purpose of this odd combination was, through the mingling of black and gray with the gleaming background, to create the mysterious (some would say gloomy) night mood of which Victorians seemed so fond.

While theorems were an individual artistic expression, the sandpaper or graphite painting was often a group exercise. During the late 19th century the drawing contest was a popular after-dinner activity. A painting or print would be placed on an easel, and all assembled would take charcoal and sandpaper in hand. The person who best duplicated the original would be given a small prize for his or her efforts.

Such parlor games were greatly facilitated by the availability in shops and by mail order of kits containing materials and a selection of prints to be copied. It is for this reason that there are so many sandpaper works that duplicate the same scene, usually the ruins of an abandoned castle or a classical cityscape. More interesting are one-of-a-kind pieces such as portraits or views of homes or small towns. Some of these also incorporate pastels to enliven the dark palette.

Scissor Cuttings

Though practiced in other parts of the country, paper or scissor cutting is particularly associated with the Pennsylvania Germans, who called the work cherenschnitte and made of it a highly creative folk art. The basic techniques are ones with which every reader is familiar. Figures cut from paper are applied to a background of contrasting color, or a single piece of paper is folded many times and then cut to create a repeating design.

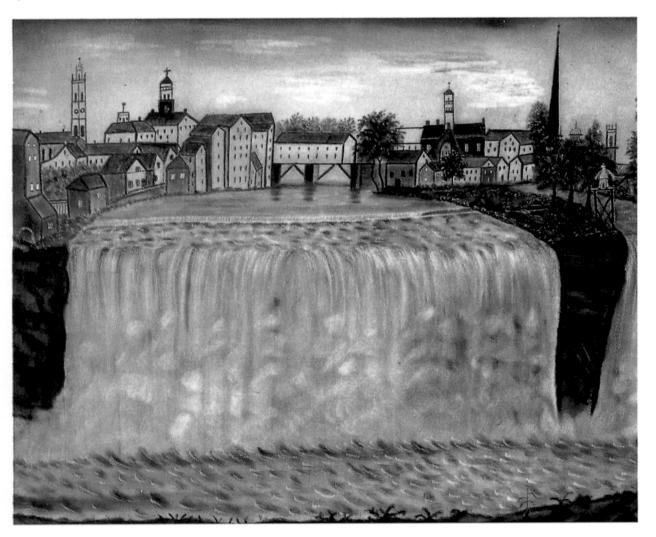

VIEW OF THE
GENESSE FALLS c.
1829-1860; charcoal
on sandpaper,
Rochester, New York.
The great falls on
the Genesee River
were the scene of
Sam Patch's last leap.
Patch, a stunt man,
had made several
spectacular jumps.
He did not survive this
one. Private Collection.

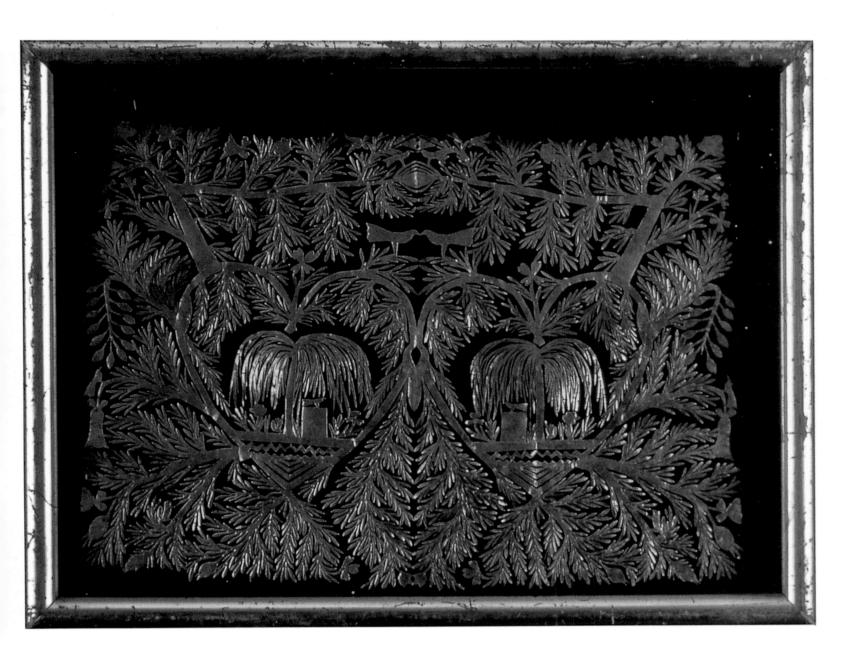

Among the earliest examples are love tokens, the forerunners of the modern valentine. A Connecticut cut-and-pasted token is based on the traditional design of a heart held or offered in the hand and is appropriately inscribed, "Heart and hand shall never part/When this you see, remember me." Pennsylvania pieces (one as early as 1754) are more often of the folded and cut variety, in many cases further decorated with watercolors or written over with expressions of tenderness. An amusing example made in 1875 states, "This thirteenth day of February It was my lot to be merry. It was my fortune and my lot to draw your name out of the hat," suggesting that the maker had attended a Valentine's Eve social gathering with the recipient and had drawn her name in a

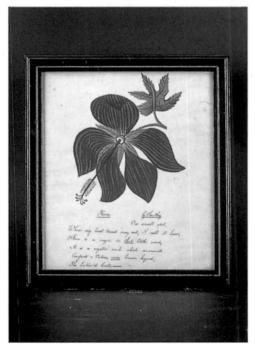

MEMORIAL c. 1830-1840; scissor cutting or scherenschnitte; gilt foil on oil cloth; Pennsylvania. Scissor cuttings in gold foil are rare; and even rarer are memorial examples. Courtesy Museum of American Folk Art.

HIBISCUS FLOWER, CALLIGRAPHY DRAWING c. 1870-1890; ink and watercolor on paper; New England or Pennsylvania. Americans of the 18th and 19th centuries were intrigued by exotic flowers such as this one. The poem beneath the bloom is by English poet laureate Robert Southey. Courtesy Museum of American Folk Art.

lottery, an ancient English custom (and, perhaps, a forerunner of the modern dating service).

Unusual scherenschnitte variations include examples embellished with hair work (presumably the maker's hair) and ones in more expensive gold or silver foil. Among the latter is a rare mourning picture now in the collection of the Museum of American Folk Art. It features matching tombs, flowers and weeping willow trees.

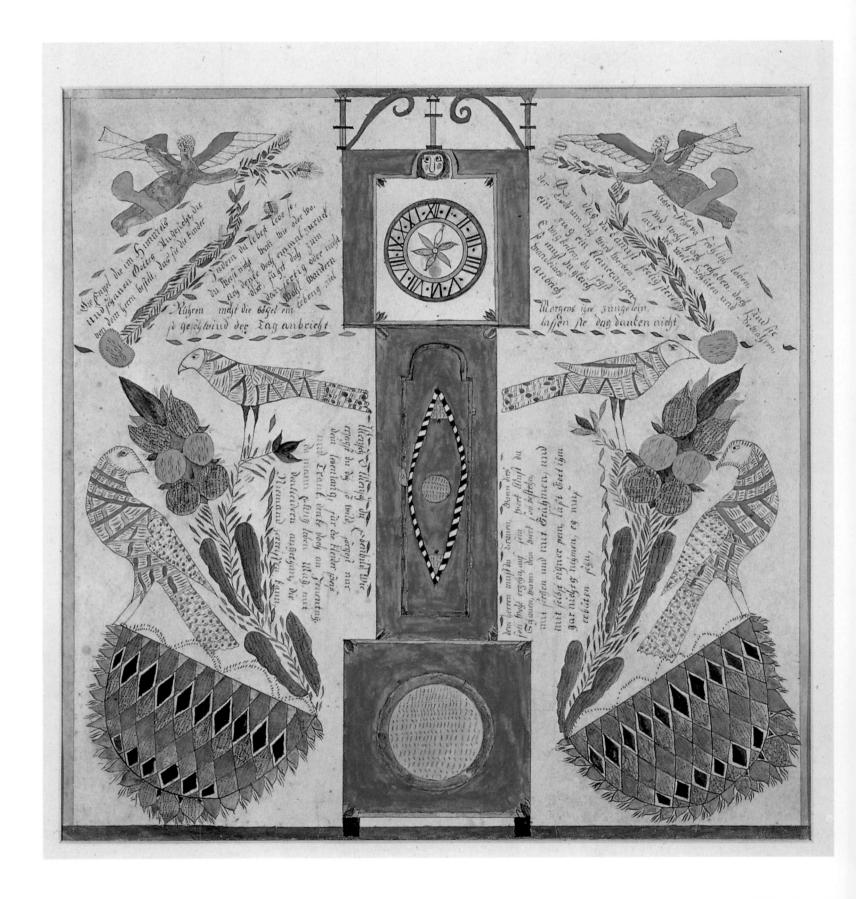

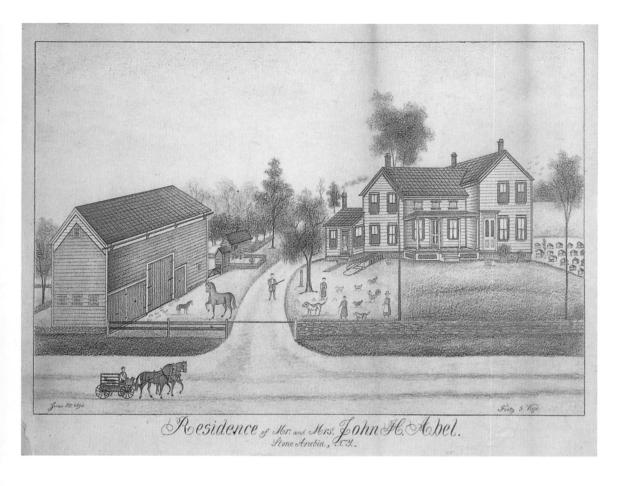

RESIDENCE OF MR. AND MRS. JOHN H. ABEL 1894; crayon and pencil on paper; Fritz G. Voght (active 1850-1900), Stone Arabia, New York. Voght was one of a group of artists who created illustrations for popular 19th-century business directories. Courtesy Sotheby's.

THE OLD SCHOOL HOUSE c. 1800-1820; watercolor on paper; New England. This charming piece was probably done by a schoolgirl who attended the pictured female seminary. *Private Collection*.

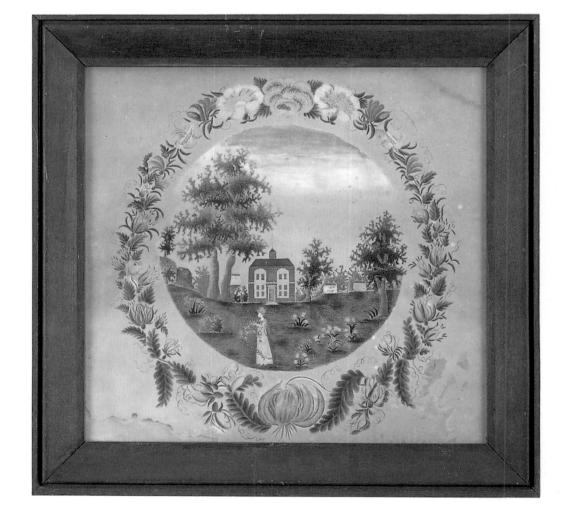

SPIRITUAL CLOCK FRAKTUR c. 1820-1850; watercolor on paper; Pennsylvania. Thought to reflect religious inspiration, this painting features a clock symbolizing the passage of temporal life. The design is related to that of Pennsyvania birth and marriage frakturs. *Courtesy Sotheby's*.

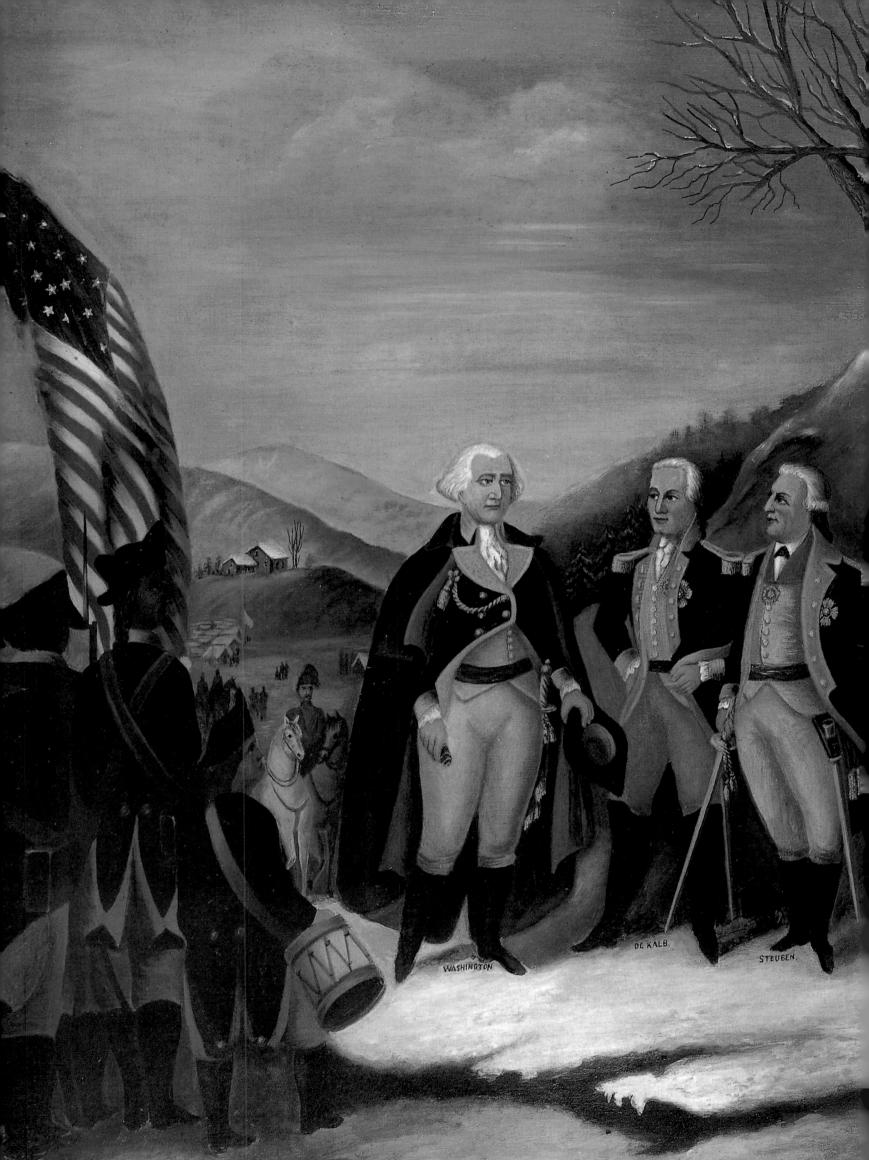

THE HERDES OF THE

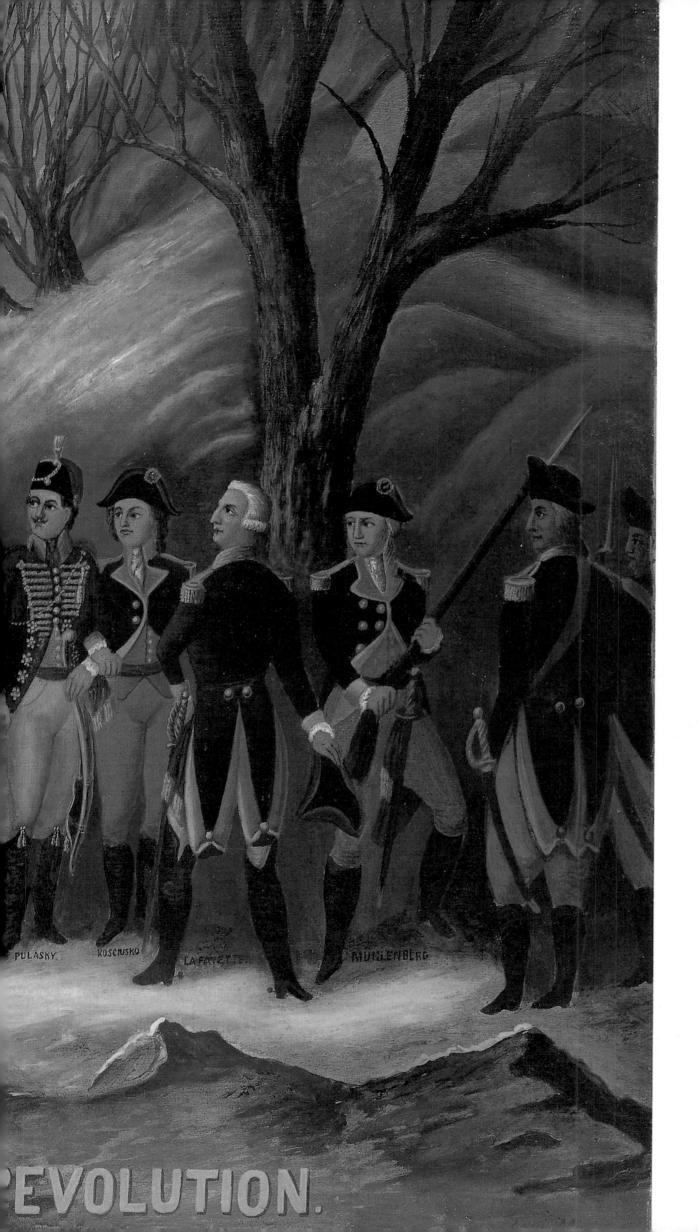

THE HEROES OF THE REVOLUTION c. 1860-1880; oil on canvas; Louis Mader (c.1842-1892), eastern United States.
Patriotic paintings like this, often taken from period prints, were popular in the mid-19th century. Courtesy Sotheby's.

BOWL OF FLOWERS c. 1850-

northeastern United States.

1900; oil on glass with lead foil;

Known as tinsel paintings, these

highly decorative pictures were

Women's magazines frequently

featured articles and instruc-

tions for making this type of

image. Private Collection.

popular with the Victorians.

Reverse Paintings on Glass

The technique of painting on glass was developed in Asia, spread to the Near East, and became popular in Italy and France during the 1600s. Introduced into England, it found its way to the United States in the early 19th century. Technically, it is a tedious procedure involving first laying down the details on the back of a glass sheet and then adding the background—the reverse of the normal procedure. Some benefit is derived from the fact that the glass protects the painting, but this is offset by the fragile nature of the work. Not only is the glass readily broken, but the oils also tend to separate from the glass, leading to major restoration problems.

Nevertheless, reverse painting is an extremely popular folk art expression. Among the earliest American examples are the glass tablets found in the upper sections of Federal mirrors. These often feature a c. 1812 sea battle between British and American warships. Also found, both as individual works and as mirror tablets, are portraits of attractive women and theatrical views, as well as uncommon representations of animals and farmyard scenes.

During the period c. 1880-1920 a large number of reverse glass paintings of American locales were produced. These include three views of the Statue of Liberty with the vessels in the background changing over time from sailing ships to sail steamers to American warships; several dramatic versions of the Titanic sinking; and numerous other popular examples such as views of the White House or resorts like Lake George in the Adirondack Mountains. It is believed that these were made at small shops in the New York City area, but so far no documentation has emerged. It is clear, though, that most were based on prints and designed to be sold as tourist items.

Reverse glass painting is still done today. The best-known practitioner is Milton Bond (1918-1994) of New York City, whose sparkling depictions of well-known landmarks like the Brooklyn Bridge and the Empire State Building are in great demand.

Tinsel painting is a variation of reverse glass painting. Here the design is enhanced by the addition to the composition of crinkled foil or bits of mother-of-pearl. Applied to the back of the picture, they add a sparkle and glow unique to this form. Though these materials might be added to any reverse painting, they are most often found in combination with floral designs, typically a vase

or basket of flowers similar in composition to those found in theorem paintings. Such pieces are still being made today.

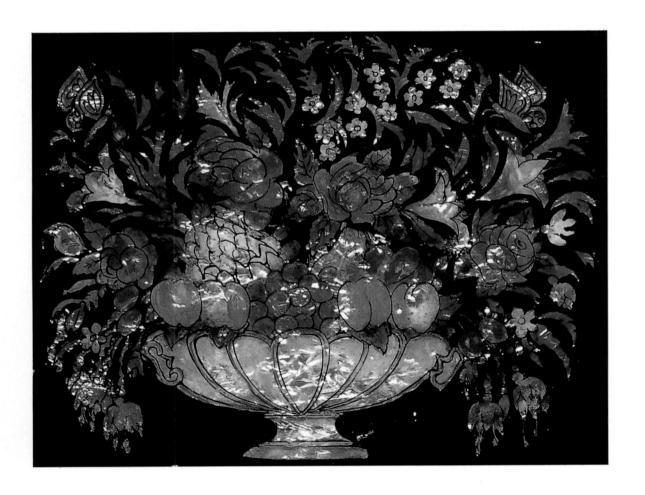

YOUNG WOMAN IN PERIOD

COSTUME c.1840-1860; reverse painting in oils on glass; New England. Pictures like this were made both in Europe and the United States. The reverse painting technique originated in the Orient and was eventually adopted by Europeans and later by Americans. Courtesy Museum of American Folk Art.

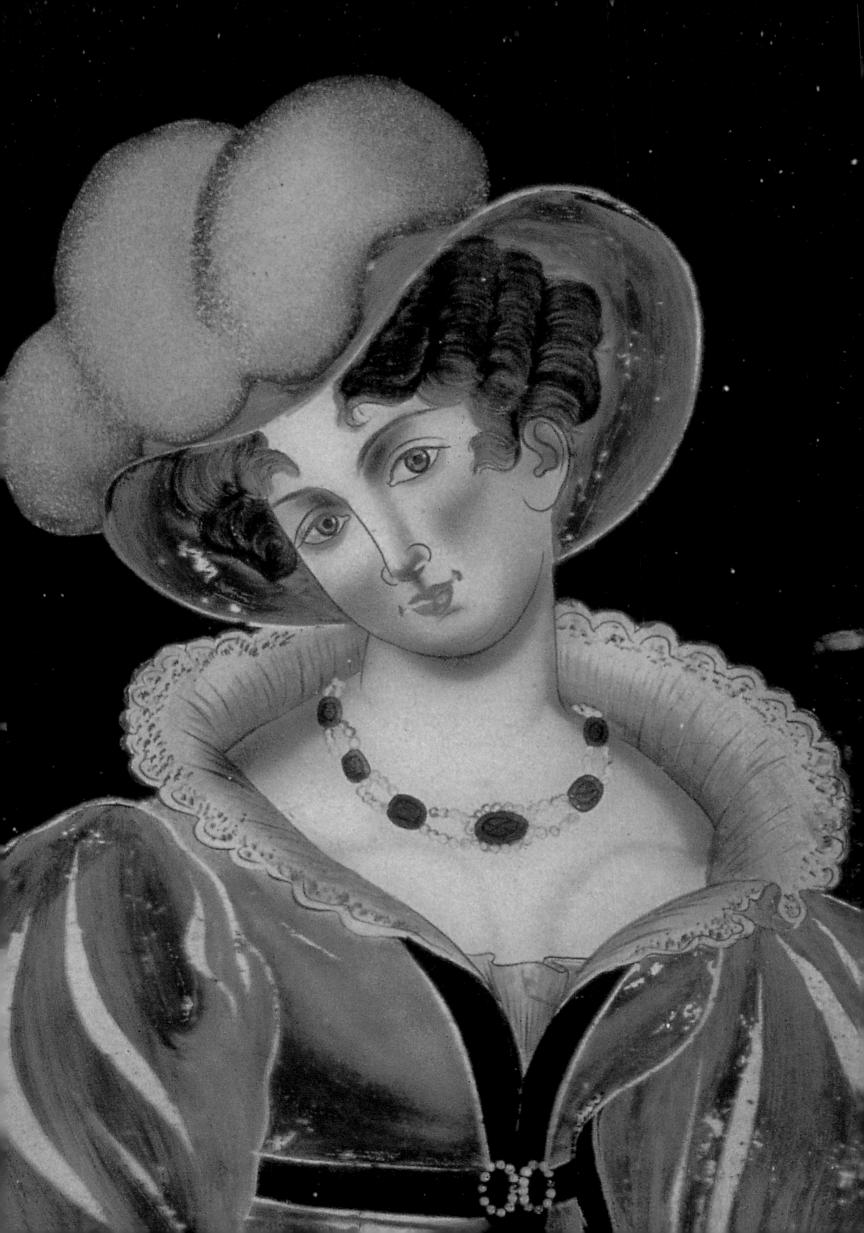

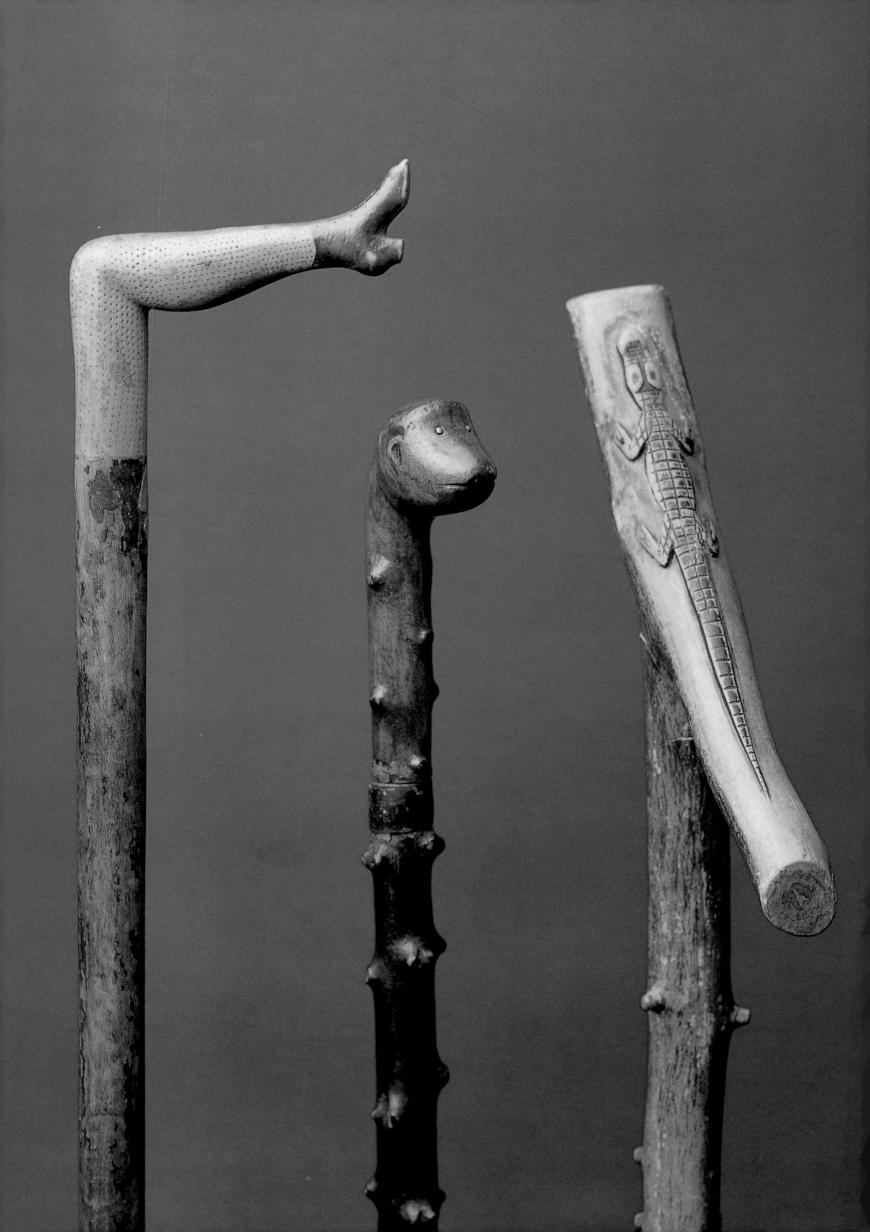

Cane and Whimsey Carving

Carving or "whittling" was a common male occupation throughout the past two centuries. Every man and boy carried a jackknife (usually Case or Barlow made) and, except among the higher social echelons, it was long regarded as quite normal to continue whittling while talking, listening to a sermon, or attending a social gathering. The prevalence of this hobby is reflected in the numerous paintings and prints which depict it.

While it was possible to carve any number of different objects, two were particularly popular: canes and whimsies. In an age when gout, arthritis, and crippling injuries were common, many men carried canes. These were often intricately worked. In the South, relief-carved snakes, alligators, possums, fish, and turtles frequently adorned the walking stick, or, in rare cases, the entire cane might be shaped in the form of a single, writhing serpent. Some have suggested that this complex and bold carving was first developed by black artisans following the African tradition of the staff of office, which reflected and enhanced a chief's power and prestige.

Northern walking sticks were more likely to bear incised, often color-filled decorations. Cut into the bark, these depicted human figures, animals, birds, and houses. Patriotic motifs like the flag and the eagle were also quite popular, particularly in times of national crisis. There was also a continuation of the European tradition of the mountain or walking staff: a heavy rod into which the climber cut the names of important mountains he had climbed and the dates of these accomplishments.

Native Americans also made carved canes; among the best-known are an important group produced by an Iroquois craftsman as well as examples from the Northwest coastal tribes. The latter are shaped in the form of the totem poles so characteristic of the region, and are related to the staffs of office carried by native shamans or medicine men.

Wash sticks, long fork-like pieces of wood used to stir the wash in wooden tubs (in the days before modern washing machines) were also often elaborately carved and presented as gifts to women by their husbands. The hearts, flowers, and messages of endearment may have reflected a bit of guilt at avoiding a difficult and unpleasant task traditionally regarded as "women's work."

Much smaller are the carved whimsies and puzzles made in great quantity by skilled practitioners. Some of these, referred to as all-of-a-piece carvings (because they were made from a single piece of wood) are true puzzles: balls within cages or lengths of wooden chain, all carved from a single block and impossible to separate without breaking. While earlier examples date from the mid-19th century, the art has not been lost—puzzle carvings are still being made today. Usually of easily-cut pine, they are seldom painted.

The bottle display is another type of whimsey: tiny carved (but rarely painted) elements are inserted into a bottle to form a composition. Among these are complete miniature workshops, church altars, and representations of patriotic scenes. Such work is clearly related to that nautical puzzle, the ship in a bottle, but appears to be less common. The only important collection in a major institution is that of the Museum of American Folk Art in New York City.

HORSE'S HEAD CANE
HEAD OR HANDLE
c. 1910-1930; painted
pine with glass eyes;
New York. Finely carved
canes like this are really
miniature folk sculptures.

Author's Collection.

CANES OR WALKING STICKS c. 1880-1920; carved and painted hardwood; left to right, Florida, New York, and Maine. Though seldom signed by their makers, canes are distinct personal expressions reflecting beliefs, prejudices, and popular myths. *Author's Collection*.

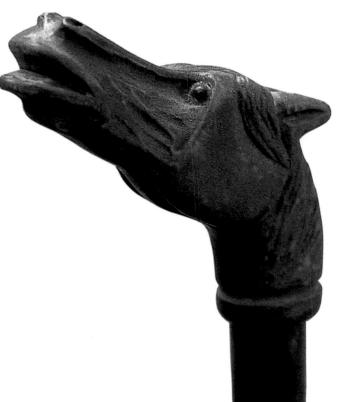

CANE OR WALKING STICK WITH SCULPTURAL HEAD c. 1850-1900; carved hardwood, red stained; New Hampshire. Canes with heavy heads like this were often made by sailors who found them useful weapons in barroom brawls. Courtesy George Schoelkopf.

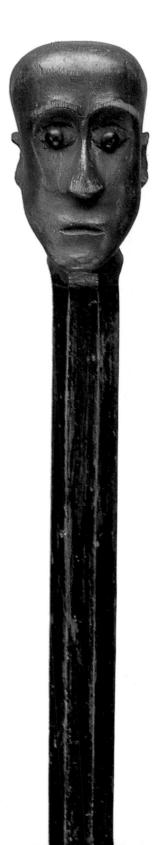

Tramp Art

Another interesting male pastime, particularly during the early 20th century, was the making of objects both large and small from scrap wood, preferably mahogany cigar boxes or fruit crates of rough pine. Such things as mirror and picture frames, wall and sewing boxes, pin cushion holders, and doll furniture as well as much larger objects like chests of drawers, planters, and even sofas were made from layers of thin wood nailed or glued together, then decorated with chip or notch carving. Many pieces were brightly painted (gold and silver were particularly popular), while others were embellished with bits of glass or colored cloth.

The term "tramp art" reflects a popular belief that these pieces were made by itinerants. No doubt some smaller examples were (many date from the 1930s when the Great Depression forced many men to the road), but larger pieces show marks of a band saw, much too large a tool for a hobo to carry about. Moreover, patterns for making tramp art objects appeared frequently in such 20th-century men's how-to magazines as *Popular Mechanics*, and some pieces are known to have been made in school shop classes.

It should also be noted that such work was not confined to this country; examples made in Europe and Canada are known. Whatever its origin, much tramp art has a wonderfully folky quality, and it is extremely popular with collectors.

Closely related is "crown of thorns" work, a more delicate technique involving assembling small pieces of notched wood which are interlocked and overlapped to form an open framework. This construction lent itself to architectural forms, and many of the relatively few surviving pieces are models of churches or other buildings, though large picture frames are also known. Unlike tramp art, crown of thorns pieces were usually left unpainted, weathering to a rich brown surface.

In the Northeast and Canada men, particularly loggers with time on their hands due to inclement weather, made another notch- carved form, the spruce gum box. These small containers had sliding lids and, unlike tramp art, were made from a single block of wood. They were usually incised with decorative motifs and bore the recipient's name, and were used to hold spruce gum, an early and not especially tasty type of chewing gum.

VIEW OF THE SCHUYLKILL COUNTY ALMSHOUSE 1881; oil on canvas; Charles C. Hofmann (1821-1882), Schuylkill County, Pennsylvania. Hofmann, an indigent alcoholic, often painted the poorhouses in which he took shelter. *Courtesy Sotheby's*.

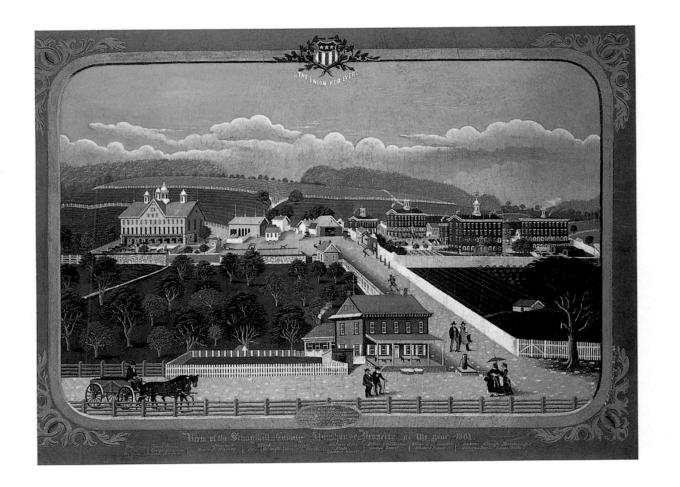

ABRAHAM LINCOLN c. 1975; carved and painted wooden relief; by Elijah Pierce (1892-1984), Columbus, Ohio. The black artist, Elijah Pierce, favored religious and patriotic images and believed that each of his carvings was a message from God. *Private Collection*.

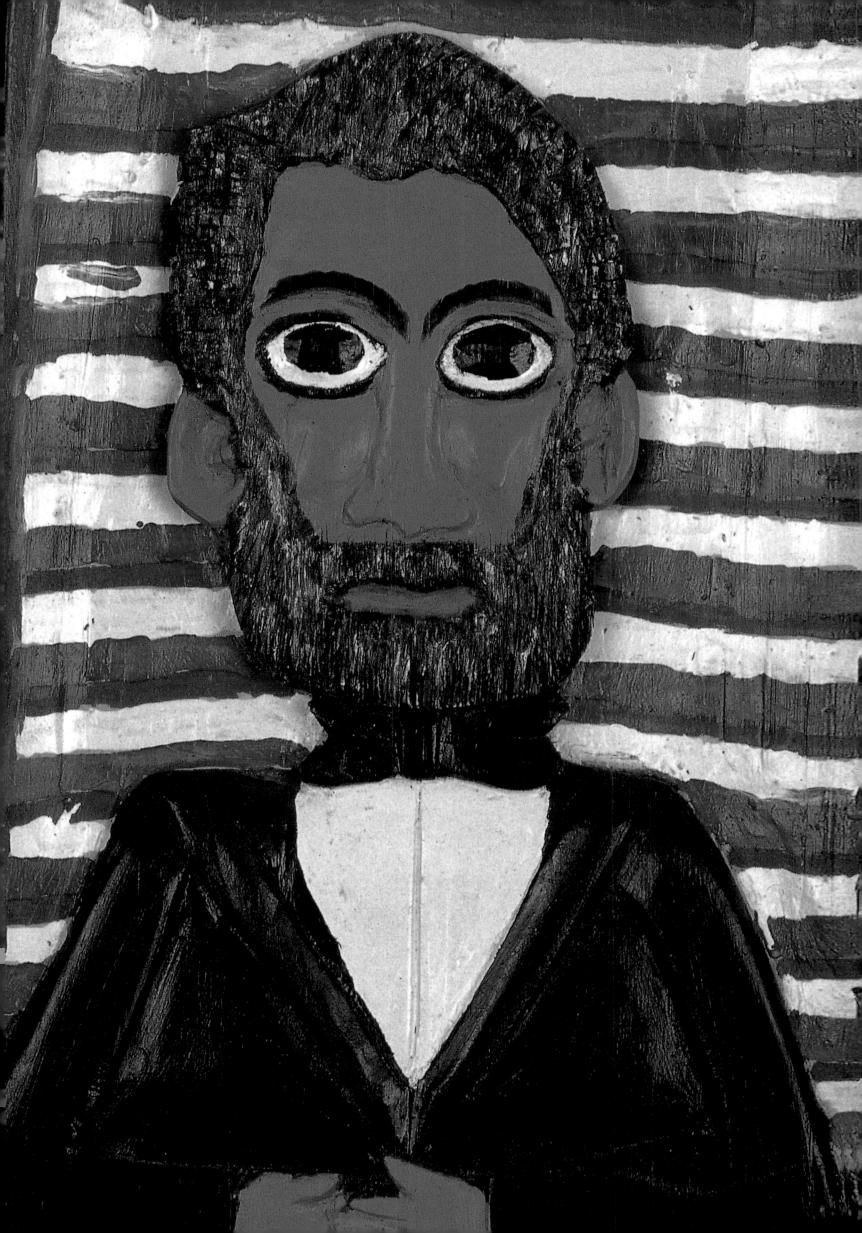

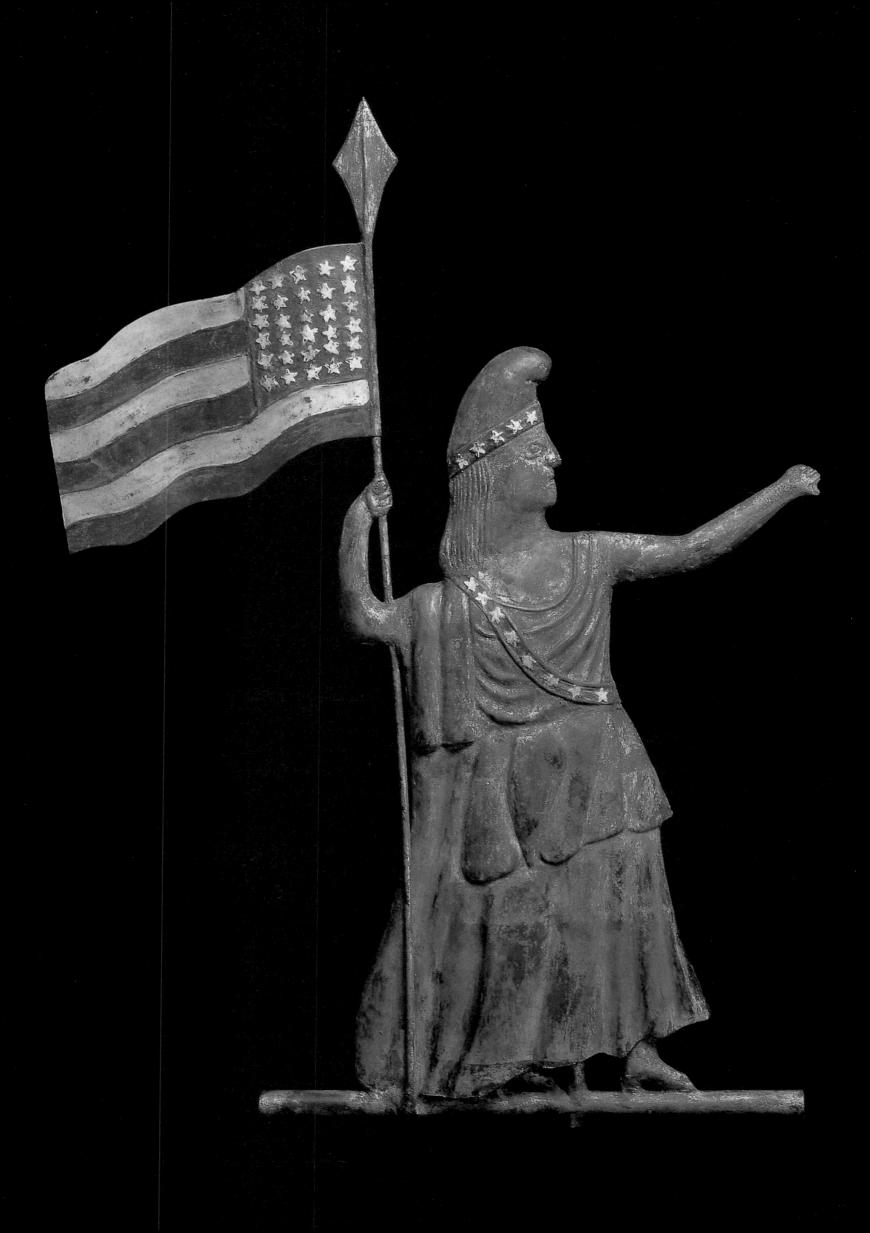

CHAPTER 4

BLOWING IN THE WIND

Weathervanes

Without doubt, weathervanes are among the most popular of all American folk art. They also have by far the longest history of any important folk art object. The weathervane served a dual function, both as a weather prognosticator and as a symbol of status.

The Romans had metal weathervanes atop their villas, and the 12th-century Viking explorers and warriors utilized similar devices on their longboats. The famous 11th-century Bayeaux Tapestry depicts a workman mounting a weathervane atop England's Westminster Abbey. During the Middle Ages, the attractive but fragile fabric banners which flew from castles, indicating their owner's rank, were gradually replaced by duplicates made of metal.

Vanes came to America with the earliest colonists, but because of their fragile nature only a few pre-1700 examples have survived. These are generally of metal, the most durable construction medium. Sheet iron was probably the initial choice of manufacturers, but by the 18th century copper, which could be formed readily into three-dimensional figures, was preferred. So it remains today, though cast iron, too, has been popular. However, those lacking metal working-skills or the money to pay for a craftsman's products have often produced charming carved and painted wooden vanes.

Traditionally, weathervanes were made in the form of a banneret (mimicking the knights' heraldic symols) or a cock, but during the past two hundred years many other types have emerged.

Bannerets

This category includes not only banner-shaped vanes, but also arrows and banner-like forms pierced with initials and sometimes dates relating to the owner. An early American example is the

mor ogram banner placed atop the old Dutch church in Tarrytown, New York in 1699. Such devices have remained popular for over two centuries; most are of sheet iron or copper, though a few wooden examples are known. The arrow pointing "down the wind" is, perhaps, the most naturalistic of weathervane

GODDESS OF LIBERTY
WEATHERVANE c. 1880-1895;
molded copper with paint
and gilding; attributed to
A. B. & W. T. Westervelt;
New York, New York.
Liberty, in various guises,
frequently appears in weathervane form. Private Collection.

ROOSTER WEATHERVANE c. 1790-1820; sheet iron; New Jersey. Like many homemade vanes, this one has a charming folk quality. Private Collection.

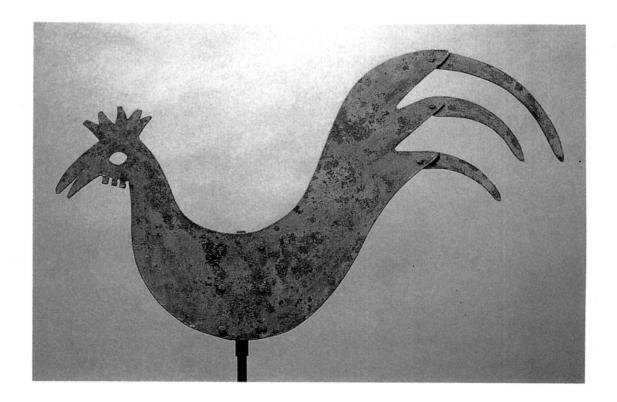

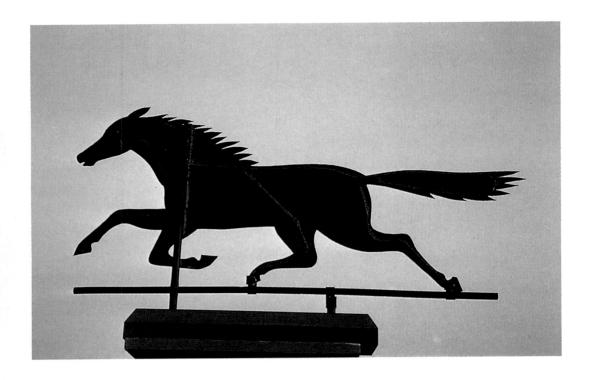

TROTTING HORSE WEATHERVANE c. 1900-1920; painted corrugated sheet tin; The design was taken

Long Island, New York. from a commercially made copper weathervane and may possibly represent Goldsmith Maid, a well-known horse of the day. Private Collection.

shapes; the large feathered tail provides excellent balance and wind surface.

The Cock or Rooster

Almost as old as the banneret is the weathercock. In the 9th century a Papal decree required that every church should have a vane in this form to remind the faithful of Peter's betrayal of Christ: "I tell you Peter, the cock will not crow this day until you three times deny me," (Luke 22:34).

The cock (which might vary from fighting cock to barnyard rooster) was very popular in this country. One of the remaining early examples is the five-foot-tall gilded weathercock made for a Boston church in 1721 by the

metal worker Shem Drowne (1683-1744). Roosters, along with eagles and horses, continue to be made both here and abroad; artificially aged modern reproductions sometimes find their way into antique shops.

Other Birds

The rooster was but one of several birds found in weathervane form. Most often seen today and still manufactured are eagles, whose position as the national symbol has long endeared them to patriotic homeowners as well as to the builders of public facilities like courthouses and town halls. Almost all are three-dimensional molded copper birds made in factories during the past century. Since many were designed to be placed high on large edifices, eagle vanes may be quite large; examples with five-foot wingspans are known.

Less often seen is the peaceful dove, though this was the symbol chosen by our nation's first commander-in-chief, George Washington. Returning to Mount Vernon in 1783 he ordered this type from a Philadelphia craftsman specifying that

I should like to have a bird...with an olive branch in its mouth. The bird need not be large (for I do not expect that it will traverse with the wind and therefore may receive the real shape of a bird with spread wings).

Other available avian forms, most rarely seen today, include the swan, ostrich, peacock, pheasant, goose, and owl. Most appear not to have been very popular. In some cases price may have been a factor. A three-and-a-half-foot high ostrich was listed in the 1893 catalog of the J.W. Fiske company at \$65, a good deal of money at the time.

Horses

Horses and men have had a long, close association, and it is hardly surprising that the equine form is found in a greater variety than any other weathervane. However, there is no evidence that

> RAM WEATHERVANE c. 1880-1910; molded sheet copper with green patina; northeastern United States. Vanes in the shape of farm animals were popular with farmers and stockmen. Private Collection.

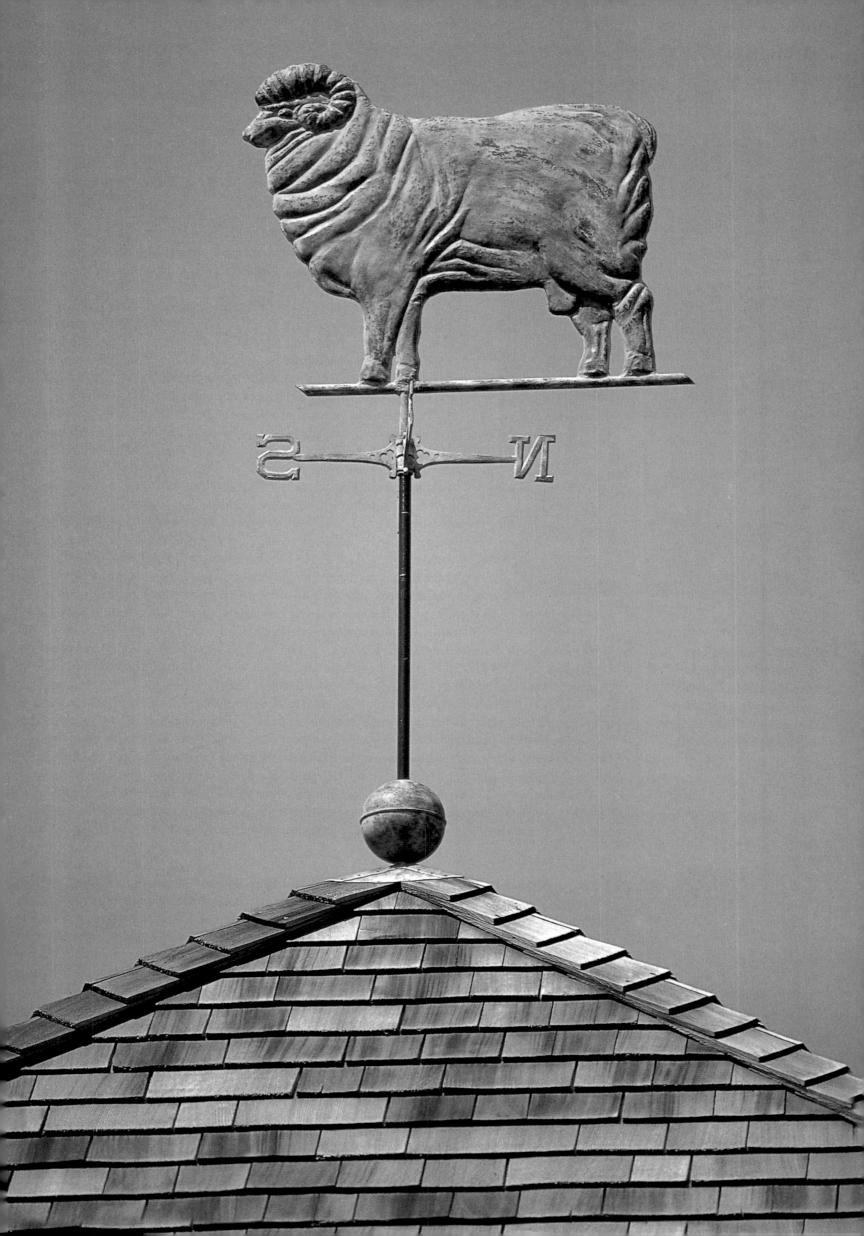

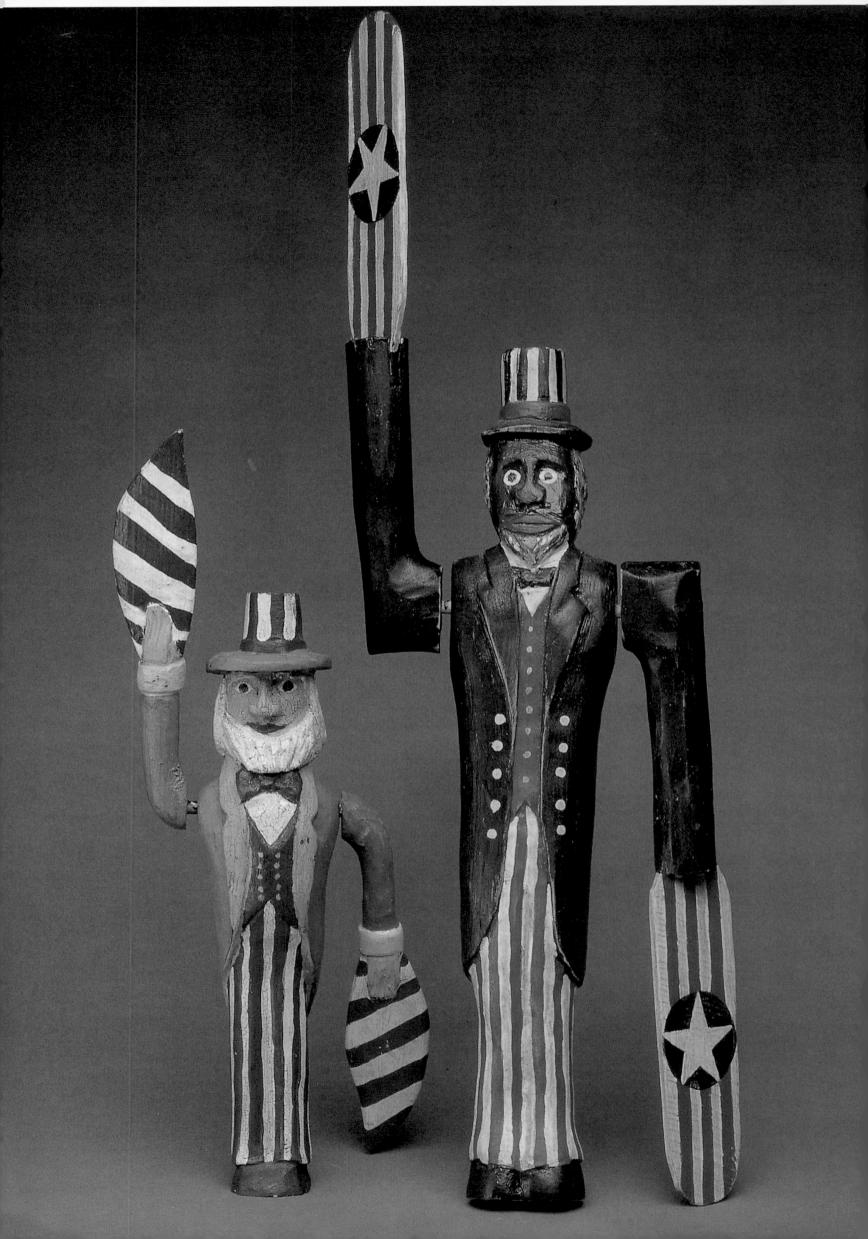

Whirligigs

Whirligigs, often referred to as "wind toys," have a clouded history. One traditional story is that the first examples, in the form of toy soldiers with blade-like arms which spun madly in the wind, were made to ridicule the Hessian troops employed by the English during the Revolutionary War. Another legend maintains that the first were created by the Amish people of Pennsylvania to provide Sunday amusement for children who were forbidden to play with toys on the sabbath. There is not a shred of evidence to support either theory and very few American whirligigs seem to date prior to the last quarter of the 19th century, suggesting that they, like some other folk art items, were a product of the nostalgia (known as Colonial Revival) which swept the country at the time of the 1876 Centennial. It is also possible that whirligigs derive from miniature versions of the European windmill, made as children's playthings as far back as the 16th century and related to the common pinwheel toy. Some whirligigs found in England and on the Continent are clearly earlier than our examples.

In any case, like weathervanes, whirligigs are wind-powered and may serve as indicators of wind direction. This function, though, is secondary to their main purpose, to serve as whimsical amusements for young and old.

There are four basic types, all usually cut and carved from wood or made from a combination of wood and metal. Most familiar is the single figure with blade-like or propeller arms which spin in the wind. Among the common forms are sailors (the Jolly Jack Tars still made for the New England tourist trade), soldiers in 19th-century dress, Indians (both standing and in

canoes), firemen, and policemen. Harder to find are witches and men on horseback. Animals and birds are also seen; ducks and geese whose wings spin madly in the breeze still grace suburban lawns, but far more interesting is the dog or squirrel whose tail flaps in time to the turning blades. There are also substantial numbers of patriotic whirligigs, including Uncle Sam,

UNCLE SAM WHIRLIGIGS 1984; carved and painted wood; Bill Duffy, New York. While Uncle Sam is a popular subject for whirligig makers, the black version is unusual. Collection of Joel and Betty Schatzberg.

BUGLER WITH FLAG WHIRLIGIG c. 1950; carved and painted wood with iron, tin, and cloth; New York. The fixed flag, acting as a tail or rudder, turns the whirligig into the direction of the wind. This causes the propeller to turn and the bugler to march. Courtesy Museum of American Folk Art.

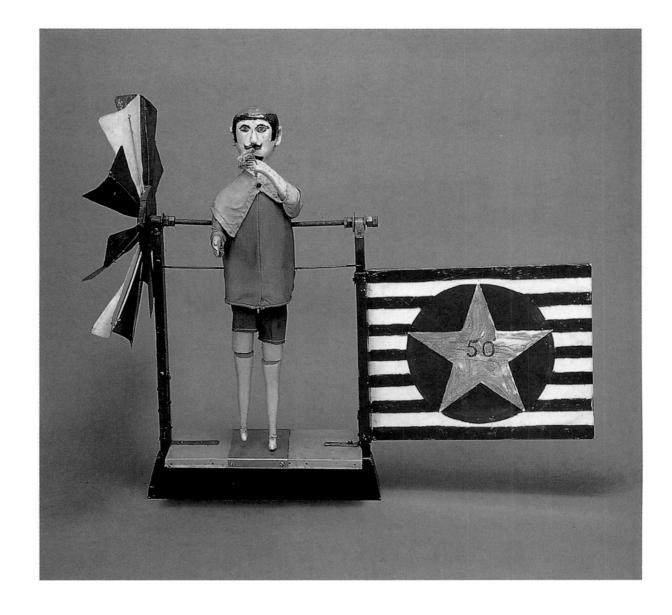

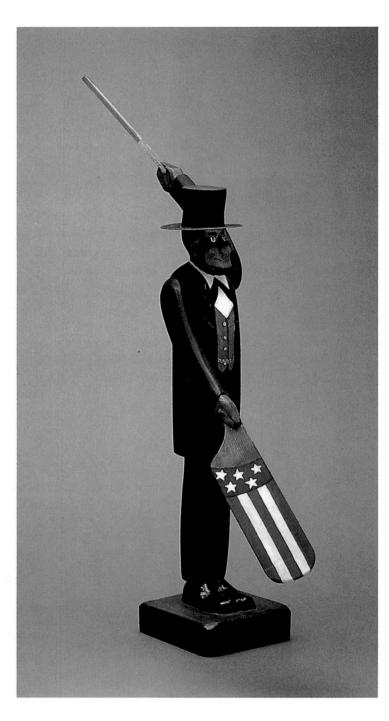

ABRAHAM LINCOLN WHIRLIGIG 1978; carved and painted mahogany with tin, by Janice Fenimore (1924-), Madison, New Jersey. This appealing contemporay rendition of a well-known theme is the artist's first work in this form. *Private Collection*.

MAN SAWING WOOD WHIRLIGIG c. 1920-1930; painted saw-cut wood; northeastern United States. Wind toys like this one often depicted such varied farm activities as sawing wood, churning butter, or pumping water. *Private Collection*.

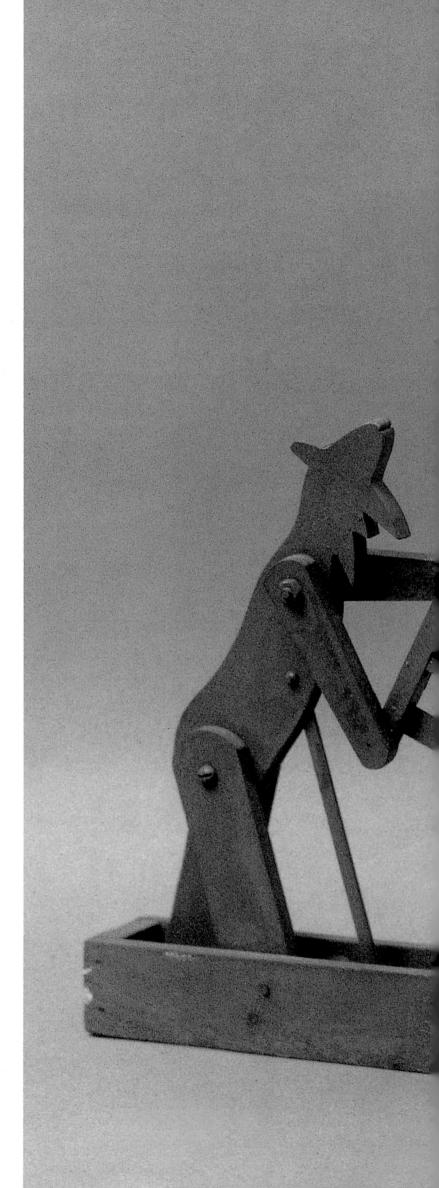

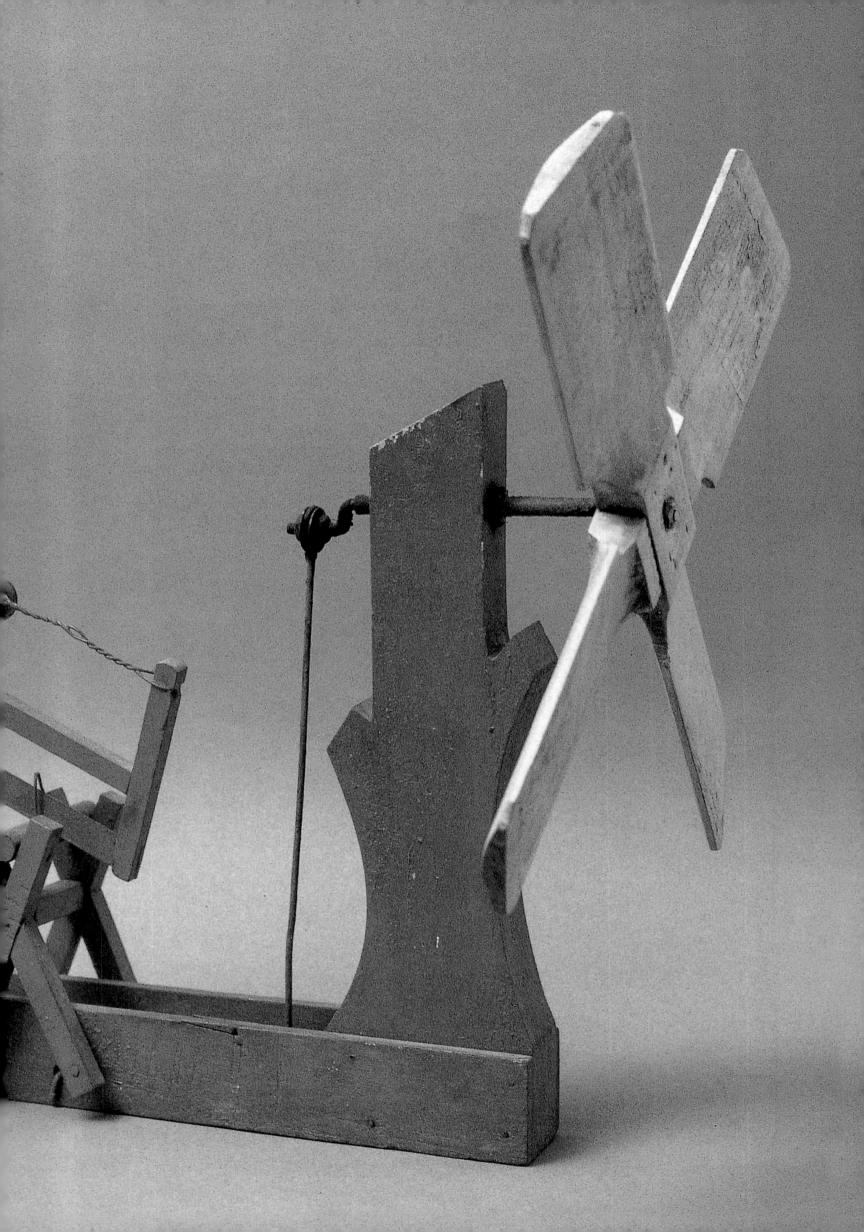

Dog Whirligig

c. 1930-1940; cut and

painted wood with iron

wire; New Jersey. In this

unusual form, a sitting

dog wags its tail as the

propeller turns in the

George Washington, Abraham Lincoln, the flag, and an early eagle with the seal of the United States on its breast and wing-shaped paddles.

Closely related are simple carved figures mounted with a small propeller. The propeller spins as the image (usually a wooden bird or animal) turns in the wind. These are essentially weather-vanes with a propeller.

More complex are whirligigs consisting of one or two figures which are geared so that the vagrant breeze will launch them on an endless, repetitive task: washing landry, sawing wood, or pumping the wheels of a bicycle. Such pieces were often made from directions provided in magazines of the 1930s and '40s such as *Popular Science*.

Far less common, much more difficult to construct, and rarely found in working order, are the Rube Goldberg-esque contraptions consisting of numerous figures which, when the wind blows, will simultaneously launch into a variety of actions: playing cards, fishing, dancing, and the like. An outstanding example is the piece known as "Early Bird Gets The Worm," which is at the Museum of American Folk Art. Since the metal gears propelling these creations are easily rusted by rain or damaged by high winds few have survived intact. They are, however, among the most extraordinary works of American folk art.

Almost all whirligigs are individually created pieces. Unlike weathervanes, many of the most desirable forms of which were made in shops or small factories, wind toys were usually turned out at home. There is, however, one exception. During the early 1900s several auto manufac-

turers produced miniature metal whirligigs as radiator cap ornaments. Among these now rare pieces are (appropriately enough) representations of traffic policemen!

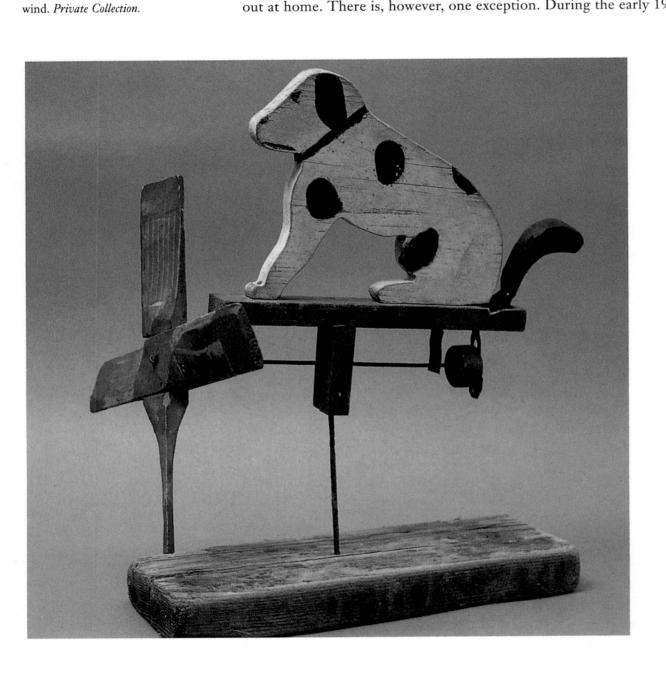

MAN IN BOWLER
HAT WHIRLIGIG
c. 1880-1910; carved
and painted wood;
northeastern United
States. There are many
whirligigs, but few
possess the dramatic
sculptural power of this
piece. Private Collection.

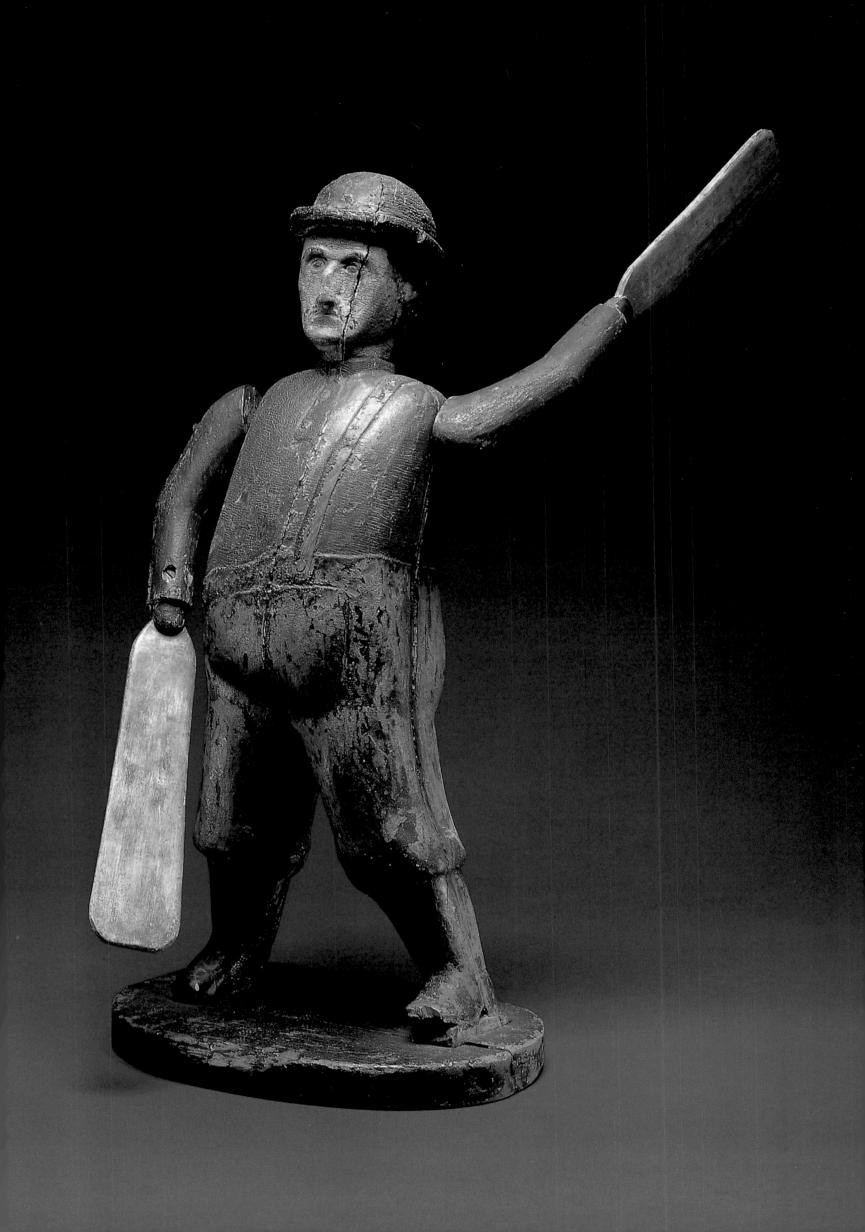

DR MORSE'S ROOT INDIAN ROOT PILLS.

* COMSTOCKS *
DEAD SHOT OF PELLETS
WORM PORTS

CHAPTER 5

PUBLIC FOLK ART

Public folk art or, rather, folk art publicly displayed has long been an American tradition and one with lengthy European antecedents. The carving and painting of public buildings was an effective way to impress upon the citizenry the power and majesty of the state. It also provided those who were taxed with some tangible evidence of where their money was going! In the United States, eagles, flags, and national shields have always been preferred for the exteriors and interiors of courthouses, city halls, and similar edifices, while a much greater variety of carving and painting was deemed appropriate for commercial buildings and private residences.

As with portraiture, there was a class of artists and artisans eager to undertake the work. Early newspapers are filled with advertisements such as that of the carver and gilder, James Strachan, who advertised in *The New-York Gazette or The Weekly Post-Boy* for October 24, 1765, that he did "all sorts of House-Carvings in Wood or Stone, at the lowest Prices."

The commercial world offered even greater prospects for the painter or sculptor. Even in a country where literacy was rapidly becoming the norm, the tradition of the graphic trade sign continued, just as it does today. Newspapers of the 18th and 19th centuries are replete with advertisements directing the buyer to "Henry Whiteman at the Sign of Buttons and Buckles, near the Oswego Market...Dennis MacReady Tobacconist at the sign of bladder of snuff and roll of tobacco" and the whalebone cutter, David Philips, who worked at his house "opposite the Sign of the Three Pigeons." Today's factory-produced signs may be generally less impressive, but they serve the same purposes—

direction and promotion. Already, some of the more interesting early-20th-century types, neon tubes and Art Deco graphics, have become collectible.

Humbler but reaching a wider audience was the art of the carousel. The tradition of carved and painted animals set on a moving platform arrived in Europe from the East during the 17th century. After the carousel became steam powered in the 1870s it was the focus of every American circus and traveling carnival, and carvers vied with one another to produce the most spectacular horses and other animals.

ADVERTISING POSTER c. 1890-1900; lithographed paper, printed in the Northeast for a patent medicine company. Since they were practitioners of "natural medicine", Native Americans were often the subject of patent medicine advertising. Author's Collection.

BUILDING ARCHWAY

DECORATION c. 1880-1915;
pine with traces of old paint;
Connecticut. An unknown
country craftsman created this
element to decorate a house or
barn. Properly displayed, such
fragments assume the aspect of
folk sculpture. *Private Collection*.

HEAD OF JUSTICE

c. 1875-1880; molded zinc; attributed to W.H. Mullins Company, Salem, Ohio. This head is a portion of a 10-foot-tall neoclassical sculpture. Works of this kind were made to adorn government offices and public buildings and are America's version of ancient Greek and Roman statuary. *Private Collection*.

Architectural Art

Only within the last decade or so has what we term architectural folk art become collectible. It began in New York City in the 1970s when artists and antique collectors began to salvage bits and pieces of 19th-century buildings which were being destroyed in the name of "progress." What they salvaged varied greatly. There were strange medieval-looking gargoyles of granite, sand-stone, or molded clay which decorated the rooftops and downspouts of turn-of-the-century tenements; there were turned oak and mahogany newel posts from earlier townhouses; and there was a variety of moldings, pillars, and cornices that, while no longer in style, had a sculptural quality which enabled them to stand alone as works of art.

As interest spread these pieces were joined by louvered fan lights from rural barns and a variety of shutters, roof finials, and porch columns which originally graced suburban Victorian mansions. Most bore several coats of weathered paint, the texture and faded color of which added to their folky charm.

Today such "accidental art" can be found incorporated into the architecture of everything from contemporary apartments to converted hen-houses, or placed upon stands in white-walled rooms and treated with almost the same respect accorded a Brancusi or a Calder.

Other more readily recognizable architectural pieces have long been of interest to folk art collectors. Perhaps the most famous of these is the gate in the shape of the American flag which is at the Museum of American Folk Art. This piece mirrors a strain of public patriotic expression which continues today with the ubiquitous Uncle Sam mail box standards. Public buildings erected throughout the last century and much of this one also display such patriotic motifs as carved eagles and figures of Columbia. Most interior examples (on lecterns, podiums, and the like) were

of mahogany or oak; exterior adornment was of the more humble pine and usually painted. As these buildings have been destroyed or modernized, such decoration has come into the hands of collectors.

The abundance of this material reflects the eclectic Victorian taste, which incorporated a variety of earlier architectural and sculptural motifs in buildings which fairly dripped ornament, as well as the presence of a large artisan class, skilled cabinetmakers, masons, and iron workers whose handiwork continues to appeal to connoisseurs.

A fascinating byproduct of architectural folk art is the commercial structure which, by its own shape, serves to advertise the product or service offered. Among the more common examples are stores in the shape of a chicken which sell eggs and fowl, dairy product vendors operating out of milk-bottle-shaped buildings, and even a car wash resembling a beached whale! While hardly collectible, these structures are the closest thing to "folk architecture" one is likely to encounter.

LIBERTY WITH FLAG AND SWORD c. 1850-1860; carved and painted wood; New Hampshire. Images of the goddess of Liberty became increasingly popular during the 19th century and could be found in many forms and sizes. This fine example once decorated a boathouse. Courtesy The Barenholtz Collection.

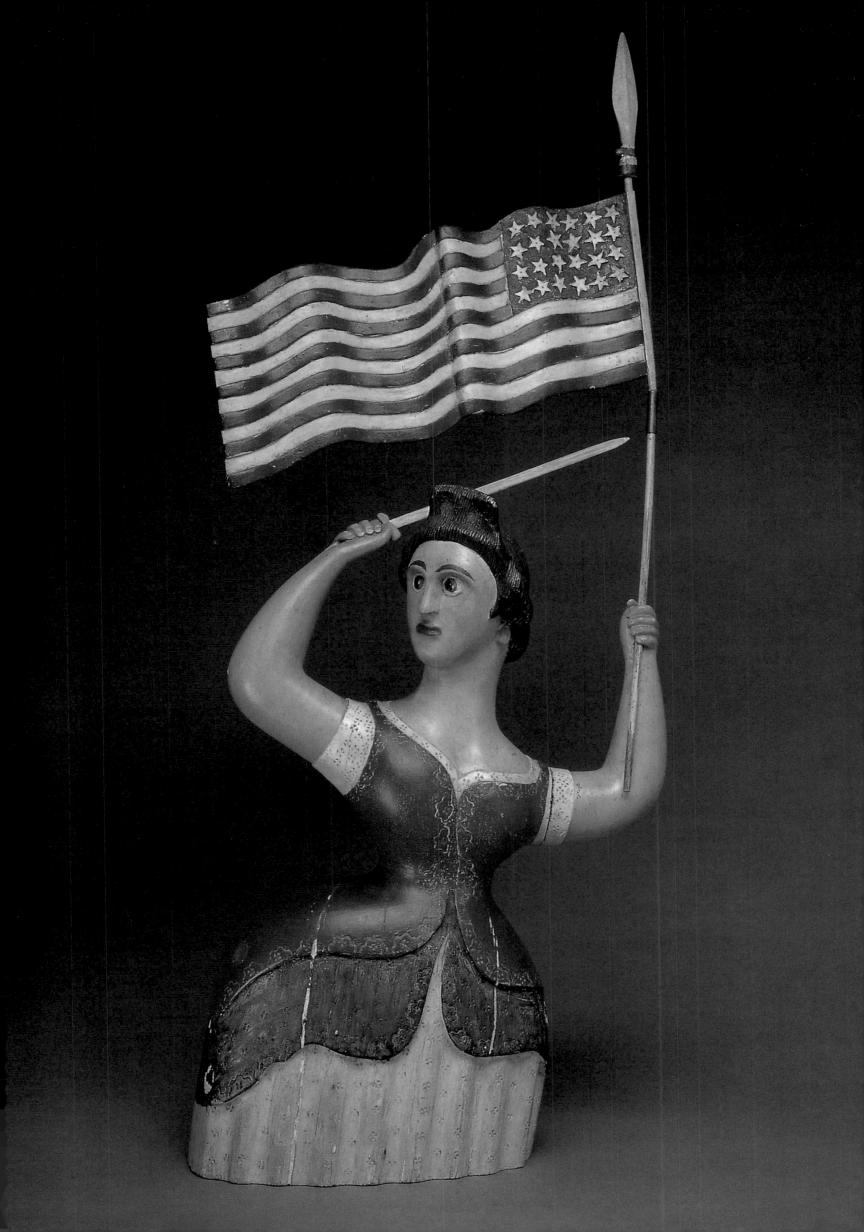

Shop Signs and Figures

It is not without reason that the painter William Williams, advertising in The New-York Gazette and the Weekly Mercury on May 8, 1769, stated that he undertakes "painting in general, viz. History, Portraiture, landskip [sic.], sign painting, lettering and gilding" (emphasis added). It was likely that a far better living could be derived at that time from painting tavern signs than from painting portraits or "landskips," and it had long been thus. Trade signs, painted on walls or shaped from clay or stone, have been found in the buried ruins of ancient Pompeii and Herculaneum; and they are frequently referred to in medieval literature. In this country, the ear-liest references are to those that hung before the taverns which were found in towns and every few miles along the "high roads" that connected major areas of settlement. A few bore a figure of Bacchus, god of wine, but most were decorated with representations of important personages such as George III or George Washington, or, of seemingly equal importance, of a great trotting horse like Ethan Allen.

The value of such marks to identify a hostelry is reflected in the fact that tavern keepers frequently referred to them in their advertisements, as did Nathaniel Ames of Massachusetts, whose 1751 advertisement in *Ames' Almanack* advised

all Persons that travel the great Post-Road South West from Boston That I keep a house of Public Entertainment Eleven Miles from Boston at the sign of the Sun.

Merchants had their own signs, many of long standing and readily recognizable to the passerby. A knife or pair of scissors marked the cutler's shop; a red and white striped pole the barber, who often doubled as local surgeon or bloodletter; a hand, the maker of gloves; and a stocking, the hosier. The druggist had his mortar and pestle, the optician his pair of spectacles, the carpenter his saw, and, perhaps most graphic (and ominous) of all, the dentist his great white tooth.

So strong was the demand for trade signs and figures that many craftsmen in related fields turned their hands to this art. Included were painters, both of portraits and houses, carpenters, and at least one pewterer, Paul Revere, who in 1770 carved and decorated a sign for Boston's Red Lion Inn.

The proliferation of elaborate and highly individualistic shop signs in 19th-century America was due to more than literacy problems. A painted and gilded trade sign or a carved tobacconist's figure not only indicated where a particular item might be bought, but also reflected the seller's status in the community. The more prominent a merchant, the larger his sign, to the extent that by the late 1800s trade signs were becoming a nuisance. Hung from rods extending from buildings or standing on brackets in the street, they obstructed the right of way and, in a high wind, became a menace to passersby (in the 1780s a pedestrian was killed outside John Duggan's tavern on Corn

Court in Boston when a gale brought down the wood and metal standard.) Trade signs even incited public disorder, as in a Wyoming town where cigar store Indians were removed from the street to prevent drunken cowboys from shooting them up on Saturday nights.

The custom of self-promotion through trade signs and figures still persists. Even in New York, the world's most sophisticated city, there may still be

CLOCKMAKER'S SHOP SIGN c. 1870-1900; painted and gilded cast iron and sheet tin; New York. It is said that the hands of clock signs such as this one are always set to show the exact time of Lincoln's assassination. *Private Collection*.

GUESTHOUSE SIGN

c. 1900-1920; carved and turned, painted wood with iron; Manchester, Vermont. In the Art Nouveau style, this sign is typical of many that graced late Victorian guest cottages and guesthouses. Courtesy Kelter-Malcé Antiques.

CIGAR-STORE INDIAN
c. 1875-1890; carved and
painted wood; by Samuel
Robb (1851-1928), New York
City. Robb was one of the
best-known makers of trade
figures and maintained a
sizable shop in Manhattan
for many years. Courtesy
Museum of American Folk Art.

found a fish store or two sporting its gilded salmon, and far downtown, a great carved pistol yet hangs above a shop that sells guns and ammunition. Moreover, signs constructed of neon tubing or painted sheet metal and tubing (as with the common shoemaker's sign) remain popular as well as collectible.

Collectors should bear in mind, though, that most of these signs were placed outside where, exposed to the weather, they suffered a variety of problems. Paint faded, wood cracked and chipped, iron fittings rusted away. Few examples are found in original condition and, as it was the custom to repaint signs or figures each spring, most will show several coats of paint.

An exception to this rule are the various signs and occasional small figures which were designed for use within a tavern, hotel or shop. Among the most interesting of these, from a historical perspective, are the small painted boxes bearing the words "To Insure Promptness." Hostelry guests were expected to deposit a few coins for the staff in these receptacles; this gratuity gradually came to be referred to by the initials, "T.I.P."

Most popular of all trade figures are the cigar store Indians or tobacconists' figures which once were found outside every "segar-store." Introduced into England from the Americas by Sir Walter Raleigh, tobacco became a favored vice. And, since it was cultivated by Native Americans, representations of these became associated with the weed.

Early 18th-century English versions reflected a lack of knowledge of Indian features, often depicting the bearer of the peace pipe and sheaf of tobacco as a black man wearing a feathered headdress and a kilt of tobacco leaves. American figures, which appeared soon after 1850, were more accurate. Chiefs, braves, and squaws were depicted, usually in traditional dress and armed with knife or tomahawk, as well as holding the traditional sheaf of tobacco.

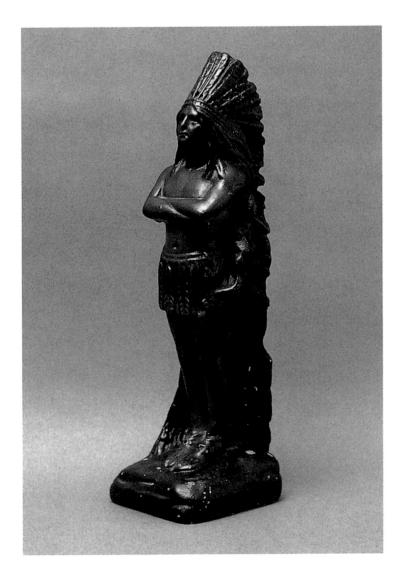

c. 1910-1930; molded and painted chalk; northeastern United States. Small pieces like this were often given

CIGAR-STORE INDIAN

to tobacconists by their suppliers for display on counter tops. *Private Collection*.

CIGAR-STORE FIGURE

c. 1790-1830; carved and painted wood; England or the United States. This is the earliest form of the tobacconist's trade sign. A blackamoor is seen clad in tobacco leaves and smoking a Dutch clay pipe. *Private Collection*.

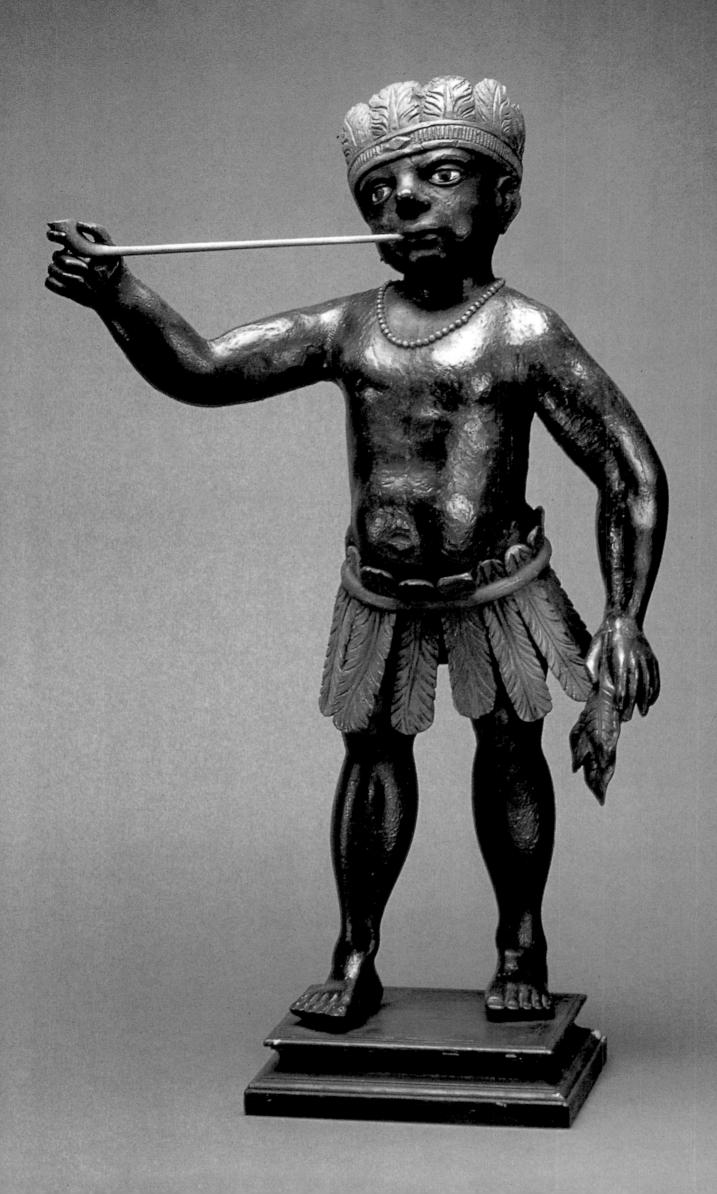

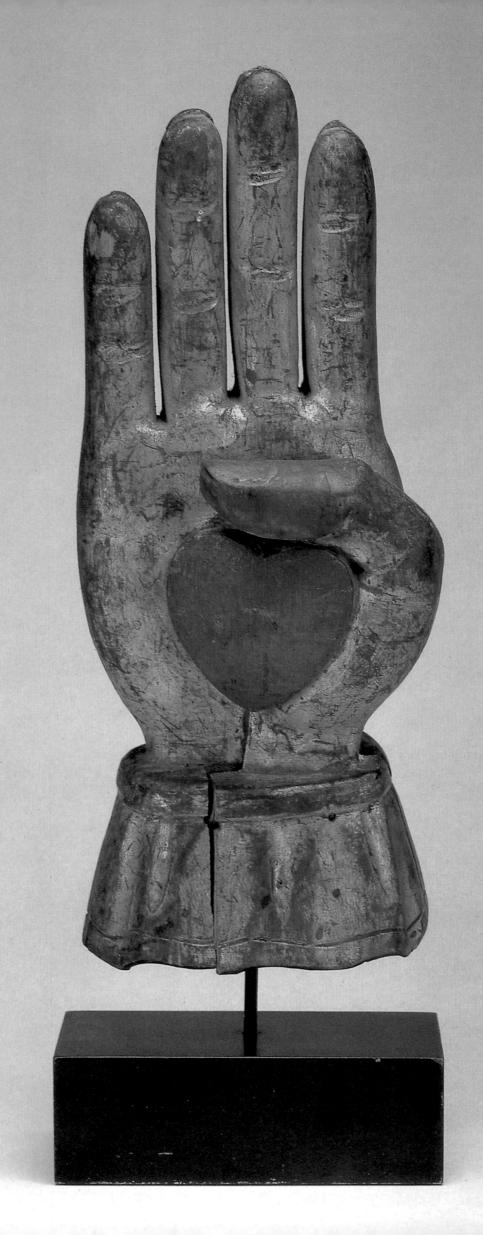

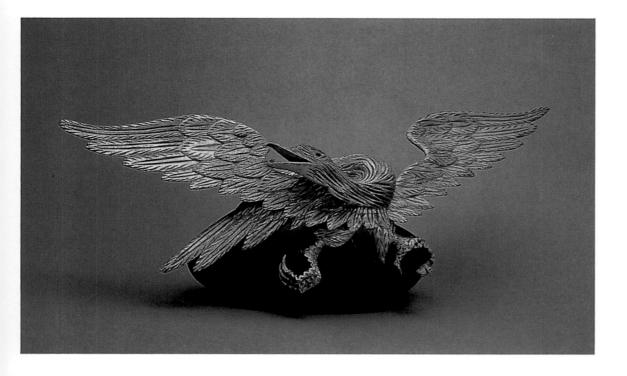

SCULPTURAL EAGLE
c. 1860-1879; carved and gilded pine; attributed to
John H. Bellamy, Kittery
Point, Maine. Bellamy
was a well-known carver
of figureheads, sternboards, and pilot-house eagles.
The eagle shown here once held an American flag in its talons. *Private Collection*.

Between 1850 and 1920 thousands of these carved and painted figures were produced in American shops. Ranging in size from two-foot counter figures to examples which towered well over six feet on their wheeled wooden platforms (so they could be hauled in at night), they depicted not only Indians but also such diverse figures as Uncle Sam, Punch, oriental potentates, frontiersmen, famous actors and actresses, and even preachers.

Since some carvers signed their work, makers like Charles J. Dodge (1806-1886), Thomas V. Brooks (1828-1895), and William Demuth (1835-1911), all of New York City, are well known to serious collectors. It was Demuth who revolutionized the field in the late 1800s by introducing cast zinc figures which he described in his advertisements as being of a "more durable substance than wood, thus preventing cracking, which will sometimes occur in Wooden Figures, especially when exposed to the climate of our Southern States." Metal Indians may have lasted longer than their wooden brothers (of whom it is estimated less than two

thousand remain in existence), but they have never attained the latter's popularity among collectors.

Carousel Figures

The carved and painted wooden horses and other animals used on carousels or merry-go-rounds are another favored form of folk sculpture. As far back as 500 AD Byzantine bas-reliefs depicted people clinging to ropes attached to a revolving overhead framework—the genesis of the carousel. By the 17th century this had evolved into a circular platform upon

CAROUSEL HORSE 1910; carved and painted wood with leather and metal, by Solomon Stein and Harry Goldstein, Brooklyn, New York. Carousel figures were usually repainted each season, so examples in original paint are rare. Collection of The Museum of American Folk Art, New York. Gift of the City of New York, Department of Parks and Recreation.

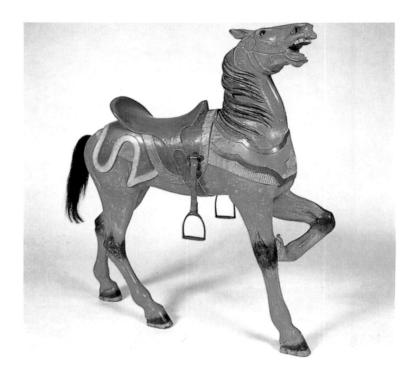

HEART-IN-HAND LODGE SYMBOL c. 1870-1900; carved, painted, and gilded wood; Pennsylvania. The heart and hand, symbolizing generosity, is a mark of the Independent Order of Odd Fellows, a male fraternal group. *Courtesy Alan Daniel*.

RESORT SIGN, "WOODTOP" c. 1900-1930; painted sheet steel; New England or the Midwest. The amusing figure reflects the influence of early-20th-century cartoon art. Courtesy Kelter-Malcé Antiques.

which were mounted wooden horses, motive power being supplied by a living horse. When, in 1870, an Englishman, Frederick Savage, provided steam power, the modern merrygo-round was born.

While also popular throughout Europe, no country has had more carousels than the United States. As many as four thousand were operating at the turn of the century. Today less than three hundred remain intact and functioning. The individual animals, divided up among museums and collectors and carefully restored, serve to remind us of the high quality of carving and decorating that went into the makers' craft. Though they appear to be solid pieces of wood, carousel figures are actually made up of numerous small sections glued and nailed together. These pieces combined to form a hollow box-like structure, the exterior of which was carved and given several coats of paint.

There are three basic types of American carousel animal, each attributed to the school of an individual maker. The first of these men, Gustav Dentzel, went into business in Philadelphia in 1867. His son, William, sold the business in 1928, at a time when many manufacturers were shutting down. Dentzel animals showed refined features and great attention to muscular detail, with minimal decorative embellishment. He and the makers who followed his lead are often referred to as the Philadelphia school of carvers.

Charles I. D. Loof of Brooklyn entered the field in 1875, remaining active until his death in 1918. Loof's less realistic creations were highly ornate, with fanciful carving and painting enhanced by the addition of glass jewels and mir-

rored trappings, in what came to be known as the Coney Island style.

Both Dentzel and Loof specialized in large, permanent merry-go-rounds with two or three rows of animals. There was, however, a need for smaller, simpler, more durable carousels to be used in carnivals and traveling circuses. These were supplied by Charles W.F. Dare of New York City who, in 1884, originated the Country Fair style. He was succeeded by the Herschell-Spillman company which produced the greatest variety of American carousel animals, including horses, pigs, zebras, sea serpents, cats, dogs, roosters, goats, deer, ostriches, and even frogs.

Among these many beasts, the most desirable are those which were made for the outside rows of a merry-go-round as these, being most visible, were most lavishly decorated. Moreover, the outer side of each animal, called the "view" or "romance" side, was always more heavily decorated. Other portions of the carousel structure, such as the case for the pipe organ or the rounding boards which concealed the machinery, were also decorated. These, too, are of interest to some collectors.

Since carousels were generally repainted at the beginning of each new season, figures are rarely found in original paint. Most collectors of carousel animals, unlike those who collect other types of folk art, generally prefer to strip their finds, restore the frames when necessary, and then completely repaint them in appropriate colors.

Uncle Sam Candy Container c. 1930-1950; lithographed paper over cardboard; United States. Made for the Fanny Farmer candy company, these receptacles were often given as favors at Fourth of July parties. Courtesy Helaine and Burton Fendelman.

c. 1880-1900; lithographed cardboard, Lowell, Massachusetts. The use of half-clad mermaids on this card is quite unusual for the staid Victorian era. Private Collection.

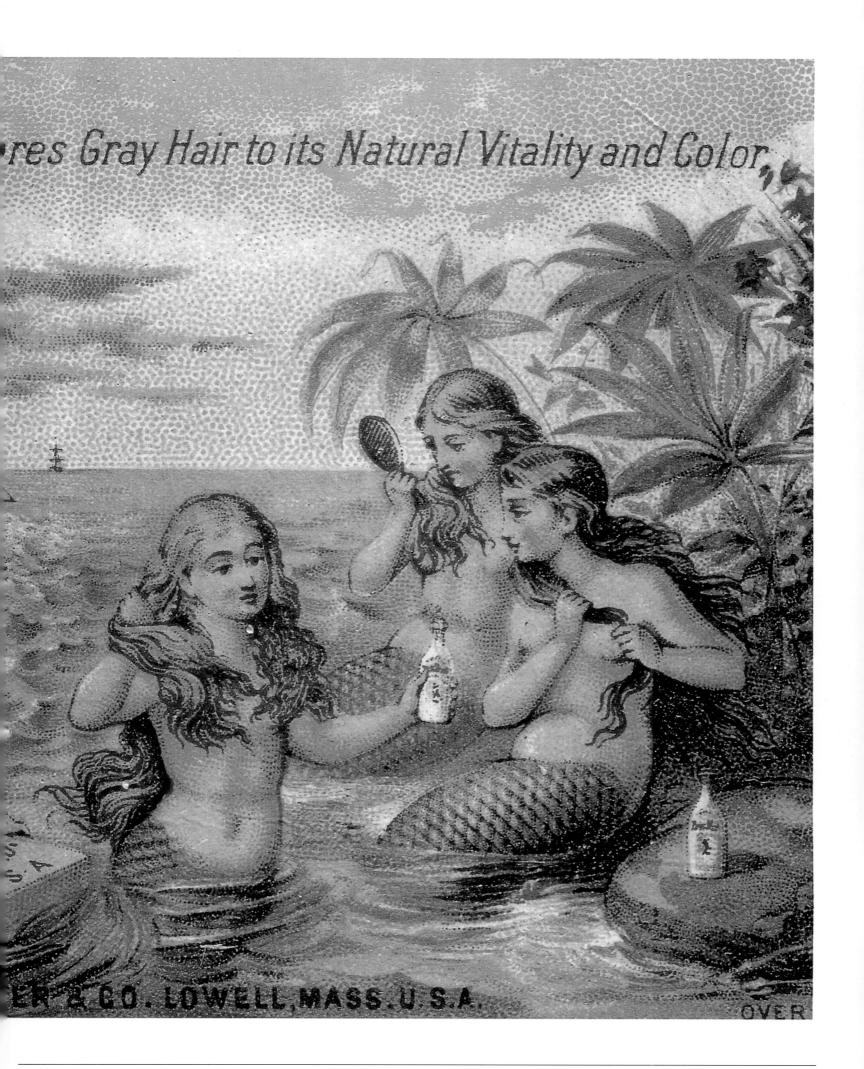

CHAPTER 6

NAUTICAL ART

No class of Americans created a greater variety of folk art than did sailors and those, such as ship carvers, who worked for them. Despite the hardships of life at sea, mariners often had long periods of inactivity which they filled with the practice of highly personal crafts such as the making of scrimshaw carvings and the building of ship models.

Ship builders and owners were concerned with the appearance of their vessels almost as much as with their seaworthiness. A carved figurehead, often accompanied by additional decorative elements such as sternboard, gangways, and taffrail, was a requirement for a ship of any substantial size. Indeed, no less a personage than John Hancock, in charge of the nation's newly created Marine Committee in 1776, admonished a builder of frigates to

let the heads and galleries for the ships be neatly carv'd and Executed, I leave the Device [figurehead] to you, but by all means let ours be as good, handsome, strong & as early completed as any building here in Philadelphia.

This pride in ownership and appearance was further manifested by the proliferation of artists who specialized in paintings of ships, both naval and commercial. Employed by merchants, owners of shipping lines, and captains of sailing vessels, these painters created a category of folk art that is highly sought-after today.

Finally, sailors like all travelers bought souvenirs. In the West Indies they purchased "sailors' valentines," shell work creations housed in mahogany cases and featuring a touching expression directed to home and family. Shell-covered boxes and other receptacles were also popular trinkets, as well as coconuts carved in the manner of scrimshaw.

Scrimshaw

The chief leisure activity of the American sailor was scrimshaw work, the incising or carving of bits of ivory, usually taken from whales. While primarily a whaleman's pastime (since they had

readiest access to raw material), scrimshandering, as it was called, was practiced by any sailors who could obtain a supply of ivory, as well as by "landlubbers."

So prevalent was the hobby in the 19th century that it was often

SCRIMSHAW WHALE'S TOOTH

c. 1820-1840; incised carbonfilled figure on whale ivory; New England. Such stylish female figures as this one were often copied from illustrations in the women's magazines of the period. *Private Collection*.

"JAGGING WHEEL" OR
PIE CRIMPER c. 1830-1850;
carved and pierced whalebone
and ivory; New England.
Featuring hinged "teeth" for
piercing crust to allow juice to
escape, this is one of the more
complex examples known and
is decorated with over a dozen
hearts. Courtesy Barbara Johnson.

SWIFT OR WOOL WINDER

c. 1840-1850; turned and carved whale bone and ivory with silk ribbons; New Bedford, Massachusetts. These complex devices were used to measure skeins of yarn. This example features a fist-shaped table clamp. *Courtesy Barbara Johnson*.

mentioned in print, as in the log book entry for May 20, 1826 of the brig, By Chance— "all hand employed scrimshonting"— and the 1842 journal of Captain William M. Davis in which he notes that

in scrimshoning we carve and work much on the ivory of whale's teeth, and by inlaying with pearl some beautiful objects are wrought.

Three types of material were employed in scrimshandering: whale or walrus teeth, baleen, a stiff, horn-like material which was used in making flexible objects like women's corset stays or "busks" and hoop skirt supports, and pan bone taken from the whale's jaw.

SCRIMSHAW SHOWCASE dated 1855; mahogany with whale ivory, brass, silver, and velvet; by William Chappell, New Bedford, Massachusetts. Chappell, a crew member of the ship *Saratoga*, made this for his captain. *Courtesy Sotheby's*.

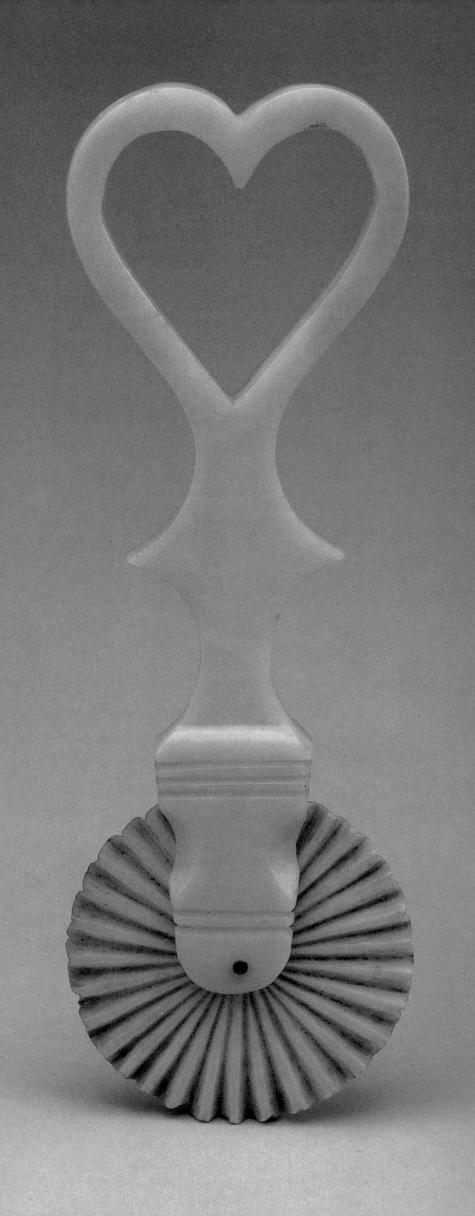

On teeth and pan bones were incised, with a needle or other sharp object, various pictures and messages for loved ones at home. Popular themes were attractive and stylish women, patriotic figures, historic sea battles, and, of course, whaling scenes. While a few gifted artists did freehand work, the majority would lay a dampened illustration from a magazine such as *Godey's Lady's Book* over the tooth, then carefully prick out its outline with a needle. The holes would then be joined together and the outline filled in with red or blue ink or lamp black.

Bone was also carved into a variety of useful objects such as pie crimpers or jagging wheels, elaborate swifts for measuring yarn, cane and umbrella handles, openwork baskets, needle cases, clothespins, ditty boxes, bobbins, bird cages, toys, and such nautical tools as fids, knife handles, seam rubbers, rulers, bodkins, and the whale stamps used to record the capture of a leviathan in the ship's log. Whale bone was also often combined with exotic woods like mahogany, teak, and ebony in the manufacture of items such as rolling pins, dippers, serving trays, and storage boxes in many shapes and sizes.

Authentic scrimshaw can bring high prices at auction (several of the "Susan's Teeth" made aboard the bark *Susan* of Sag Harbor, Long Island in the 1820s have sold for over \$20,000). However, fakes and reproductions have been made for decades, and collectors must be extremely cautious.

SCRIMSHAW WHALE TEETH c. 1830-1840; ivory teeth with incised decoration filled with lamp black; New England. Matching pairs of teeth, such as these patriotic examples, are rare. Courtesy Sotheby's.

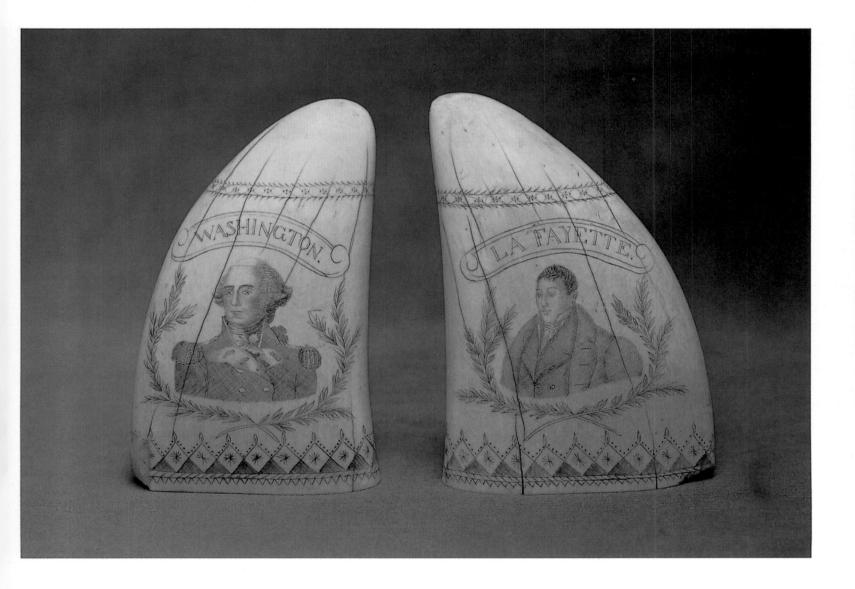

"JAGGING WHEEL" OR PIE CRIMPER c. 1850; carved whale bone and ivory; Nantucket, Massachusetts. Pie crimpers were among the many tokens of affection made by sailors for their wives or sweethearts. *Courtesy Barbara Johnson*.

SHIP'S FIGUREHEAD c. 1865-1875; carved and painted pine; Maine. This stern figure is believed to be a representation of President Ulysses S. Grant. Courtesy Frank Maresca

Rope Work

Rope work was another nautical pastime. Sea chest handles or beckets were woven of coarse line as were floor mats, some the size of small carpets. These mats were often plaited or interlaced in a complex manner reflecting the sailor's skill with knots, an ability most frequently displayed by mounting various examples on a polished mahogany board.

Ship Models

Ship models were made by sailors, of course, but they were also created by others who never sailed the seas. There are three general categories to be considered: free-standing models, shadow box vessels, and ships in bottles. All have been produced over a long period of time, and are still being made.

Free-standing models are designed to be miniature replicas of full-sized ships. Some early ones were actually builder's models used as a construction guide. Most, though, were made for pleasure. A Maine seaman wrote to his wife in 1861 to tell her that

I have whittled a ship and a lighthouse for you with a pilot boat putting out to sea. It is a copy of the A.C. Watson....She is a sweet little schooner.

The best of these models are built to scale and include all the important details found on a comparable vessel: planked hulls, life boats, gun ports, anchors, cabins, and, most important, proper rigging. Size varies greatly. Some examples are five feet long; most are under two feet. A few of the finer specimens have been mounted under glass cases to protect their fragile sails. Particularly prized are "prisoner-of-war" models—usually made from discarded soup bones—which were the product of French, English, or American sailors imprisoned during the wars of the late 18th and early 19th centuries.

Shadow box models were made both at sea and in many seafaring towns along the Atlantic coast. They consist of a simplified hull with rigging, which is cut in half and mounted against a wooden background painted to resemble an ocean scene. This was then set within a deep, glass-covered shadow box frame. Such models were rarely built to scale, and they are frequently inaccurately rigged. However, they may be wonderfully folky with their brightly painted ground and toy-like ship. Larger examples may incorporate several vessels and a shoreline built up with model houses, trees, and the requisite lighthouse.

Less frequently seen are dioramas: sailors in a longboat in pursuit of a whale, a shipboard scene, or a dramatic hand-to-hand battle between naval boarding parties. Since these involve the carving of human figures, they were usually undertaken by only the most skilled craftsmen.

Perhaps the most generally popular of all nautical art is the ship in a bottle. Designed to baffle (how did they ever get that thing in there?) as well as amuse, these miniature models have been made at least since the mid-19th century. Earlier examples are mounted within handblown bottles. Size is determined by the available bottle; most fit within a quart-sized or smaller container. The vessel (or vessels) within is mounted on a painted plaster sea and frequently rides at anchor before a small harbor or port town on a hill, built of plaster and wood. Many reproductions are available: some are made in the traditional way, others of incredibly delicate blown glass crafted in Italy.

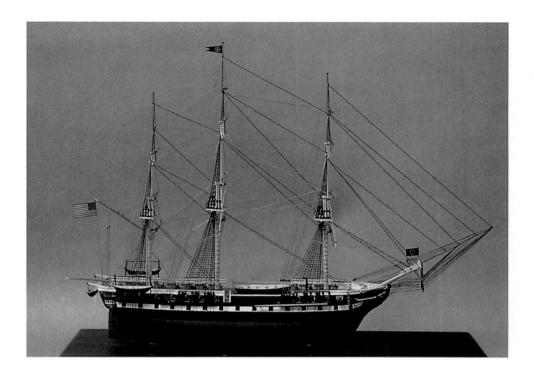

MODEL OF U.S.S.
CONSTITUTION c. 1920-1940; carved and painted wood with cloth, thread, and iron wire; New England. The Constitution is among the most popular subjects for ship modelers. Private Collection.

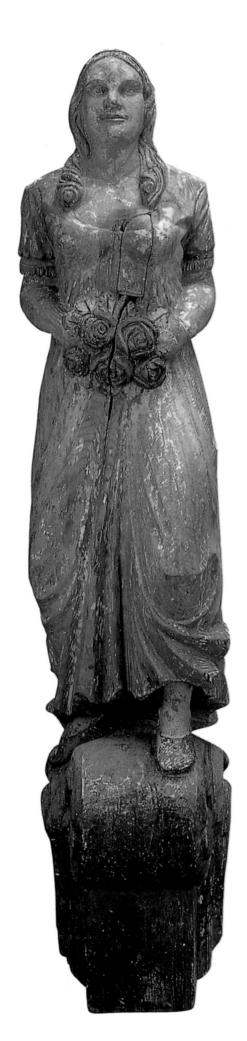

c. 1830-1850; carved and painted wood; Portland-Boston area. Women were a popular subject of figurehead art for sailors who were often away from wives or sweethearts for several years at a time. Private Collection.

Ship Carving

Carved bow-mounted ships' figureheads come from a tradition of great antiquity. They were found on Roman and Egyptian vessels, and are related to the dragon-like prows of the Viking whaleboats. No doubt the earliest were designed to strike fear into the hearts of superstitious foes, but prestige eventually became a more important consideration: a finely-carved figurehead demonstrated the wealth of the ship's owner.

The earliest American examples appear to have been in the form of a lion, reflecting traditional British iconography. A bill submitted in 1689 by the carvers Edward Budd and Richard Knight of Boston for the sloop, *Speedwell*, referred to a "Lyon," and "a neat carv'd Lyon's Head fit for a ship of about 400 Hogsheads Burthen" was offered for sale in 1745 by a Maryland firm.

Other animal forms such as horse heads gradually became popular, but by the mid-1700s these were largely replaced by representations of humans. Simeon Skillin (1716-1778) and his sons, John and Simeon, Jr., among the most highly regarded of these early carvers, produced a wide range of figures including Spanish *dons* or cavaliers, Venus, English heroes like the Black Prince, "Old Put" (the devil), and even a Portuguese king. American sculptors of the 19th century preferred women, including semi-nude figures, as well as a variety of personages including statesmen, politicians, and, of course, Uncle Sam.

The gradual introduction during the second half of the 19th century of steel-hulled vessels made installation of figureheads more difficult; and when the United States Navy, in 1907, ordered them removed from its ships, the tradition came to an end. A substantial number of examples have survived in museums and private collections.

The pilot house eagle was another important form of nautical carving, a dramatic representation of the national bird mounted atop the small building in which the helmsman stood. Relief- carved eagles also decorated the paddle boxes of American steamships and the tops of masts. The greatest carver of these eagles was John Bellamy (1836-1914) of Kittery Point, Maine.

Less often seen are the large and elaborate sternboard carvings decorated with complex floral and figural motifs, gangway boards that decorated the entrance to the ship, and cat heads, traditionally carved in the form of a lion face, which served as cranes in raising the anchors. Because so many of the old sailing ships were broken up without regard to the artistry of their carved work, little of this subsidiary folk sculpture has survived.

Ship Paintings

The United States has a long tradition of nautical painting. Among the earliest examples are the small reverse glass paintings of naval battles of the Revolution and War of 1812.

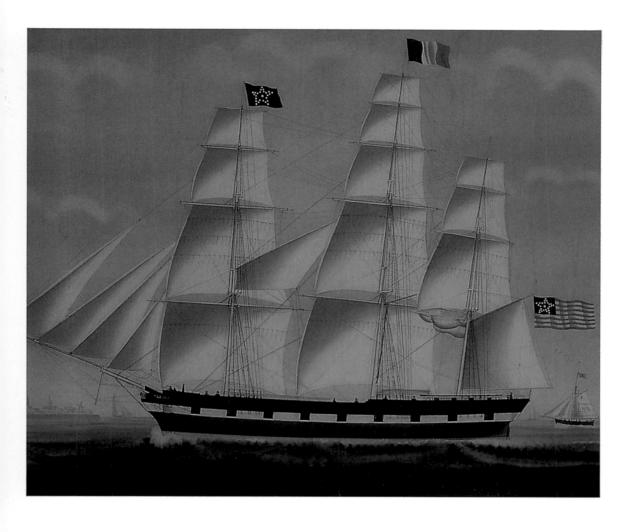

THE SARAH PASSING FLUSHING dated 1849; reverse painted oils on glass; China. Chinese port artists often painted views of American vessels, in this case a clipper ship passing Flushing, New York. Large numbers of Chinese paintings depicting American subjects were exported to the United States during the 19th century. Courtesy

Museum of American Folk Art.

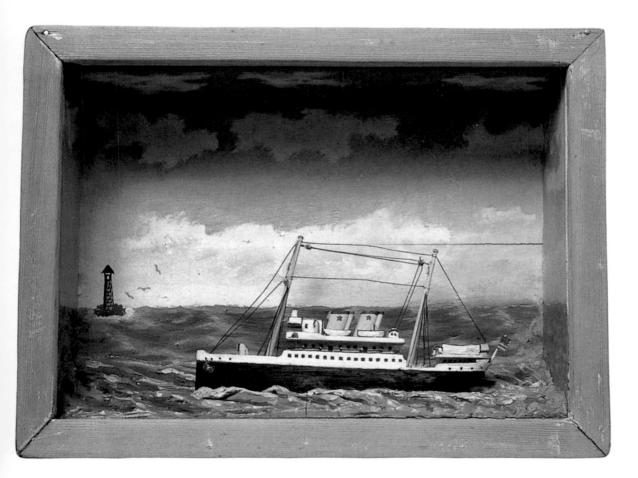

SHADOWBOX MODEL

c. 1910-1930; carved and painted wood with painted plaster sea and watercolor sky, set within a shadowbox of wood and glass; New York. Folk art using maritime subjects, such as this American steamship, was often the work of sailors who used their spare time to create a wide range of objects. *Private Collection*.

HARBOR SCENE

c. 1950-1960; oil on masonite; by Earl Cunningham (1893-1965), St. Augustine, Florida. Cunningham, who spent his life as a sailor, painted over 500 works, most of which were seascapes. *Private Collection*.

These usually depict one-on-one conflicts between a ship of the infant American fleet and one of the sea-tested Royal navy. Inspiring great patriotic fervor, representations of such victorious engagements as those between the *Constitution* and the *Guerriere* and the *United States* and the *Macedonian* were frequently featured on the glass tablets which adorned many Federal mirrors and clock faces. Ironically, these folk adaptations were usually based on British prints. Having lost the battles, the English won the market!

The earliest known portrait of an individual American sailing ship is that of the *Bethel* of Boston, painted in the mid- 18th century, but the great majority of such paintings date to the period after 1850. By this time our commercial fleet had expanded tremendously, and clipper ships flying the stars and stripes dominated international trade. The proud builders, owners, and captains of these vessels wanted to preserve them on canvas, and a small group of artists set about to satisfy their wishes. Most of these painters worked in seaports along the Atlantic coast where both patrons and subject matter were readily available.

Many of these men were academically trained, but there were also some successful artists working in the folk tradition. Chief among these were Antonio Jacobsen (1850-1921) and the brothers James (1815-1897) and John (??-1856) Bard. Jacobsen, Danish by birth, began to paint in New

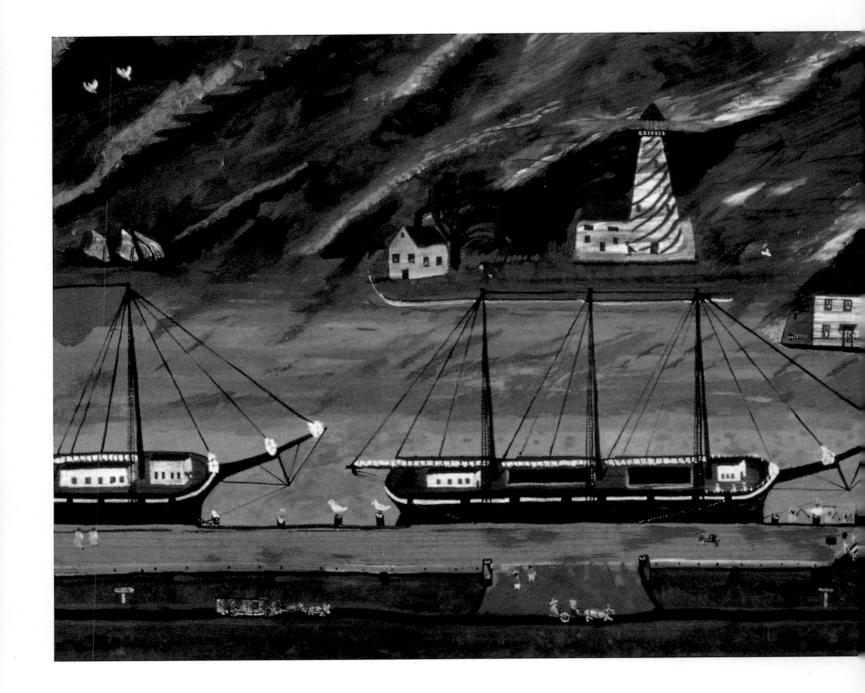

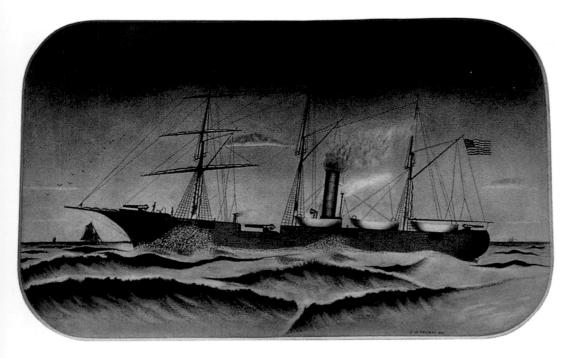

U.S.S. MERCIDITA c. 1870-1890; charcoal and ink on paper. The naval vessel, shown under way, is a transitional ship combining sail and steam propulsion. *Private Collection*.

York City in 1875. He later established a studio in Hoboken, New Jersey where he turned out hundreds of paintings on canvas and artist's board. These ranged from clippers and other sailing ships through sail-steamers, steamships, and yachts, to the small harbor tugs which handled the larger vessels. Famous for his attention to detail, Jacobsen earned a good living catering to the shipping trade of New York Harbor.

The Bard brothers were even more prolific. They worked together in New York City for about twenty years, and following John's death, James continued on into the 1890s. He alone is credited with over a thousand paintings, about half of which have survived. Somewhat less proficient than Jacobsen, his work is characterized by naive backgrounds and tiny, crude human figures set against blue skies and sparkling seas.

Though born in the same era, the folk painter J.O.J. Frost (1852-1928) of Marblehead, Massachusetts did not begin his career as a nautical painter until 1923, when a visitor asked him for a sketch recreating a scene of his youth as a sailor. During the next five years Frost turned out some eighty oils of nautical topics, and he is now regarded as one of the most important 20th century folk artists.

Due to the great demand for nautical paintings, the work of Jacobsen, the Bards, and even Frost has largely been priced out of the range of the average collector. However, there are many other little-known or unknown painters of the same period whose work is both interesting and relatively inexpensive.

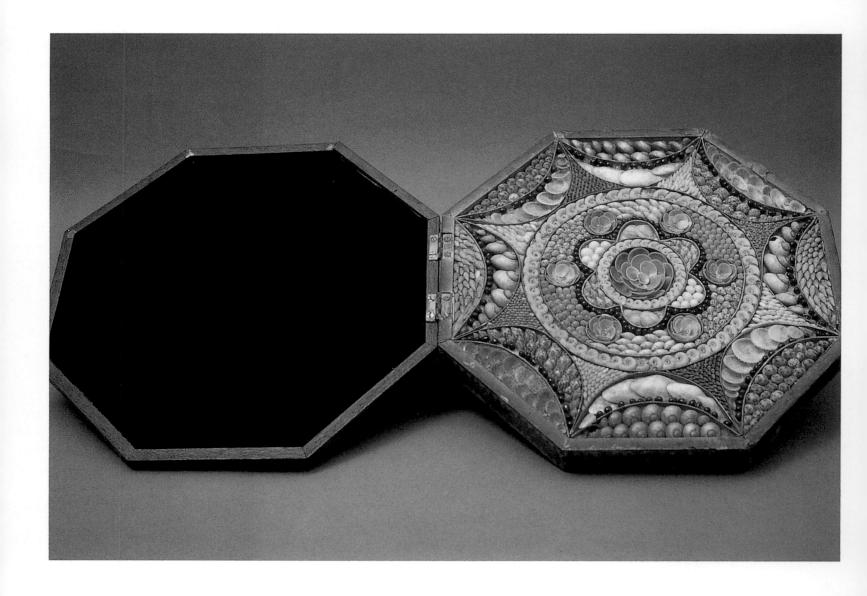

SAILOR'S VALENTINE

c. 1890-1910; seashells mounted in a felt-lined mahogany box; British West Indies. These souvenirs weren't made by sailors but were purchased by them to be given as gifts. Most of these pieces came from tropical ports where a wide variety of complex and colorful shells abounded. *Private Collection*.

Sailors' Souvenirs

Sailors were also tourists, and though not made in this country many of the objects they brought back from their travels have become part of the American folk heritage. Captains, mates, and other well-heeled members of the crew purchased "port paintings," done on canvas or glass by native artists, depicting ships, crew members, or the "hongs" or Chinese trading posts. From England wealthier sailors brought embroidered wool pictures featuring American sailing vessels, and from Japan and China more finely made embroideries with silver and gold thread, featherwork, and paintings on silk. These often had a small pocket into which could be inserted a picture of the seaman or a loved one.

Crew members settled for a less expensive class of mementos such as the "sailor's valentine," a shell mosaic produced in the West Indies. A mahogany box, usually octagonal and often with a hinged cover, was filled with vari-colored sea shells set under glass in a floral or geometric pattern (hearts were especially popular). Worked into the design would be a homely phrase such as "Remember Me," "To My Love," or "Souvenir of Barbadoes." Particularly popular today are double valentines with two mosaics hinged together; these often sell for over a thousand dollars.

Shells were also used to decorate a variety of useful objects including small boxes and picture frames. A particular favorite with seamen was an anchor-shaped, shell-covered wooden wall plaque, often with a cloth-covered pin cushion attached. Many of these were made in the British Isles where they were offered to tourists at beach resorts, but they were also made for sailors stopping at ports in such diverse spots as the Philippines and South Africa.

Large, heavy shells such as the conch and cowrie were engraved by grinding away the outer

layer of shell, leaving a pictorial relief set against the mother-of-pearl of the interior. Most of these were produced in Italy. Similar work was done in the warmer climes employing the ivory nut or palm tree seed. After the rough outer bark was peeled away this hard, rich brown nut could be engraved with nautical scenes such as the traditional "sailor's farewell." In an interesting variation, the two small depressions at one end of the nut were fitted with glass eyes and a face carved about them, giving the object some resemblance to a small, weasel-like animal.

The sand bottle, a glass vial or bottle filled with simple layers of different colored sands or with a picture built up from vari-hued earths was another unusual sailors' novelty. These were being made by the 1840s on the Isle of Wight, and later in the century seafarers visiting Chile obtained examples in rare colors produced from the nitrate bearing sands of that country. Sand bottle art is still being created today, especially in the American west, but it is no longer strictly nautical in content.

Finally, there was straw work, a form of marquetry practiced by sailors, especially prisoners of war. This involved decorating boxes, tea caddies, picture frames, and even small pieces of furniture with plaited strips of colored straw glued to the surface in various designs, both geometric and pictorial. The best of this ware was produced in the early 19th century by French seamen; the art was continued into the 1900s by Austrian craftsmen.

SAILOR'S DITTY BOX

c. 1810-1830; baleen with pine top and bottom; scrimshaw decoration; Nantucket, Massachusetts. Baleen, a flexible whale membrane, was used to shape this oval storage box. Courtesy Barbara Johnson.

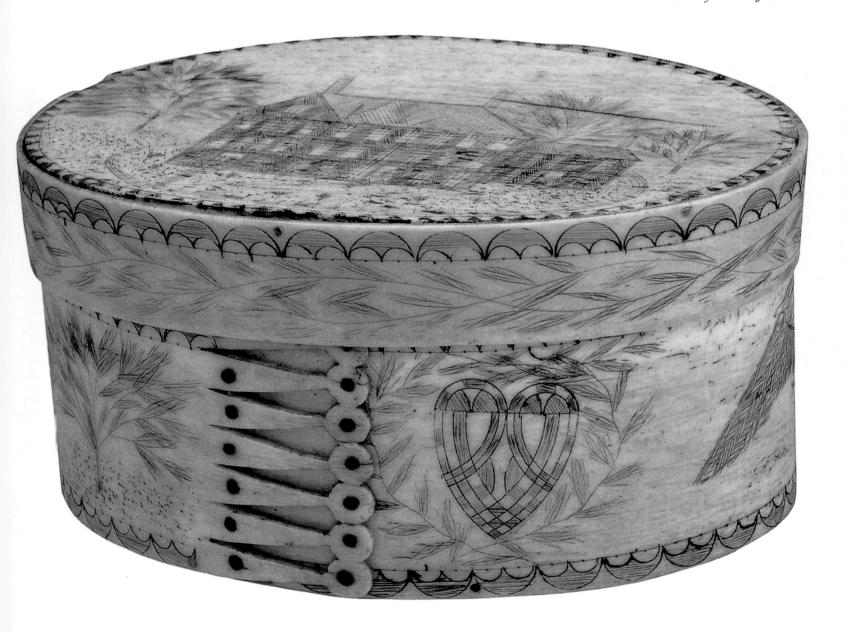

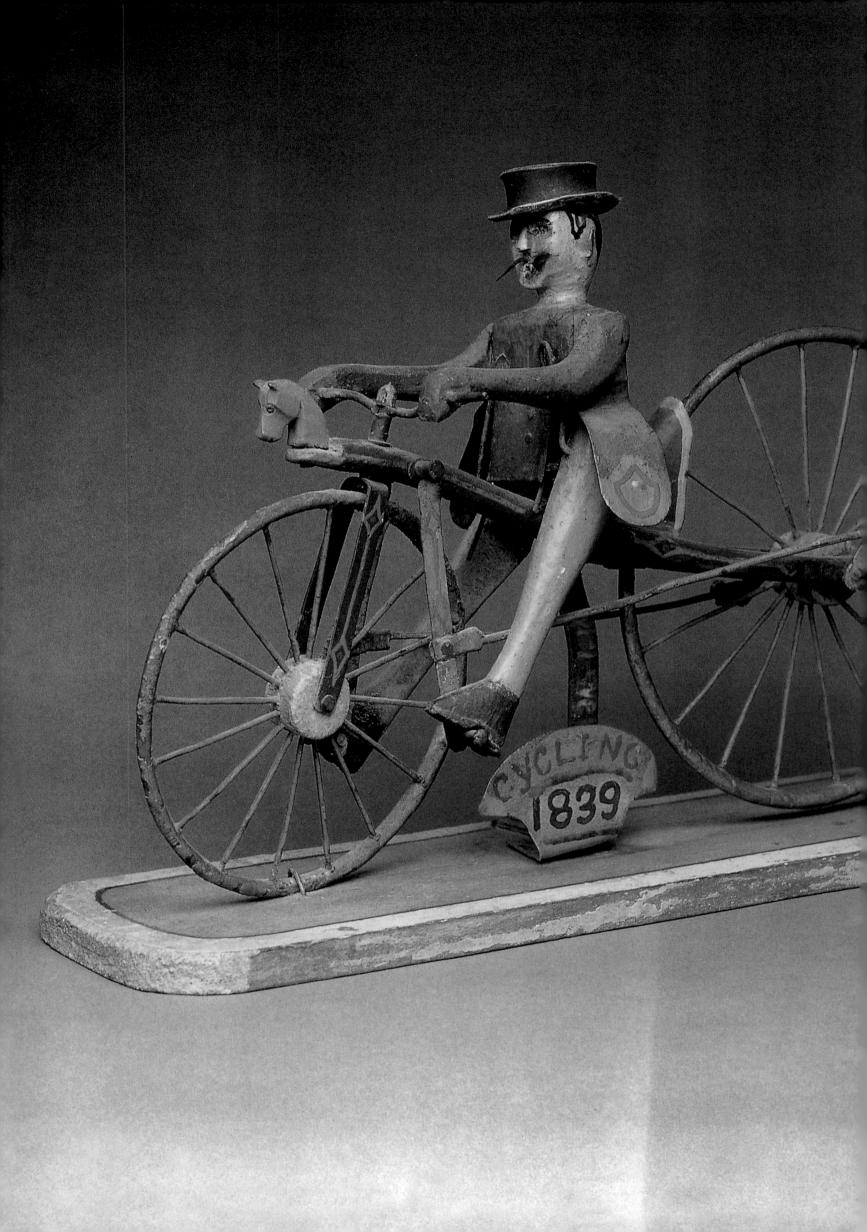

THE WORLD IN MINIATURE

A rt often imitates life, and this is especially true of folk art, the practitioners of which frequently enjoy creating miniaturized versions of the larger world around them. In some cases the objects produced serve a very practical purpose, as with the decoys made to lure ducks and shorebirds as well as fish. More often the pieces are purely decorative. The molded gypsum figurines known as chalkware were made "for pretty" to be displayed as decorations in otherwise drab houses. This was also true of the small toys and figurines made in earthenware and stoneware by American potters. On the other hand, miniature books of marble or slate were produced as gifts or novelties, as were the rustic wooden objects often referred to as "wacky wood." Whatever their original purpose, all these objects are now part of the folk art pantheon.

Decoys

The gregarious nature of waterfowl makes it practical to lure them within hunting range by using either other live ducks or artificial decoys made to resemble their living brethren. At least a thousand years ago Native Americans, the Tule Eaters of the southwestern United States, employed duck-like lures of bound reeds and feathers for this purpose.

By the 1850s American hunters were using duck and shorebird decoys carved and painted in a realistic manner, made either by themselves or by local craftsmen. Since they were easily lost or

damaged by bird shot, few of these early examples have survived. However, the great popularity of hunting over the past century has led to the production of so many decoys that examples from this period are the most readily available of all American folk sculpture.

Waterfowl decoys fall into two broad categories: ducks and shorebirds. The duck may be further subdivided into floaters and stickups, which are mounted on a rod

MAN ON BICYCLE c. 1893-1920; carved and painted wood with iron and tin; northeastern United States. The date 1839 may relate to the development of the bicycle. In that year a Scottish blacksmith, Kirkpatrick Mac-Millan, fashioned a two-wheel vehicle that may have looked like this. *Private Collection*.

c. 1930-1950; carved and painted cedar; New York. Clearly, a sophisticated carver has taken care to insure that his piece closely resembles a living bird. *Private Collection*.

MALLARD DRAKE DECOY

FISH DECOY c. 1930-1950; carved and painted pine; Minnesota. Few fish decoys are as well carved as this representation of a white sucker, a common forage fish. *Private Collection*.

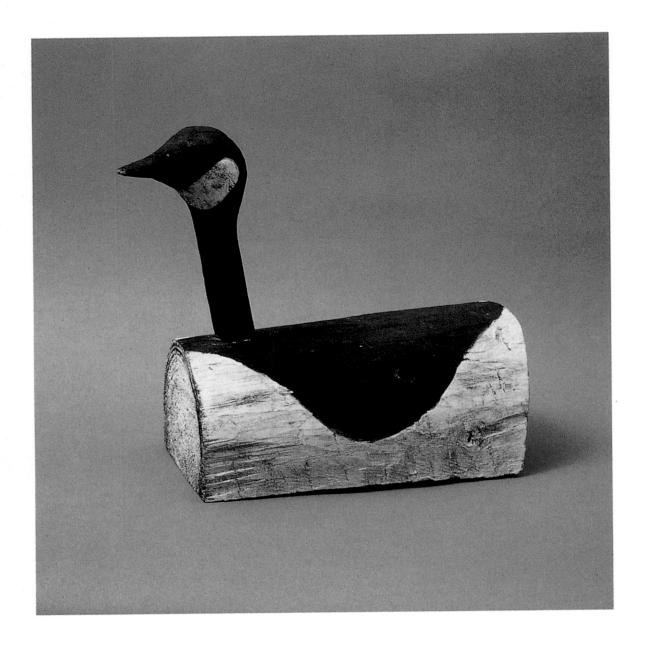

CANADA GOOSE DECOY c.1920-1930; carved and painted pine and cedar; Connecticut. A true folk decoy, the goose's body consists of nothing more than a section of painted log. *Private Collection*.

YELLOWLEGS DECOY c. 1890-1910; carved and painted wood; Long Island, New York. Since hunting for shorebirds or "peeps" was outlawed early in the 20th century, examples of this type of decoy are uncommon. *Private Collection*.

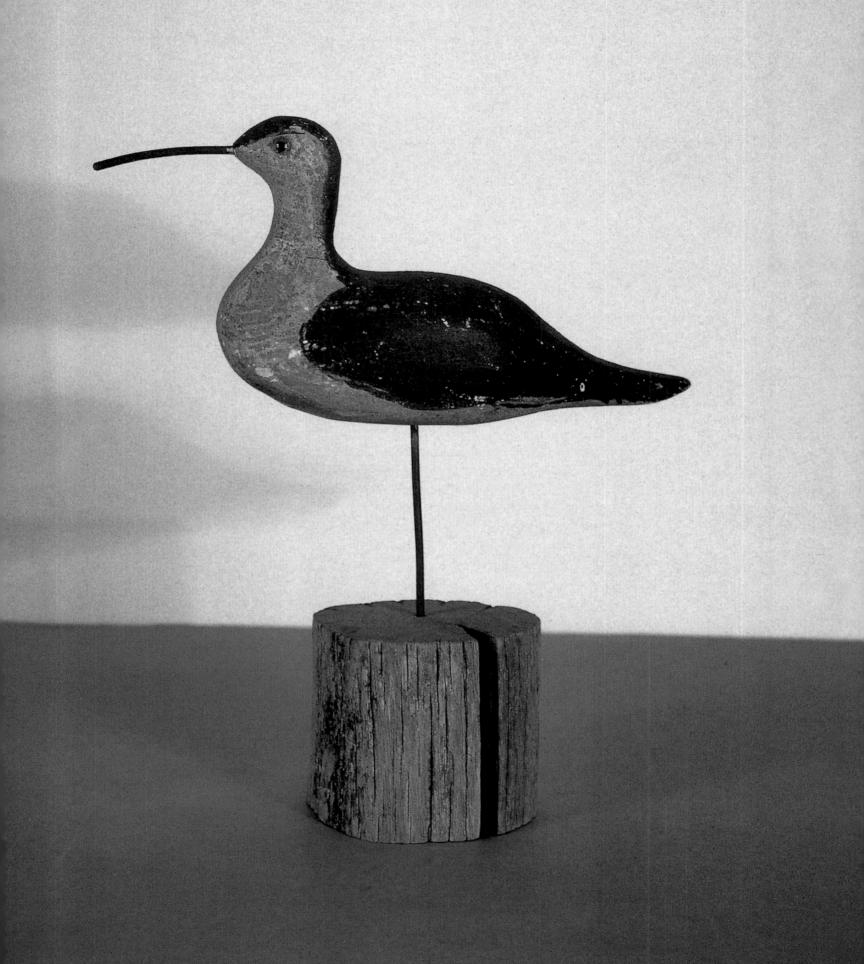

for planting in the ground. Shorebirds, which mimic the small birds like yellowlegs, curlews, and plovers which feed along the tidal flats, are always made as stickups.

Authentic duck decoys are far more common than their shorebird counterparts, as hunting the latter was outlawed early in the 20th century. As a result, thousands of decoys shorebird decoys were thrown away or burned as kindling wood.

While most decoys—including the most collectible—are of carved and painted pine or cedar, they are also found in other materials. Some are made of canvas stretched over a wire frame, others have balsa wood bodies, and there are even cast iron examples which were mounted on rafts. Shorebird decoys are found in painted, stamped tin as well as wood. Both types can be either fully three-dimensional or flat silhouettes.

Not all decoys were made in the form of ducks or shorebirds. Birds such as swans and sea gulls, which are not hunted for food, were mimicked in the belief that these "confidence decoys" would encourage huntable birds to approach. Pigeon and crow decoys were also made, as were owls designed not to attract but to repel birds which attacked crops.

Decoys are tremendously popular not only with folk art enthusiasts but also among hunters and decoy specialists who collect no other folk objects. As a result prices have escalated in the last decade, with a few examples bringing over \$100,000. The more valuable items tend to be those made by famous carvers like Nathan Cobb, Charles "Shang" Wheeler, and A. Elmer Crowell. Still, a finely carved and beautifully painted but unidentified bird will quickly find a home.

The fish decoys used in ice fishing on the northern lakes are a related collectible. Fish decoys are also usually made of carved and painted wood, generally weighted to keep them upright, and mounted with tin or leather fins. Some are carefully painted to resemble actual fish such as suckers, sturgeon, and sunfish. Most, however, are decorated in garish colors unknown in nature but thought to attract game fish.

The fish decoy, which does not have hooks, is lowered on a line through a hole in the ice and jiggled up and down to create the impression of a living meal for a large fish. When the predator approaches the fisherman attempts to jab it with an iron trident-like spear.

Though most are small (less than ten inches long) and crudely made, fish decoys have attracted a cult-like following of enthusiasts who seek out the relatively few examples by respected carvers like Oscar Peterson (1877-??) of Cadillac, Michigan. There are also a substantial number of factory-made specimens produced by firms which make fishing tackle. One of the major prob-

PAIR OF MALLARDS

c. 1940-1960; carved and painted pine with castlead legs and feet; New England. Decorative decoys such as these miniatures are popular with many collectors. *Private Collection*.

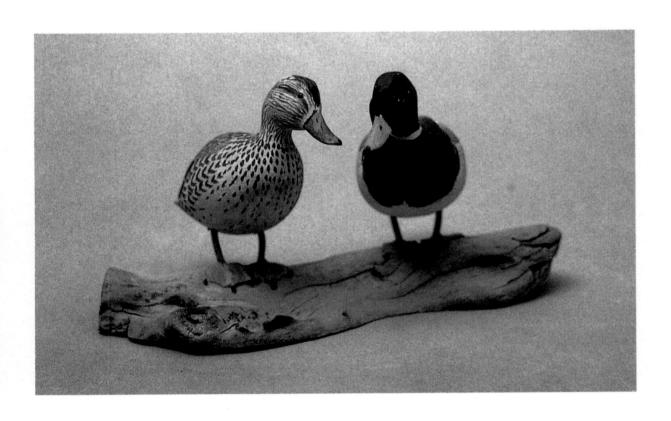

lems in the field is the vast number of contemporary reproductions which are often offered to the unsuspecting as old, used decoys.

Also very collectible are the wrought iron spears used in ice fishing and for spearing eels and freshwater fish, usually at night with aid of a spotlight. Fish spears are often fine examples of the blacksmith's craft with delicately shaped fanlike blades terminating hooked Mounted on a wooden block or against a wall, they become folk sculpture.

Chalkware

Among the most charming of American folk sculptures are small figures cast from plaster or gypsum, allowed to dry, and then painted in bright colors (typically red, yellow, blue, green, and black). Long associated with Pennsylvania, most either originated in Europe or were made here by immigrant craftsmen. Philadelphia newspapers carried mid-19th century advertisements by several Italian workers who produced such wares, carrying their molds, plaster, and paints on their backs from town to town.

Considering how fragile they were, a surprising number of old chalk figures have survived. A major collection at the Museum of American Folk Art in New York City contains dozens of figures, six to twenty-four inches tall, in several different designs.

Birds were a particular Pennsylvania favorite; doves, swans, roosters, parrots, and pairs of lovebirds were particularly popular. Among the many animals are lions, pigs, horses, squirrels, deer, goats, sheep, rabbits, and several types of dogs. Cats were so popular that some of the largest examples of chalkware were in this form. Human figures are less common and tend toward the Victorian sentimentality of little girls with doves, mothers and children, or sprightly "bloomer girls." Rarities include the fireman in full uniform with his axe upon his shoulder and George Washington on horseback.

Some of the earliest examples of chalkware are in the form of religious plaques and figures. These include scenes of the last supper and the holy family; angel statues in various sizes were also popular. Church models, among the largest of chalkware pieces, were probably designed for Christmas displays, as were the rare figures of Saint Nick.

Uncommon types of chalkware include watch safes (stands in the form of classical facades which were used to convert a pock-

etwatch into a small clock) and garnitures in pairs for mantel display. The latter were usually made in the shape of pineapples (symbolizing hospitality) or baskets of fruit and vegetables (another sign of welcome and bounty).

Some pieces of chalkware were given slots and used as penny banks, while smaller birds and animals were sometimes mounted on a fabric and wood bellows so that when pressed down they made a noise (hence their name, "squeak toys"). The nodder, a piece with its head attached to its body by a steel spring or wire loop so that it would bob about when touched, was another interesting variation. A figure of a talkative old woman is typical of the type, though animal nodders are more common.

While most chalkware is found in and around Pennsylvania, some appears to have made its way west. In his *Adventures of Huckleberry Finn*, Samuel Clemens has Huck describe a house with a mantel upon which sat "a big outlandish parrot on each side of the clock made up of something like chalk and painted up gaudy."

There is no doubt that most chalkware was intended for such decorative use, perhaps serving in place of more expensive Staffordshire earthenware mantelpiece figures. On the other hand, both the form and the decoration of chalk owes more to continental Europe than to the British Isles.

Chalkware went out of style and production in the late 19th century, but it reappeared in the 1920s in the form of prizes given away at carnival and circus games of chance. These pieces, which are still made, may be distinguished from 19th-century examples by the fact that the earlier pieces are always hollow. Carnival chalk, though also cast, is solid and heavy, and is more likely to be painted in pastel shades and sprinkled with bits of silver or gold glitter.

CHALKWARE DOG
c. 1880-1900; molded
and painted plaster of
Paris; Pennsylvania.
Dogs, modeled on English
Staffordshire mantelpiece
figures, were a popular
subject for the makers
of chalkware novelties.
Private Collection.

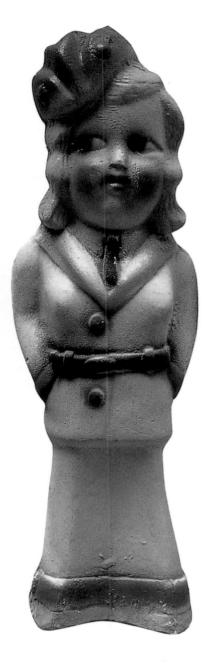

CHALKWARE CARNIVAL FIGURE c. 1920-1930; molded and painted plaster. Unlike 19th century examples, these inexpensive novelties are not hollow. *Private Collection*.

MICKEY MOUSE STILL BANK c. 1930-1940; painted composition with sheet tin base, marked "Walt Disney Crown", United States. Banks made of plaster-like composition material were fragile. Few have survived. Courtesy The Margaret Woodbury Strong Museum.

Long ignored as gaudy and of too-recent vintage, carnival chalk is now eagerly sought out by certain collectors attracted by the variety of figures to be found. There are of course, the usual animals, especially dogs and horses, a few birds, and even a fish or two. But the big attractions are the humans, everyone from flappers and Indian chiefs to movie icons like Betty Boop and Charlie Chaplin. Cartoon characters such as Mickey Mouse and Donald Duck are of equal popularity.

Another source of appeal is cost. While chalk figures from the 1800s regularly sell for \$200 and up, carnival ware is seldom priced above \$50, other than for rare cartoon or movie figures. There is a great quantity available, so much that one need not settle for damaged pieces—a similar undamaged example will be along soon enough.

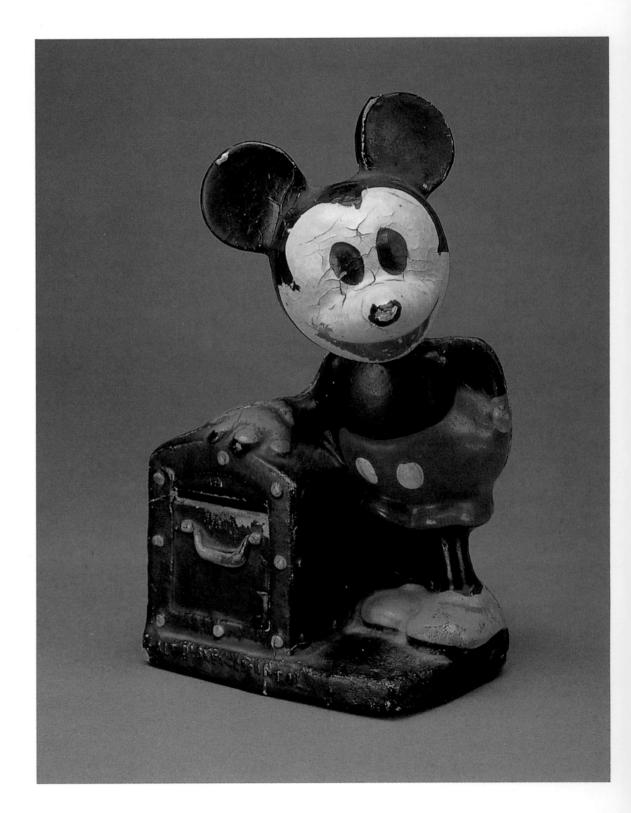

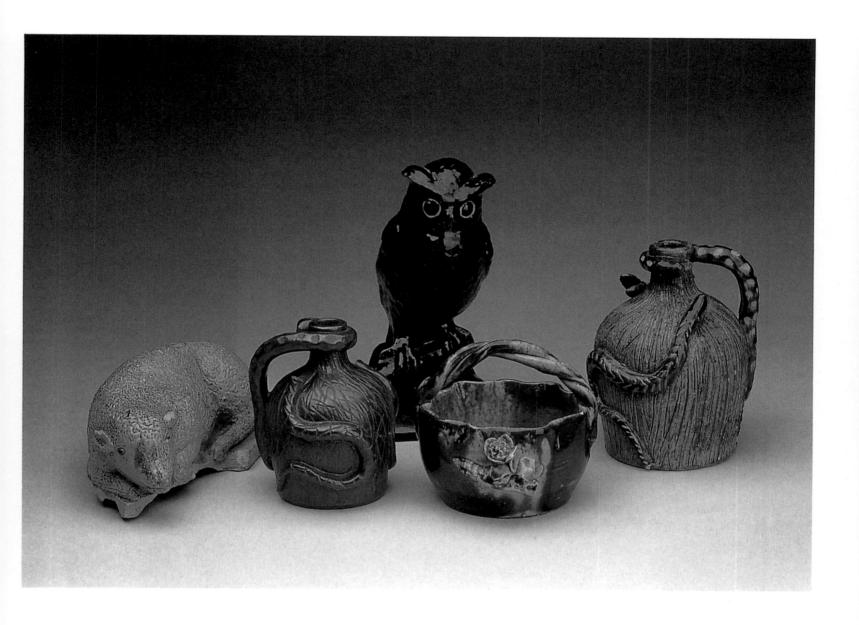

Figural Ceramics

Miniature figures were also produced from ceramic materials. From the 18th through the late 19th centuries American potters made everything from toys to reproductions of Staffordshire figurines in redware or the more durable gray stoneware. As early as 1660 the Manhattan potter, Dirck Claesen, was described as making "clay toys," and throughout the 1800s Pennsylvania craftsmen turned out such objects as redware whistles, tops, marbles, penny banks, and various miniature versions of jugs, crocks, and pitchers. Most of these were shaped by hand, making them true one-of-a-kind pieces of folk art. Some were left unglazed, others covered with a shiny lead glaze, and a limited number were splashed with slip in several colors.

Examples in stoneware covered with a clear salt glaze or a rich brown Albany slip include doorstops in the form of lions, dogs or classical figures, and a group of bizarre jugs, most from the Anna, Illinois pottery (c. 1859-1896), which are covered with snakes and other unpleasant creatures (a not-too-subtle reference to delirium tremens and a plea for abstinence from hard liquor). Another product of this factory was a group of small whiskey tasters in the form of pigs, the backs of which were incised with the route of an Illinois railway line.

One of the most interesting and folky forms, made both in stoneware and redware, is the face jug: a jug-shaped vessel, the front of which has been sculpted into a human likeness, often with white porcelain teeth and eyes. Most of these originate in the South, and some have argued that the form shows African influence. There is no doubt, however, that similar pieces were being made in Europe as far back as the 1700s. Whatever the case, numerous contem-

EARTHENWARE VESSELS

c. 1880-1900; glazed stoneware; Missouri. This group of pieces, from various potteries, includes two socalled snake jugs, a lamb, a basket, and an owl-shaped doorstop. *Private Collection*.

FOLK ART

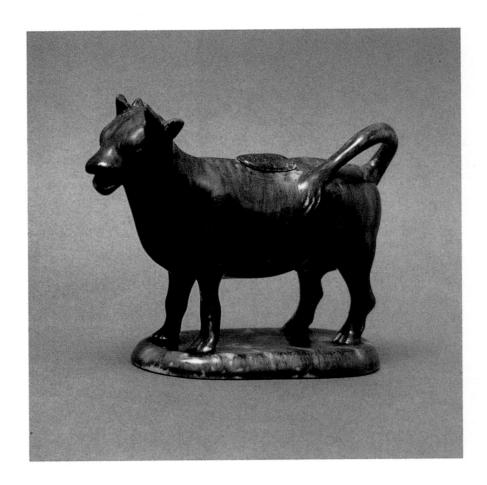

Cow CREAMER
c. 1849-1858; molded
Rockingham glazed
yellowware; Bennington, Vermont.
The piece was filled
through a hole in
the back, and cream
flowed through the
mouth when poured.
Private Collection.

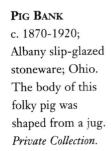

porary potters throughout the South are reproducing these popular jugs today, and they are a favorite tourist purchase.

Figural forms were also made in Rockingham and yelloware. The famous United States Pottery (1847-1858) at Bennington, Vermont turned out a great variety of figures in the brownsplashed yellow earthenware called Rockingham, including cow-shaped creamers, whiskey bottles which looked like books, men in long robes, and mantel ornaments in the form of lions, deer and cows. These were customarily cast in molds but often had hand- applied decorative elements. Figural yelloware is less common, but among the known examples are banks shaped like pears or barrels, a rare cow creamer, and numerous food molds designed to turn out everything from fish to fowl.

MECHANICAL ARTILLERY
BANK c. 1892-1910; painted cast iron with steel spring; by W. J. Shepard Hardware Company, Buffalo, New York. A coin placed in the cannon barrel may be fired into a slot in the bank.

Courtesy The Margaret

Woodbury Strong Museum.

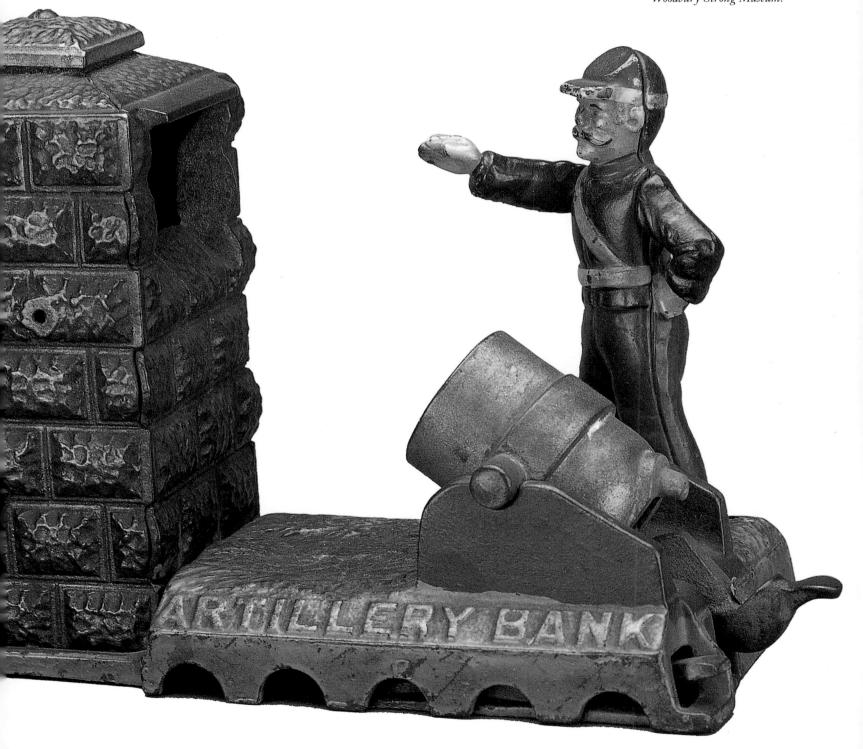

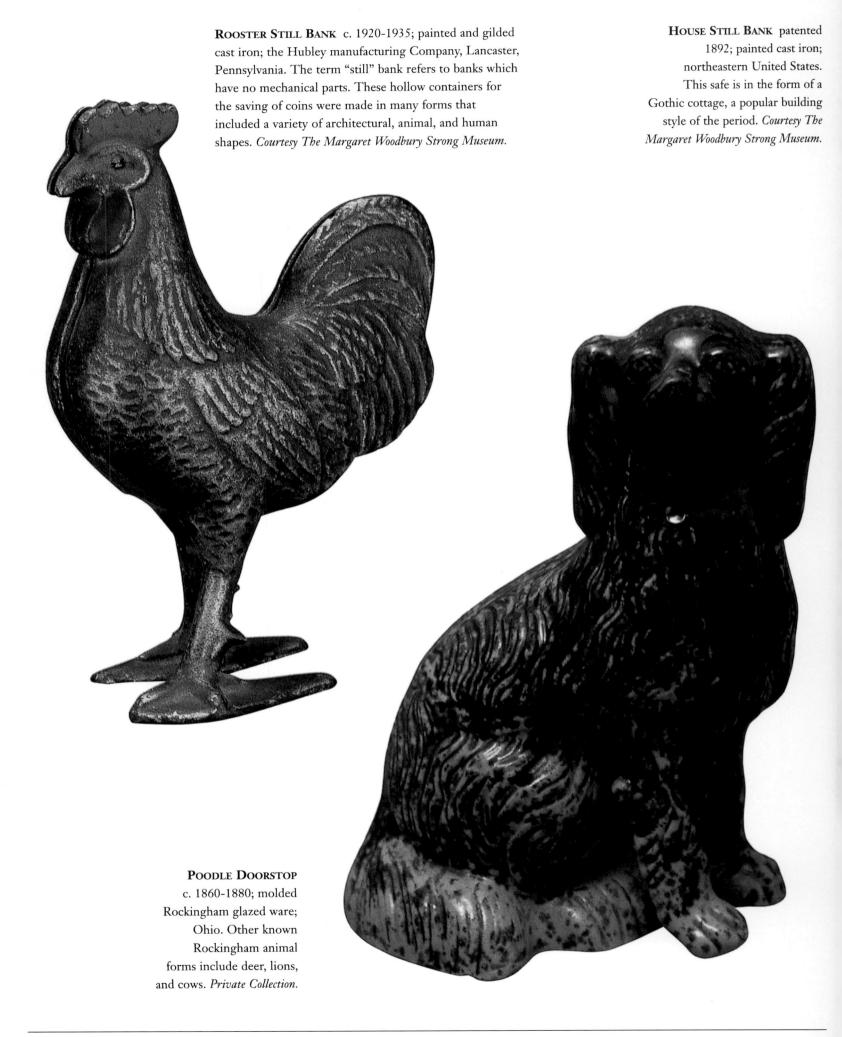

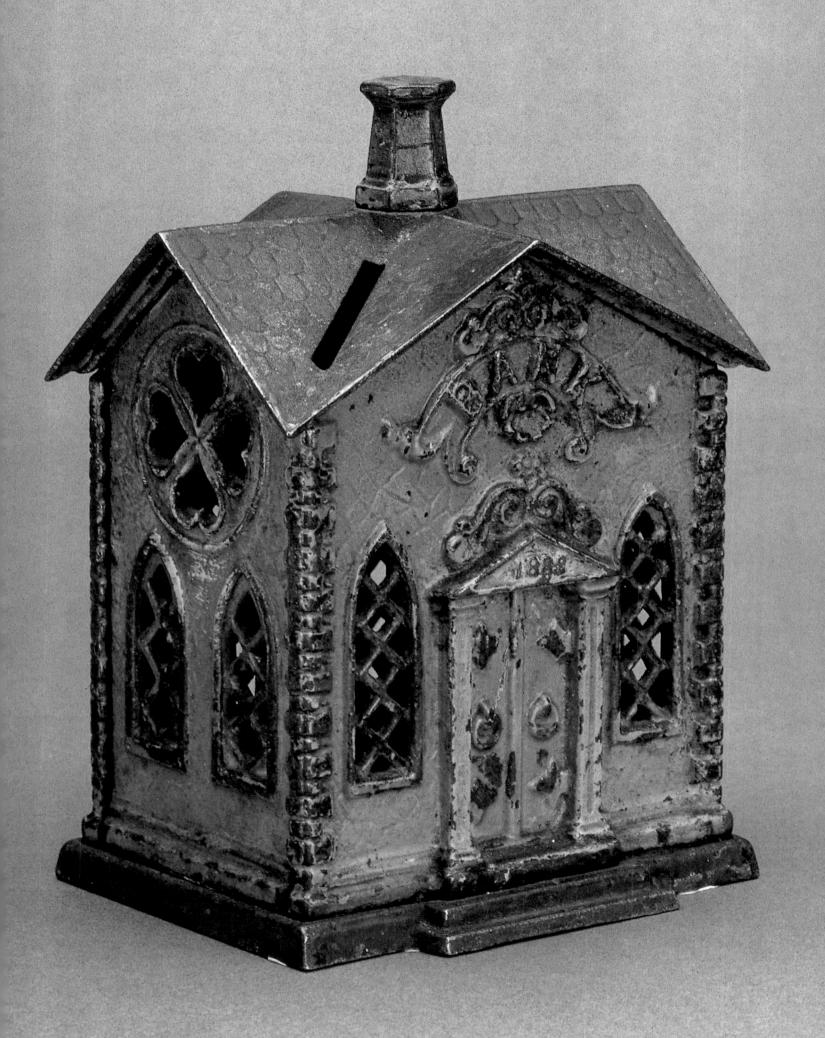

Miniatures in Stone

The material a folk artist employs often reflects his primary occupation. In New England, particularly Vermont and New Hampshire, the men who worked in the quarries cutting building stone developed a very personal type of folk art: they shaped miniature books of marble or red or black slate. Usually no more than four by five inches in size, these were incised with titles, the names of recipients, or Victorian motifs such as a bird or bunch of flowers. From their form and size it seems likely that these uncommon items were designed to serve as paperweights.

These craftsmen also produced larger pieces, multicolored bricks and octagonal balls which were either made from several stones of contrasting colors or polychrome painted. Their bulk and weight indicates that they were probably designed as doorstops.

WATCH HUTCH c. 1880-1910; turned and carved marble; Vermont. A watch placed in the round hole would serve as a miniature mantel clock. *Private Collection*.

STONE DOORSTOPS OR PAPERWEIGHTS c. 1870-1890; left, polychrome painted marble; right, assemblage of vari-colored marble

sections; both Vermont. Private Collection.

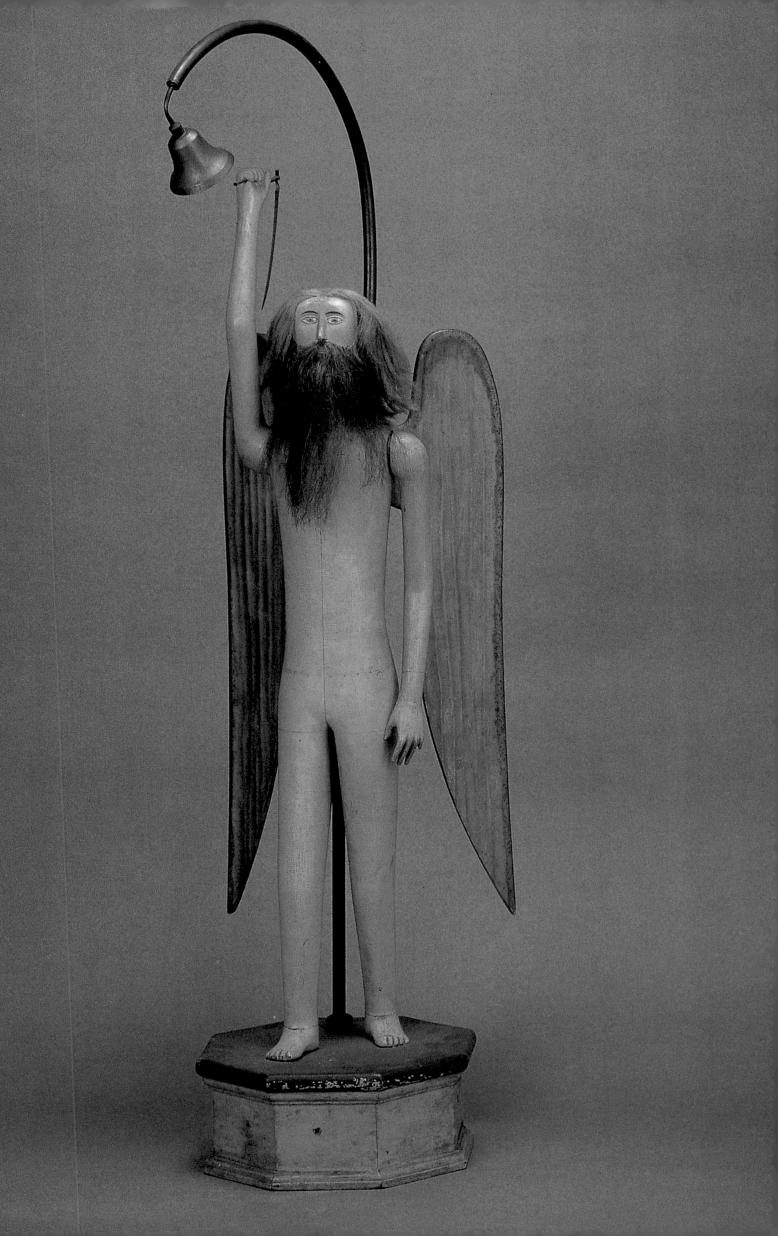

Wooden Whimsies

Another unusual and distinct group of small items appeared during the early 20th century. Reflecting the rustic craze of the period, which included everything from hunting lodges and rooms full of twig or horn furniture to Native American crafts and costume, these objects included handmade wooden pitchers, mugs, and bottles, many of which were decorated with declomania representations of Native Americans or slogans etched with a hot iron. The miniature wishing well, a round well with overhead crane from which a bucket was suspended, was an especially popular item. Most of these were designed to be sold as souvenirs, and they bore sentiments like "Welcome to Lake George" or "Souvenir of the Poconos" or the name of the town or historic site where they were being sold.

Known today among dealers and collectors as "wacky wood," these modestly-priced pieces have gained a substantial audience aware of their handmade status and distinct local provenance. It is possible, for example, to assemble a collection focusing solely on a particular resort area such as New York's Adirondack Mountains or the Blue Ridge area of Virginia.

Following page:
CHRISTMAS TREE
ORNAMENTS c. 1920-1940;
a group of painted blown
glass ornaments; Germany.
The finest and most complex
ornaments were handmade
in Germany prior to World
War II and were collected
and cherished by many
American families. Courtesy
Helaine and Burton Fendelman.

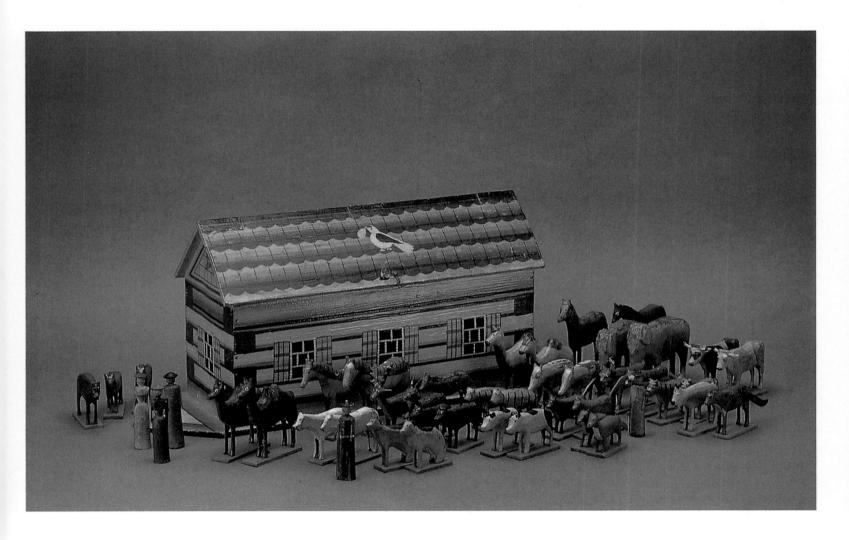

FATHER TIME c. 1900-1910; carved and painted wood with human hair and brass accessories; New York. The purpose of this piece is unknown, though originally the articulated arm allowed the figure to ring the bell. Courtesy The Museum of American Folk Art.

NOAH'S ARK c. 1900-1920; carved and saw-cut painted wood; Germany. Because of its religious nature, the Noah's Ark was regarded as a suitable toy in even the strictist families. Courtesy The Margaret Woodbury Strong Museum.

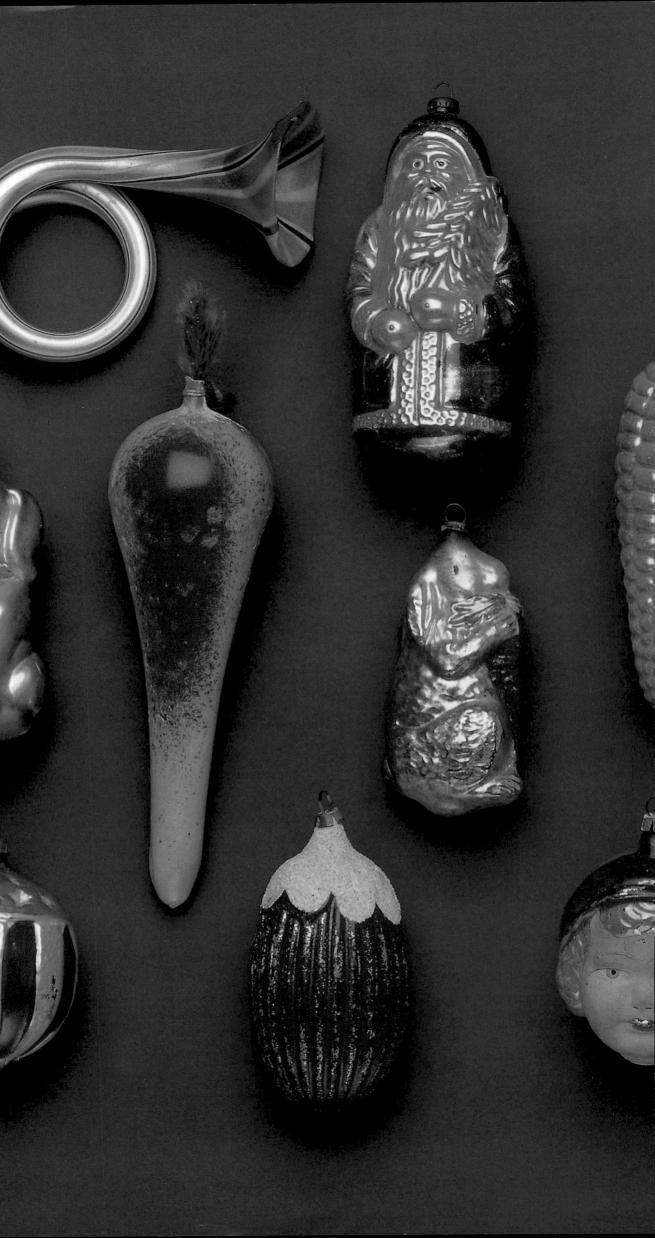

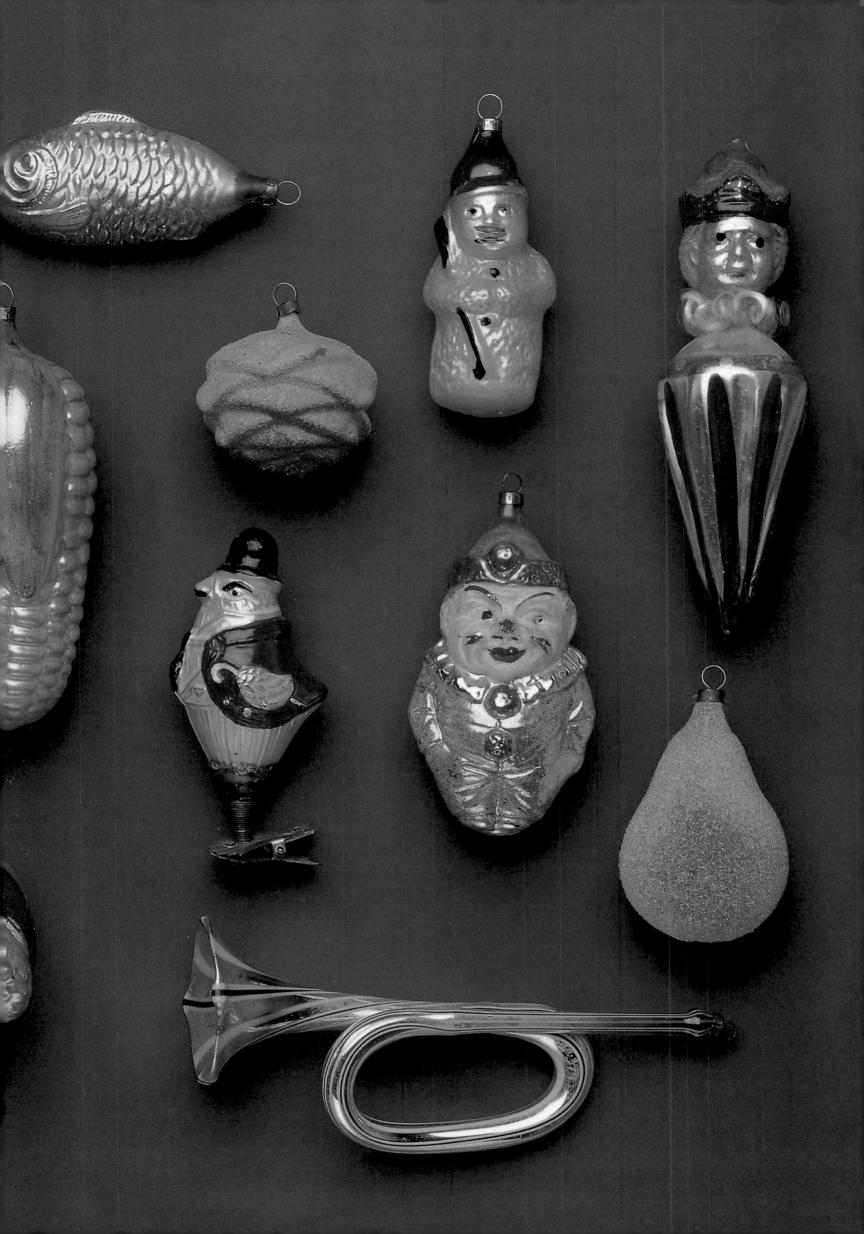

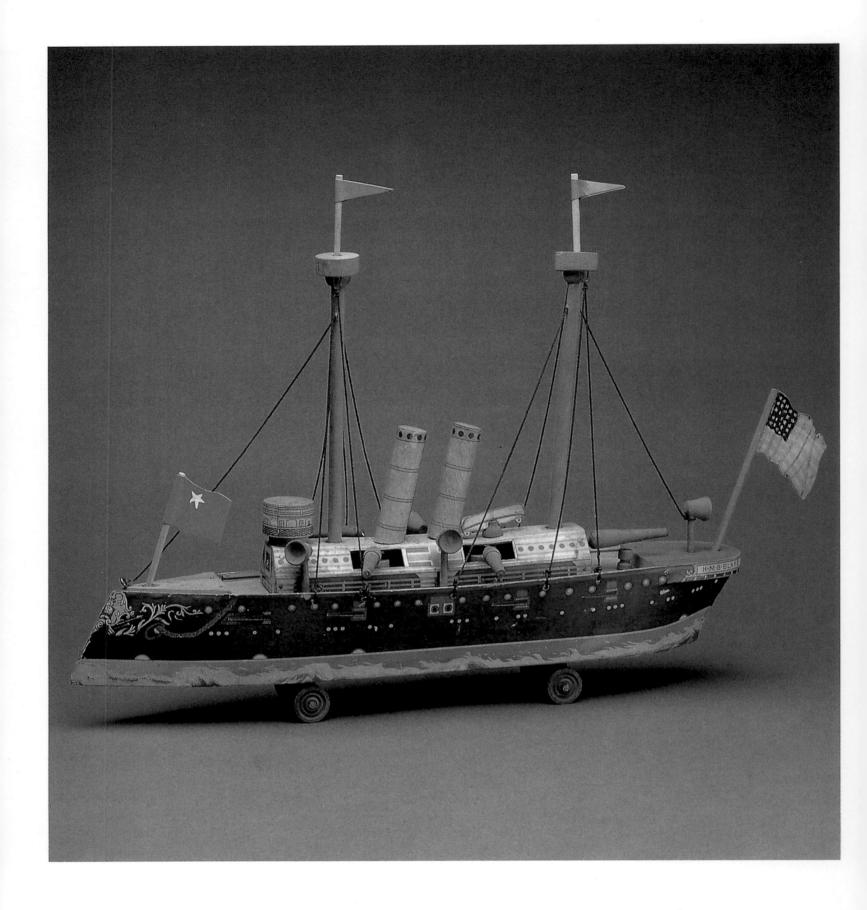

Warship, H.M.S. Blake c. 1890-1910; lithographed paper on jigsaw-cut stained wood; R. Bliss Manufacturing Company, Pawtucket, Rhode Island. Ships, in all materials, are among the most popular antique American toys. *Courtesy The Margaret Woodbury Strong Museum*.

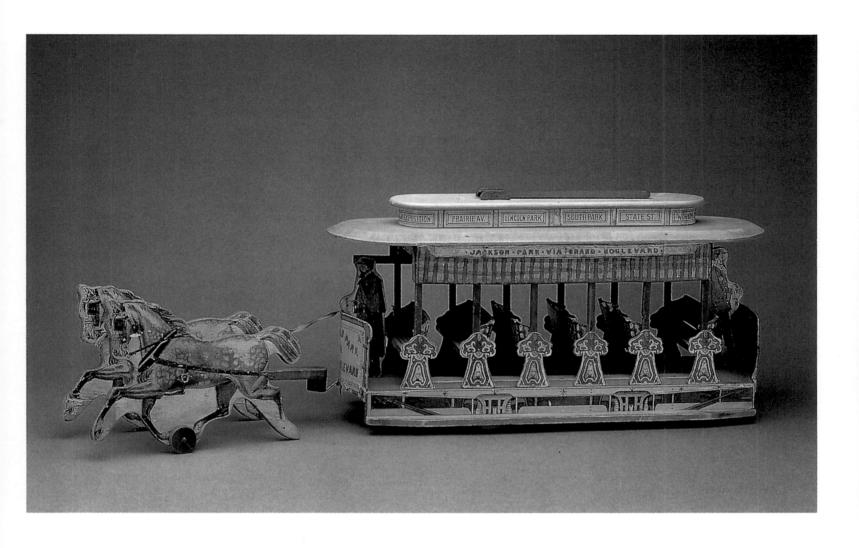

COLUMBIAN TROLLEY

c. 1893-1905; lithographed paper over stained saw-cut wood; R. Bliss Manufacturing Company, Pawtucket, Rhode Island. This pull toy first appeared in 1893, the year of the Columbian Exposition in Chicago. It is similar to the trolleys which conveyed the huge crowds to the fair. Courtesy The Margaret Woodbury Strong Museum.

NOAH'S ARK WITH PANORAMA

patented 1877; lithographed paper on painted wood; United States. This unusual toy features a panoramic wheel in the door of the ark which displays various wild animals. Courtesy The Margaret Woodbury Strong Museum.

HOSE REEL WAGON

c. 1900-1910; lithographed paper on jigsaw-cut wood; R. Bliss Manufacturing Company, Pawtucket, Rhode Island. Inexpensive though fragile, wooden toys have long been popular. Courtesy The Margaret Woodbury Strong Museum.

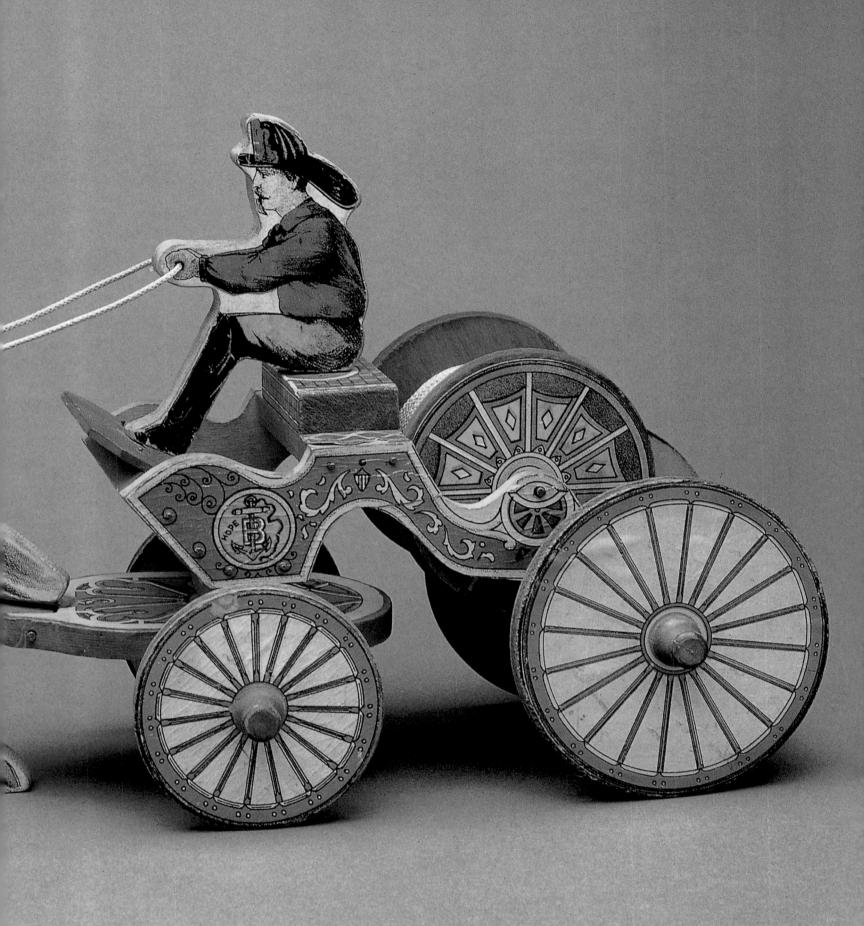

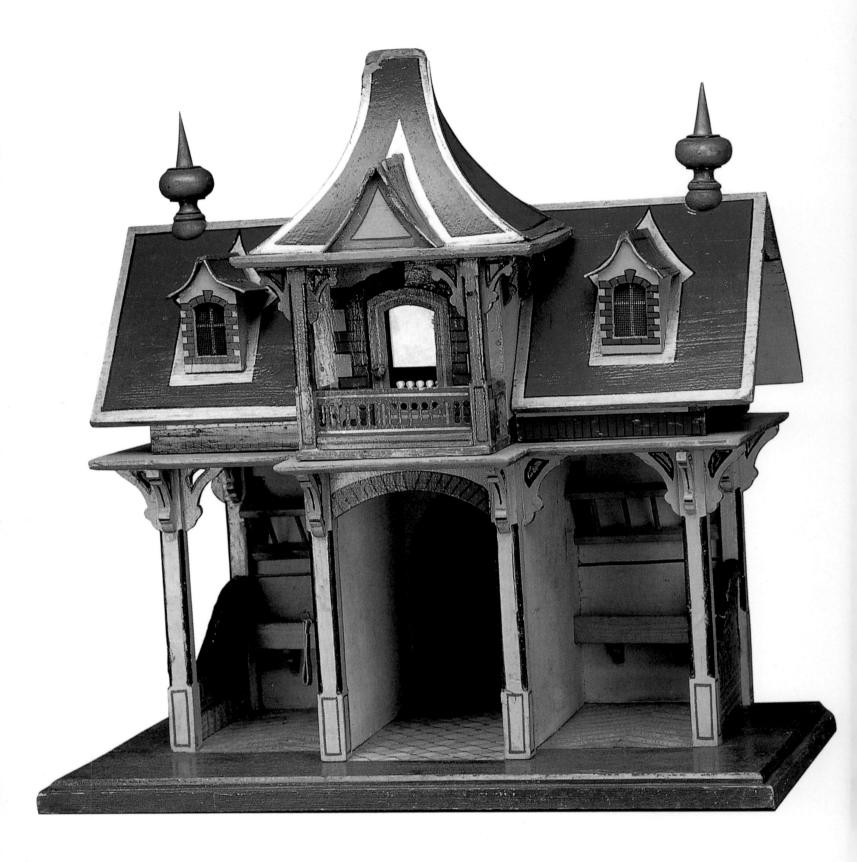

CARRIAGE HOUSE c. 1900-1910; lithographed paper on stained saw-cut wood and fiberboard; Germany. This attractive example of a Victorian outbuilding, was perhaps part of a set which included two or three other such structures and a large, elegant main house. Courtesy The Margaret Woodbury Strong Museum.

DOLLHOUSE c. 1900-1910; lithographed paper on stained saw-cut wood; R. Bliss Manufacturing Company Pawtucket, Rhode Island. As in this case, folky toy dollhouses often mimicked current architectural styles.

Courtesy The Margaret Woodbury Strong Museum.

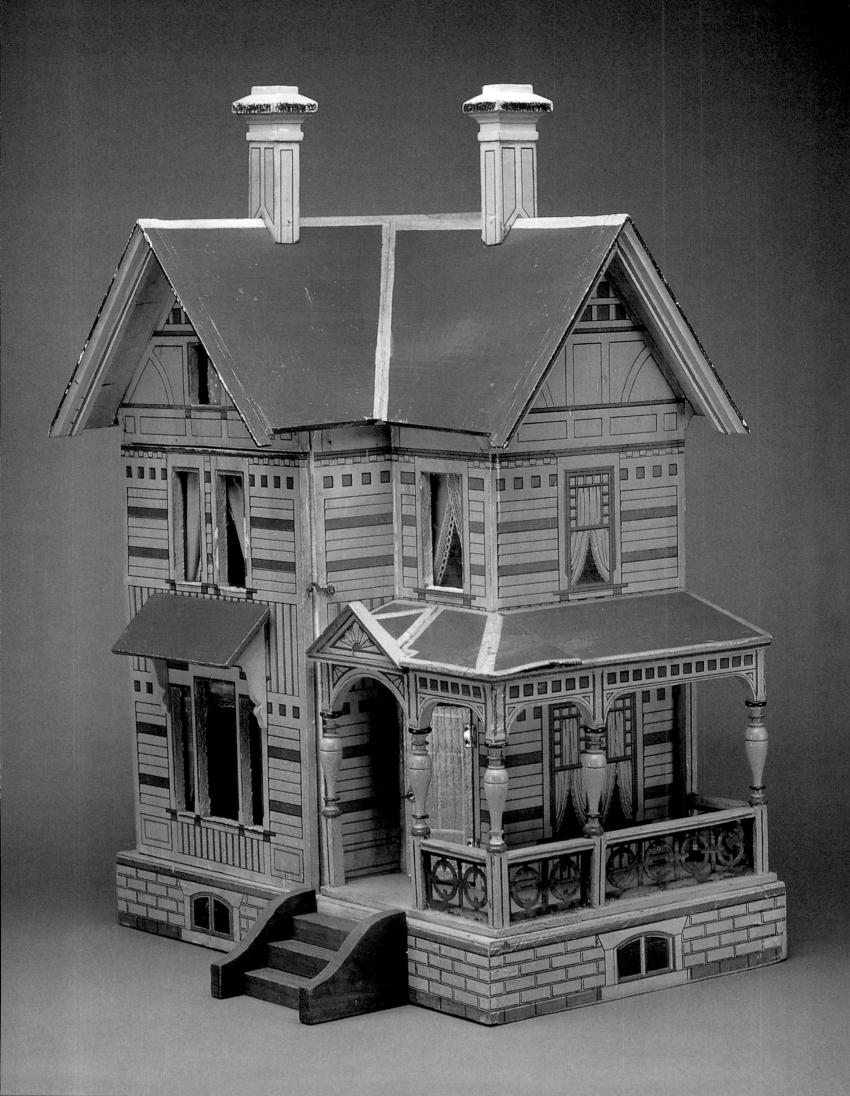

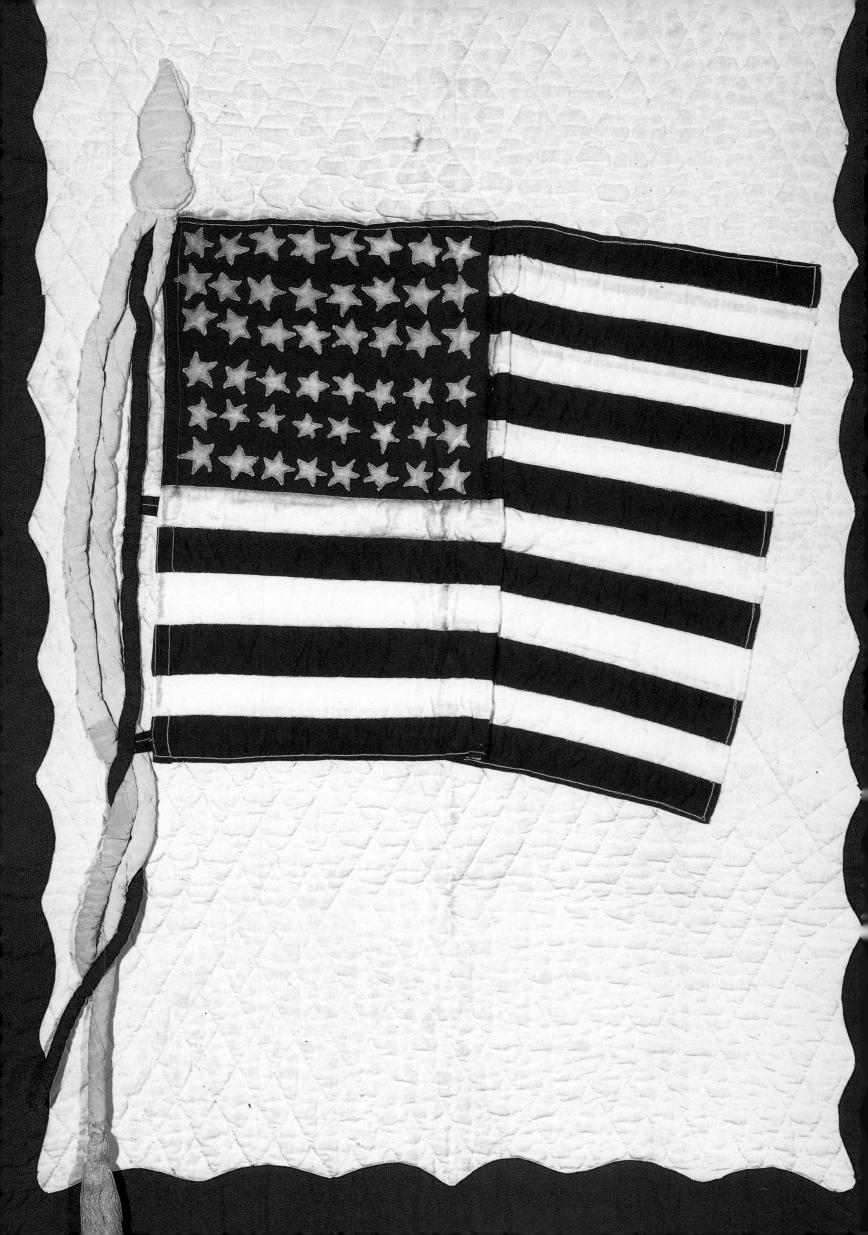

CHAPTER 8

FOLKY FABRICS: TEXTILE ART

While quilts, coverlets, and hooked rugs are often considered apart from other folk-art crafts, nevertheless they are fabrics with a distinct folk character. Indeed, if defined by the maker's intentions they are among the most folky creations of all. The famous folk painter Grandma Moses started out designing worsted pictures, a form of embroidery akin to rug hooking—and rug hookers were nothing if not creative. In *Collecting Hooked Rugs* (Century Publishing Company, New York, 1927), the authors Elizabeth Waugh and Edith Foley described the source of one such artist's inspiration

"What is that?" one of the authors once inquired of a modern design representing what appeared to be a jellyfish with octopus-like tentacles; she was collecting rugs in Newfoundland and thought perhaps she had happened upon a rare drawing of some strange monster of the deep.

"A ram" was the reply.

"Ram" means tomcat in the language of Newfoundland.

"But" she protested, "how did you come to draw a cat like that?"

"The us first catched the ram; then us held him down on the mat and us drawed around him. But he wriggled some."

But there was passion as well as humor in folk textiles. Denied access to many areas of artistic expression, women often put their creative souls into their work. As one quilter described it

ALBUM QUILT c. 1850-1860; attributed to Pennsylvania. This appliqued bed covering is composed of nine large blocks set within a rolling floral border, a characteristic Pennsylvania construction. *Private Collection*.

It took me more than twenty years, nearly twentyfive, I reckon, in the evening after supper when the children were all put to bed. My whole life is in that quilt. It scares me sometimes when I look at it. All my joys and all my sorrows are stitched into those little pieces... I tremble sometimes when I remember what that quilt knows about me.

THE STANDARD BOOK OF QUILTMAKING AND COLLECTING,
DOVER PUBLICATIONS, NEW YORK, 1960

Quilts

Quiltmaking was for many years one of the major forms of artistic expression for American women, as well as an important social occupation. While it is generally agreed that the technique of quilting—sewing together two layers of fabric within which is often contained a third, which might be

CRIB QUILT c. _940; pieced and appliqued cotton with "stuffed wcrk". Eastern or Midwestern. Crib quilts are very popular with collectors as they can readily be mounted for wall display. Courtesy Kelter-Malcé Antiques.

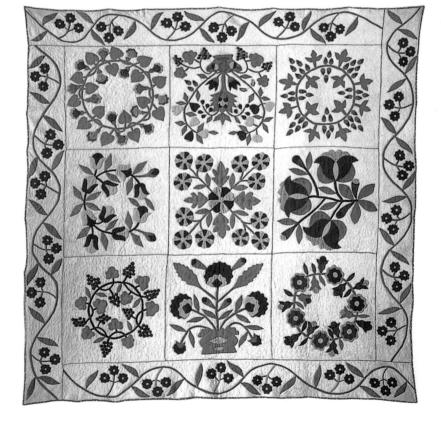

FOLK ART

anything from raw cotton to an old woolen blanket—is Asiatic in origin, it is also clear that it was in the United States that the technique was brought to its highest form of development as a bed-covering. In fact, other than for a few late-19th century English crazy quilts (thought to have been inspired by American examples), early quilts were exclusively American in origin.

There are three basic quilt types—pieced, applique, and crazy—though the elements of each may often be combined with the others. Examples of the first two categories may date in some cases as far back as the 18th century, while the crazy quilt is a late Victorian development. All might be—and usually were—assembled by an individual, working alone over a wooden quilt frame. However, the quilting bee, a social occasion when many women gathered to assemble and stitch together previously prepared quilt blocks, has become as synonymous with rural American life as the barn dance or the corn husking bee.

Pieced quilts are in a sense the embodiment of American thrift and artistic expression. In homes where nothing could be wasted, bits of fabric—usually cotton or wool from discarded garments or bed clothes—were cut into various geometric shapes and laboriously sewn together into intricate designs which were given exotic names such as Blazing Star, Nine Patch, Endless Chain, or Wandering Foot. The latter was a pattern never made for a young man's bed for fear it might inspire him to "go West" and join the great migration of the 1800s that severed families and populated the empty plains.

The completed patchwork quilt top was then joined to a backing, usually of store-bought printed fabric, but in poorer families of bleached flour sacks. An interior filling provided warmth. The term quilting actually refers to the intricate and time-consuming stitchwork which joined the three layers together. For some collectors this needlework quilting—often in floral or geometric patterns integrated into the overall design—is far more important than the spectacular and colorful pieced work. The much sought-after Amish quilts of Ohio, Indiana, and Pennsylvania in particular, often consist of large blocks of geometric patterning set in a simple though bold color-scheme with remarkably detailed quilting.

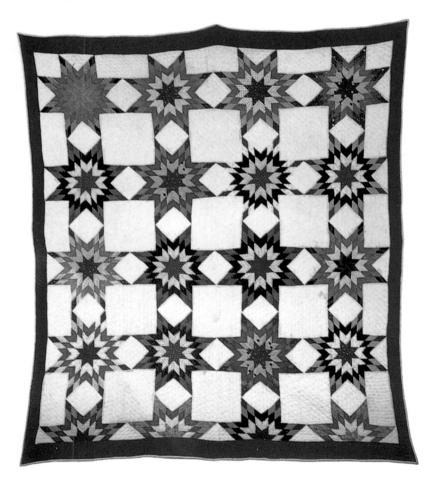

HARVEST SUN QUILT

c. 1870-1890; Southwestern United States. This pieced quilt is one of numerous variations on the popular star pattern. In Massachusetts it is called Ship's Wheel and in the Midwest, Prairie Star. *Private Collection*.

c. 1840-1870; pieced and appliqued fabrics with a variety of figural designs.

Eastern United States, possibly Maryland.

A spectacular example of the sampler quilt featuring an American sailing ship.

Private Collection.

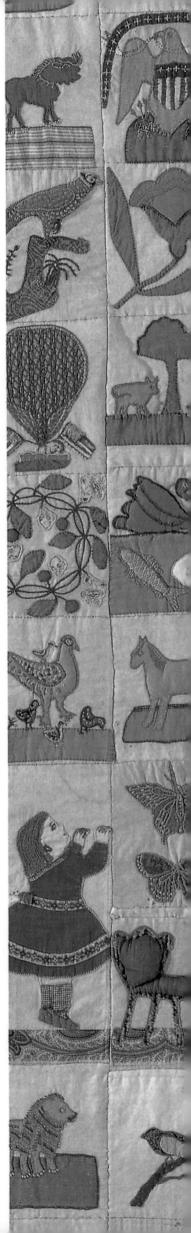

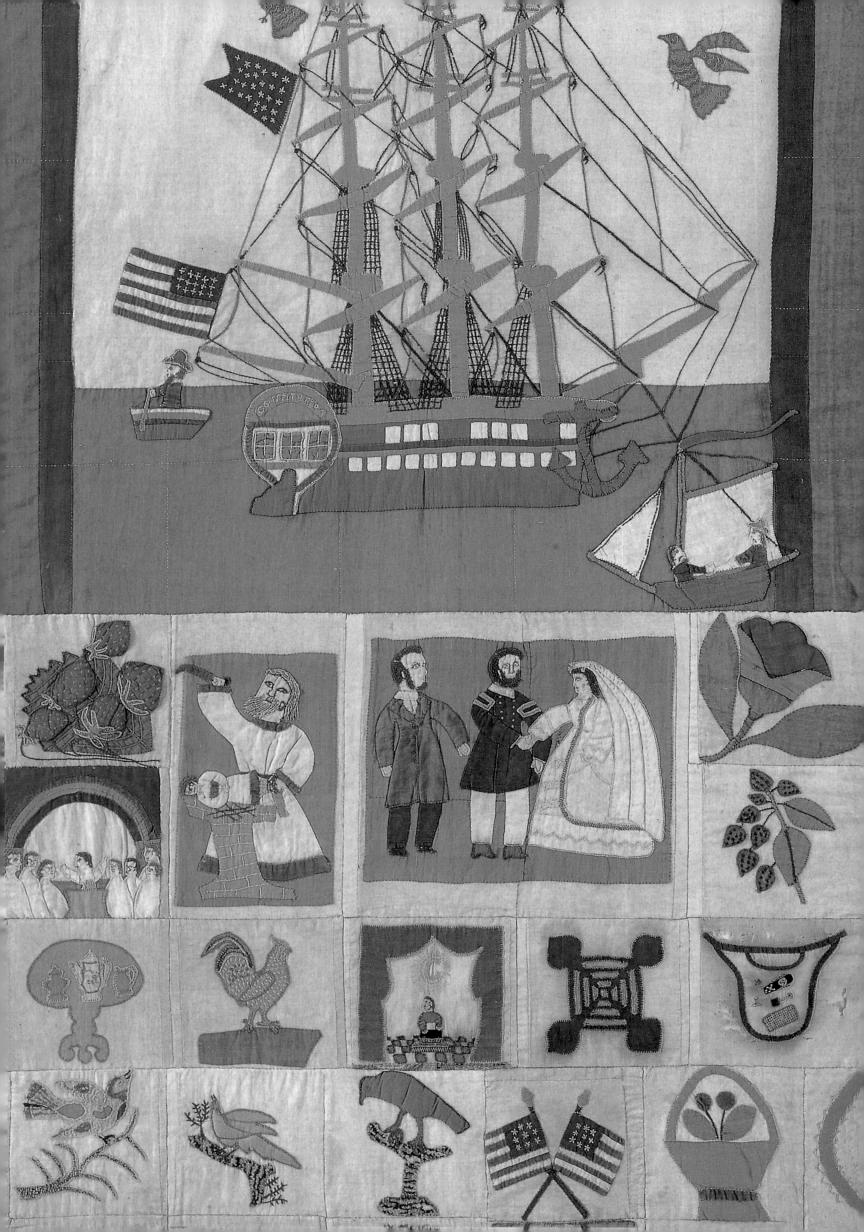

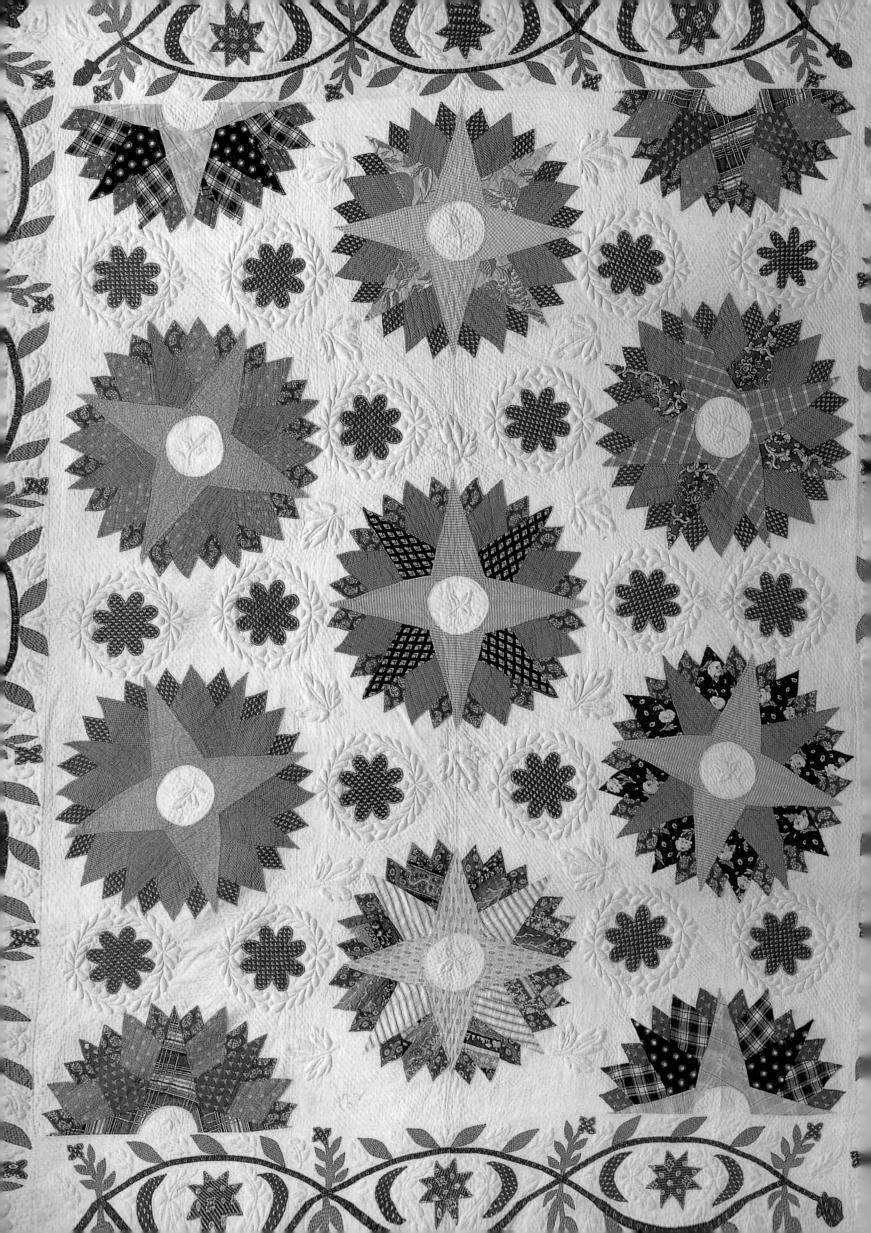

Applique quilts, a category much favored by collectors, are made by cutting out figural design elements—flowers, humans, and animals for example—and sewing them to a quilt top made from a single piece of fabric. In the so-called album quilts a group of women often contributed a single square each with applique figures. These were quilted together at a bee amidst neighborhood gossip, singing, and general merriment.

Since the ground for an applique quilt was usually a single piece of cloth—in early times a costly imported cotton or linen spread with the design elements cut from chintz or calico fabric—such bedspreads tended to be more costly than the usual pieced quilt. They also were sometimes produced by professional quiltmakers who used metal or paper templates to "line out" patterns which they or their customers completed. A good example is the category of famous Baltimore album quilts, produced in the vicinity of that city during the 1840s and 1850s.

It was also quite common for quilters to combine the applique and piecing techniques, as in album or friendship quilts, where individual appliqued squares were pieced together. Friendship quilts were often made for a local minister and contained a square made by each parishioner.

The final evolution of quilted bedcoverings, the crazy quilt, developed during the late 1880s when well-to-do homemakers began to put together bits of silk, satin, and other costly fabrics in random, usually geometric, patterns enlivened by embroidery and the addition of such unexpected items as political party ribbons and silken pictures given away with cigars and cigarettes.

WREATH QUILT 20th century;
American. This appliqued and finely quilted bedcovering incorporates various religious motifs as well as other unexpectedly secular ones such as a dollar sign and a group of bombs! Contemporary quilters often deal with such nontraditional themes.

Private Collection.

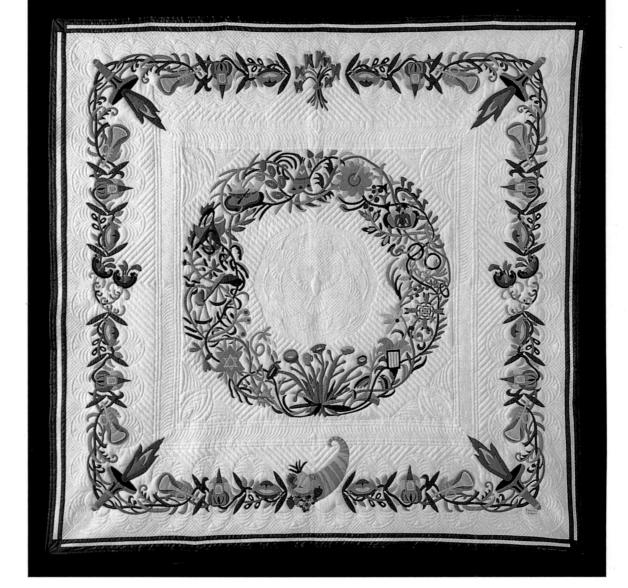

PIECED AND APPLIQUED QUILT c. 1860-1880; Eastern or Midwestern. Quilting quality is very important to some collectors, and this piece shows the complexity of needlework that is highly sought after.

Private Collection.

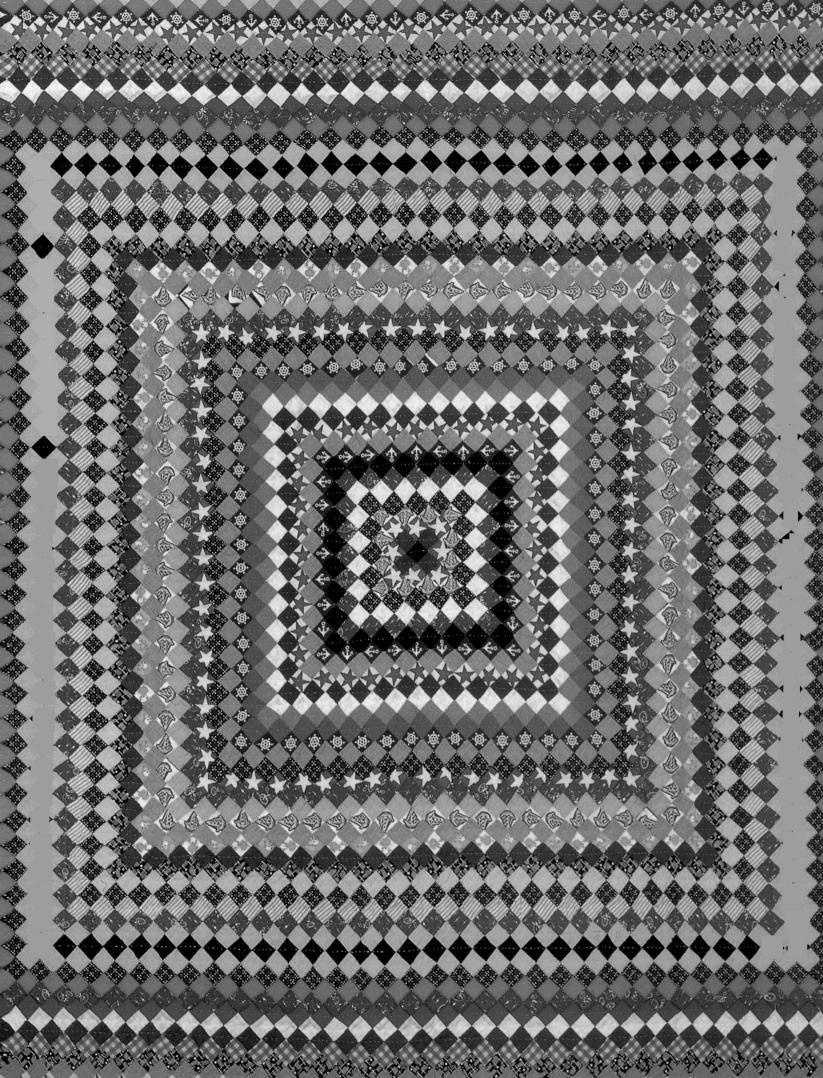

Few crazy quilts were ever intended for a bed. They were far too fragile for such use. Made in various odd sizes, they served as throws to drape the backs of sofas or to be spread upon pianos or tables. While all quilts are fragile, silk and satin ones are particularly so. Few examples in mint condition can be found today.

Crazy cuilts typically combined piecing and applique. Quilting, so important in earlier forms, was of the simplest sort taking a distinct secondary role to the elaborate embroidery executed in multi-colored silk floss. Unlike most other traditional quilt types, crazy quilts are often signed and/or dated, allowing a researcher to trace their manufacture and history.

Closely related are embroidered quilts, another turn-of-the-century development. In these bed-coverings, sheets of cotton, or in rare cases woolen, fabric are covered with embroidered figures, slogans, names, and dates. Not so much quilts as large pieces of needlework, these have attracted scant collector interest and remain quite inexpensive.

Quiltmaking, which appeared to be dying out in the late 1800s as inexpensive, factory-made bed-spreads became widely available, has undergone a renaissance in this century. During the 1930s, economic depression spurred home production of bedclothes, and since 1960 a wave of needlework craft enthusiasts has produced tens of thousands of new quilts, often in revolutionary designs that seem more related to contemporary art than to traditional patterns. Collecting early examples has become an obsession for some, with rare or popular examples such as Amish and elaborate applique quilts bringing prices in the tens of thousands of dollars, while seminars and shows devoted to the craft flourish. It appears that quilts and quiltmakers will be with us for many decades to come.

Following Page:
HOOKED RUG 1979;
made by Ethel Bishop,
Maine. Hooked in felt,
cotton, and wool on
burlap, this interesting
rug captures the massive
appearance of a domestic
animal. More recent rugs are
often as appealing as earlier
examples. Private Collection.

DIAMOND IN SQUARE
QUILT c. 1900-1920;
Amish; Pennsylvania.
Powerful geometric forms
combined with sophisticated
quilting on the pieced woolen
fabric set apart the highly
desirable Amish quilts.
Private Collection.

TRIP AROUND THE WORLD QUILT c. 1940; Pennsylvania. A variation of the simple one-patch quilt, this pieced pattern consists cf hundreds of tiny cotton fabric squares, all sewn together *Courtesy Kelter-Malcé Antiques*.

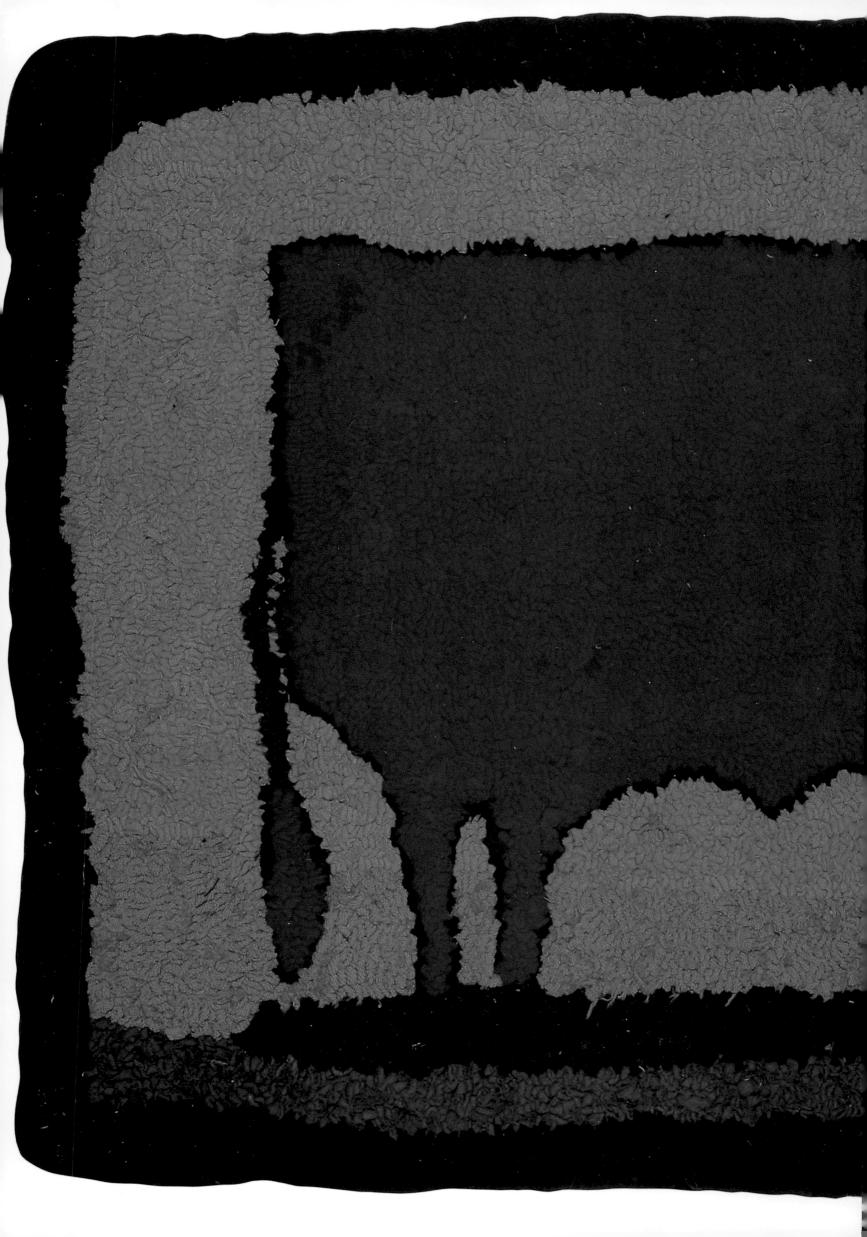

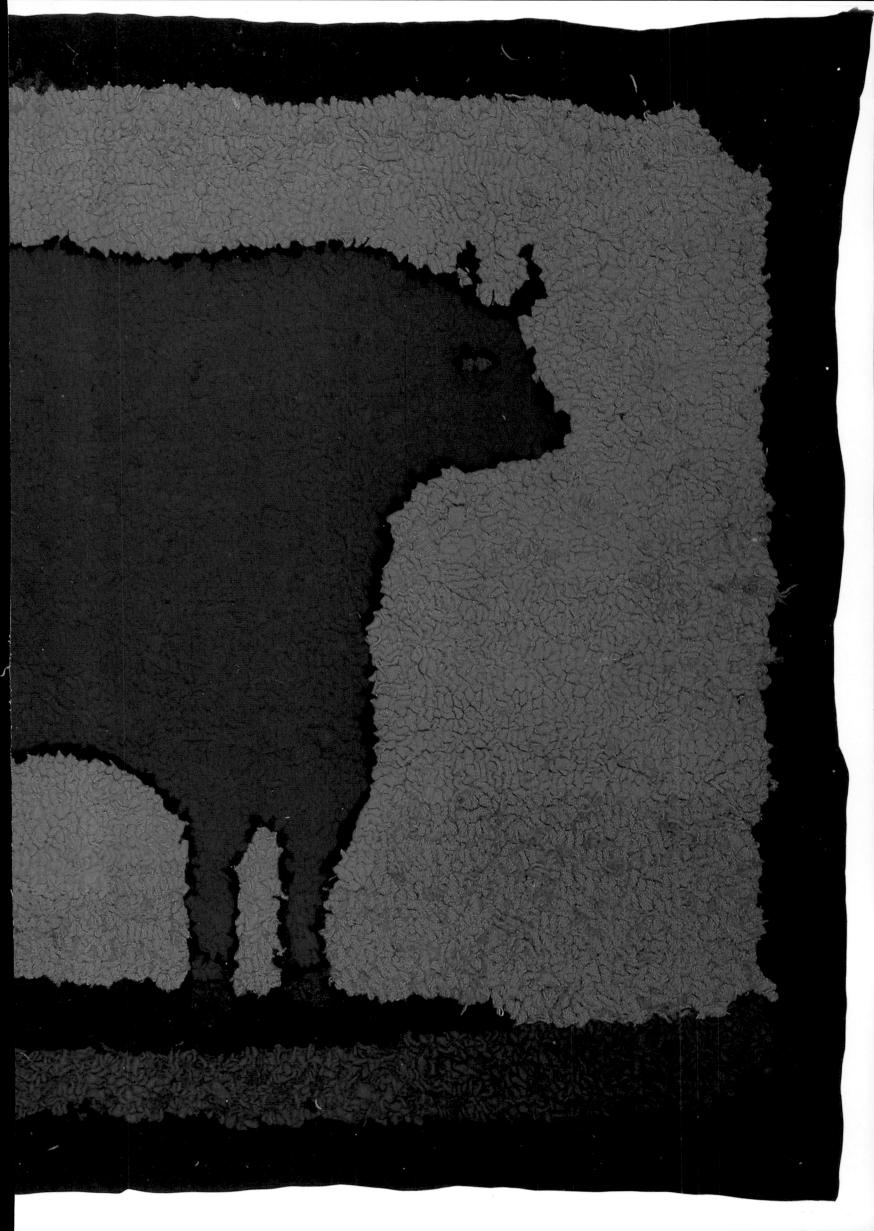

Hooked Rugs

Another popular folk craft is rug hooking. With this relatively simple technique a design is created by pulling foot-long strips of colored yarn or cut cloth through a burlap backing with a large, needle-like tool. Loops are formed which support each other on the rug surface, while they are pulled tight against the backing to create a duplicate pattern on the reverse side of the rug. Color variations in the fabric create the rug's design.

While one-of-a-kind patterns may be created by drawing freehand pictures on the burlap, most hooked rugs are built on commercially printed burlap. This is ideal for the purpose, since its loose crosshatch weave allows easy entry for the tool and fabric strips. The earliest commercial rug patterns appeared in the mid-1800s. One of the better known fabricators was Edward Sands Frost of Biddeford, Maine who began peddling his own designs in 1868. Today, Frost patterns, including his well-known lion, are eagerly sought by collectors.

However, it would be a mistake to assume that the introduction of standard patterns always resulted in a lack of originality on the part of the rugmaker. Anyone who has examined many hooked rugs and mats quickly recognizes that the same pattern in different hands assumes a different look. Despite manufacturers' color recommendations, makers almost always chose their own hues, either through preference or availability. Moreover, many added their own design elements—a border, flowers, or other figures—to the standard format.

In some cases even today, rugmakers eschew commercial patterns for their own compositions. In the early 1900s a farm wife expressed her artistic aspirations in a letter to the newspaper, *The Rural New Yorker*

I enjoy making my own designs. I never knew how to sing or paint or draw; no way to express myself, only by hoeing, washing, ironing, patching, etc. and while I never hope to accomplish anything extraordinary, I do love to plan out and execute these rugs that are a bit of myself, a blind groping after something beautiful.

Rugs are typically hooked on the lap or on a small frame; as a result, few are very large. Square, round, oblong, or oval examples ranging from 14 inches square (a typical chair mat) to 3-by 5-feet

xamples ranging from 14 inches square (a typical chair mat) to 3-by 5-feet are most common. Also found are long, narrow stair runners and demi-lune forms designed for

doorways—the latter often with the friendly "WELCOME" greeting. Room-size, hand-hooked carpets are extremely rare, though beginning collectors may be confused by the large pastel-colored, machine-made rugs which were produced c. 1930-1950. These may be useful carpeting, but they

are not true folk art.

HOOKED RUG c. 1875-1900; New England. The combination of eagle and rabbits in this wool and cotton rug is unique, while the word "Blackhawk" (the name of both an Indian Chief and a famous trotting horse) defies explanation. *Private Collection*.

HOOKED RUG c. 1900-1920; New York. Pictorial rugs like this example in wool and cotton on burlap are highly desirable. The best examples are, in effect, fabric folk paintings. *Author's Collection*.

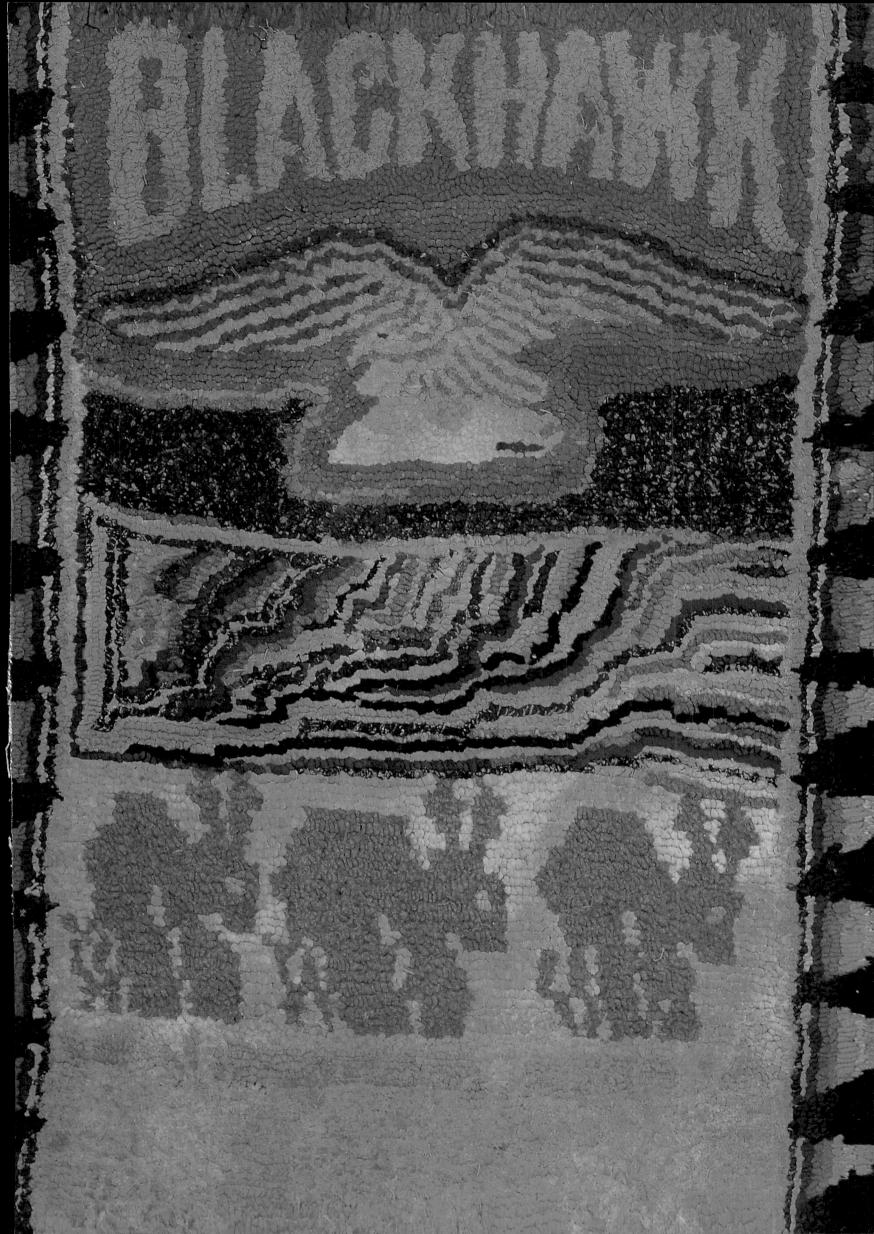

FOLK ART

Like quilts, hooked rugs are distinctly North American in origin. The earliest examples seem to have appeared in Canada or the United States around 1800, at a time when only the rich could afford imported floor coverings. But by employing scrap fabrics (often home dyed) the housewife could produce thick, warm rugs. The craft really became popular at mid-century when loose woven burlap, used to pack goods from the Orient, replaced heavy cotton or linen foundations upon which patterns had to be laboriously punched out.

Rug designs fall into three broad categories—floral, geometric, and pictorial. Floral rugs, often based on the patterns found in imported Aubusson and Savonnaire carpets, were probably the first development. They range in pattern from highly formal compositions, often featuring a central bouquet or basket of flowers surrounded by a floral border; through naturalistic renditions in the folk-art manner; to abstract designs. In the 1920s and 1930s when collectors first became interested in the field, floral rugs were preferred. Today they are considerably less popular.

Geometric rugs feature various combinations of squares, rectangles, triangles, stars, and other similar forms. They appear to have been especially popular with women who could not afford to buy commercial patterns, since one could, with a bit of thought, devise one's own pattern. The rural housewife quoted above described her technique to *Moore's Rural New Yorker*

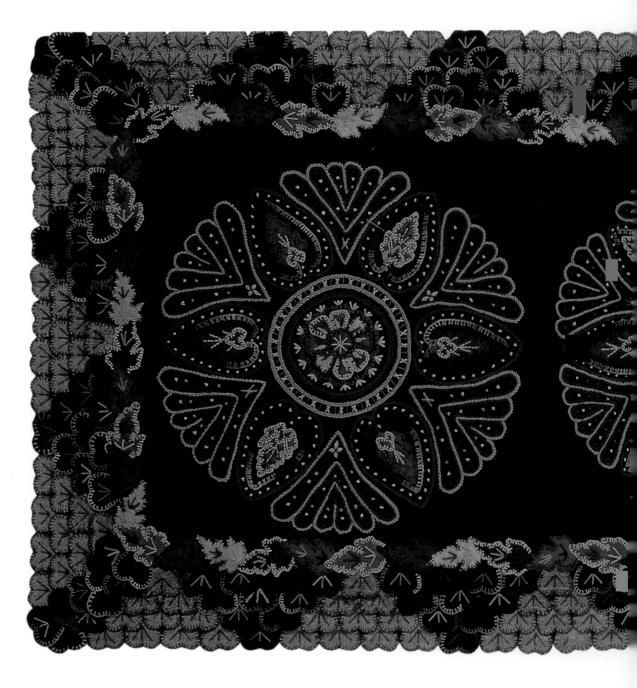

HEARTH RUG c. 1870-1900; Ohio. This interesting woolen piece is both appliqued and embroidered with various motifs primarily hearts and leaves. *Courtesy Helaine and Burton Fendelman*.

Yes, my grandmother taught me how to hook. She used to make the sea shell pattern... took an old cup plate and lay it down on the material then run around it with a piece of charcoal wood from the fire. She used to lay one over the other so the whole rug looked like shells or fish scales.

Other rug hookers employed objects such as bricks, cups, and simple templates cut from heavy cardboard to produce their design elements. As with all hooked rugs, color contrasts often determined the artistic success of any given piece. Geometric and floral elements were often combined in a single rug, as with a central diamond motif, surrounded by a floral border. Other variations included swirling Art Deco designs produced during the 1930s.

By far the most popular with contemporary collectors are pictorial rugs featuring humans, animals, village scenes, ships, trains, and early automobiles. Earlier and more primitive examples are seen as textile folk paintings and may bring auction prices in the thousands of dollars. Particularly sought are the delicate, tightly-hooked mats and rugs made at the Grenfell Mission in the Canadian Maritimes during the early 1900s. Unusual, in that they are often made from discarded silk-stocking material rather than the usual wool or cotton fabric, these rugs feature local scenes with seagulls, puffins, whales, dogsleds, and even Eskimos. Many are labeled, "Grenfell Industries, New Foundland, Labrador."

Rug hooking remains popular. Contemporay designers have incorporated synthetic fabrics and modern themes but continue to work in the time-honored manner, while collectors continue to seek out unusual and artistic examples regardless of age.

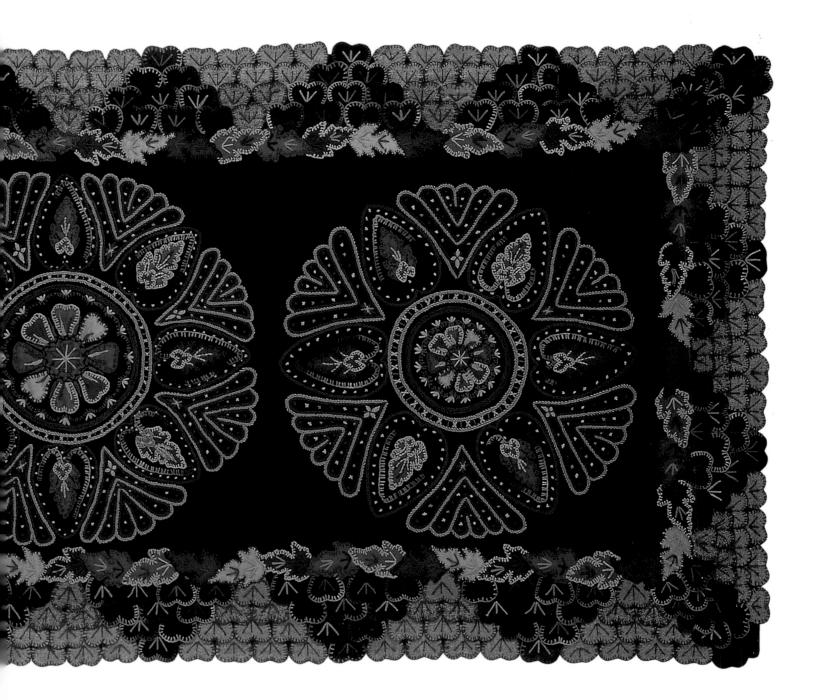

JACQUARD COVERLET

c. 1876; Pennsylvania. This all wool bedcovering can be recognized as a later example by the fact that it is a single piece rather than two pieces joined. The eagle motif reflects the patriotic impulses surrounding the Centennial Celebration. *Ex Collection Jay Johnson*.

JACQUARD COVERLET c. 1840-1850; Pennsylvania. Woven of cotton and wool, this coverlet has a border of prancing horses and a patriotic motif consisting of seventy eagles each bordered by the words, "E Pluribus Unum". Courtesy America Hurrah Antiques.

Coverlets

The term coverlet has come to be applied to heavy bedcoverings or spreads which are made from a combination of cotton and wool. Unlike quilts and hooked rugs, which are made without use of machinery, they are woven on looms.

There are two distinct types of coverlets. The earlier, made in this country before 1800 and still produced, are referred to as "geometrics," reflecting the fact that the woven designs incorporate geometric patterns that lack curvilinear elements. Such textiles are also often woven on narrow looms so that two pieces must be seamed together to make a bedspread.

The second form more popular with collectors, is the Jacquard coverlet, which is named for a Frenchman, Joseph-Marie Jacquard (1752-1834), who invented a device—something like a player-piano roll—which when attached to a loom, made it possible to weave curving pictorial elements. The Jacquard device was introduced in this country in the 1820s, leading to a proliferation of coverlets with large, floral, central medallions surrounded by borders which might feature sailing ships, rows of houses, eagles, or representations of George Washington.

Created on looms of various sizes, Jacquard coverlets may be made of either one or two pieces. They are also found in as many as four or five colors, unlike the geometrics which usually are of two hues—

dyed cotton (typically blue) and undyed wool. Another distinction between the two is that while the weaving of geometric coverlets was typically a home craft carried out by women, Jacquards were made by professional male weavers, some of whom were itinerants traveling from place to place, taking orders, and setting up their looms to do the work. One of the reasons that collectors are so fond of this form is that it is often signed and dated by the weaver and may also bear the

name of the person for whom it was made—a useful genealogical tool. Ultimately though, it is the wonderful, folky quality of the human and animal images incorporated into Jacquard coverlets that makes them so appealing to collectors of American folk art.

COVERLET 1853; mady by F. Yearous. Ashland County, Ohio. The double rose pattern was popular in Pennsylvania and the Midwest. Many coverlets bore dates as well as the names of maker an/or owner. Courtesy Ruth Bigel Antiques.

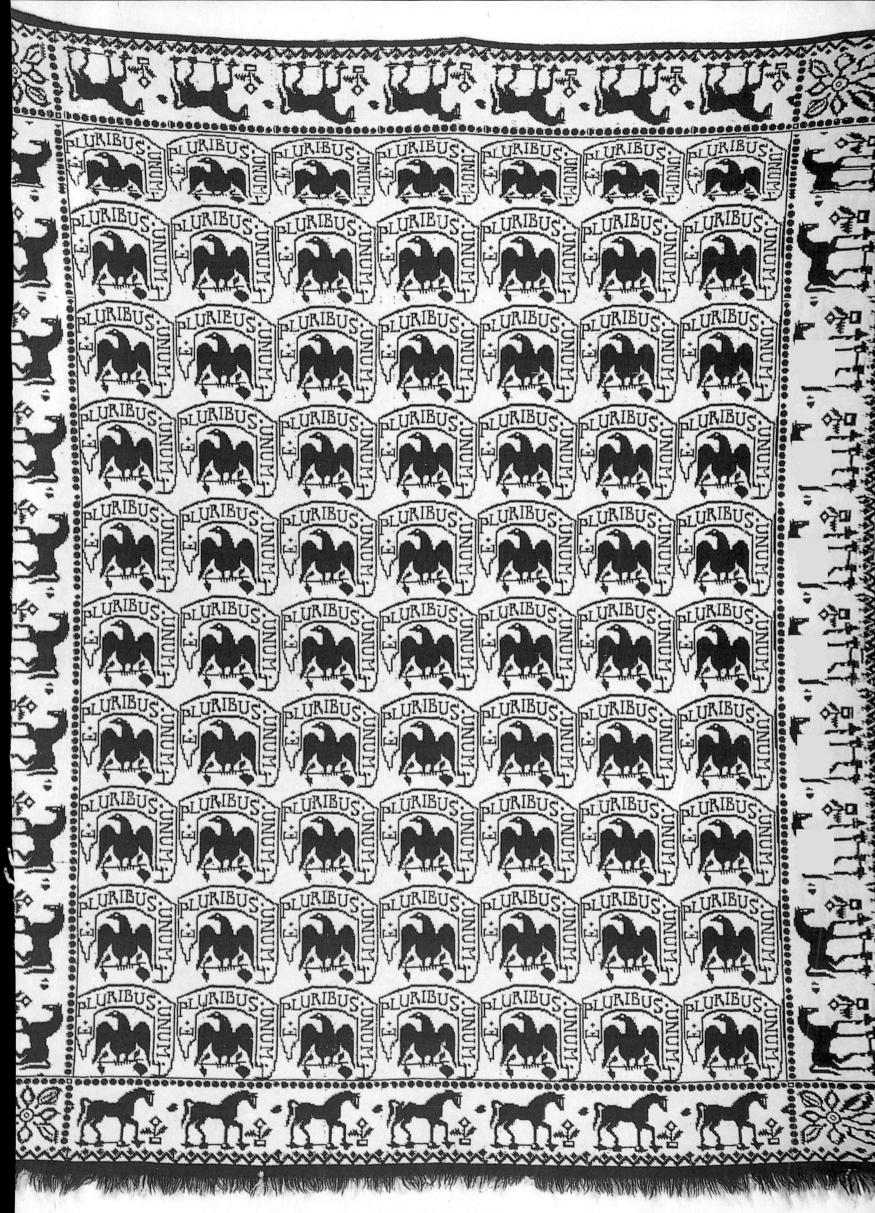

INDEX

Page numbers in bold-face type indicate photo captions.

advertising
by history painters, 18-21
by portrait artists, 10
posters, 77
by public folk artisans, 77
shop signs as, 81-85, 81-86
by silhouette artists, 17
African-Americans, canes carved by, 61
album quilts, 129, 130, 133
altar screens (reredas), 45, 45
American flag, 78
Ames, Nathaniel, 81
Amish quilts, 130, 135 Amish quilts, 130, 135 andirons, 37, 37, 39 animals andirons, 37, 37, 39
animals
buildings in shape of, 78
carousel figures, 80
ceramic, 112, 114
chalkware, 109, 109
decoys, 105-8, 105-8
scrimshaw, 91-95, 91-95
ship figureheads in shape of, 66, 68
whirligigs in shape of, 71, 74
applique quilts, 133, 133
Arageo, Jose Rafael, 46
architecture
archway decorations, 77
public art of, 78, 78
Archuleta, Felipe, 46
automobiles
weathervanes in shape of, 69
whirligigs as radiatorcap ornaments on, 74
bables

banks
ceramic, 112-15
chalkware, 109
bannerets, 65-66
Bard, James and John, 100, 101
Bascom, Ruth Henshaw, 11
Bellamy, John H., 85, 98
birds
chalkware, 109
decoys, 105-8, 105-8
weathervanes in shape of, 66
whirligigs in shape of, 71
sse also eagles; roosters
Bond, Milton, 58
bone carving (scrimshaw), 91-95, 91-95
bootjacks, 39, 39
bottles, ships in, 97
bowls, 26
boxes, 30
sailor's ditty box, 103
sailor's ditty box, 103
sailor's ditty box, 103
box 103
sailor's ditty box, 103
box 103
box 103
box 104
box 105

calligraphy drawings, 51, 51-53
canes, carved, 61, 61
carnival chalkware, 110, 110
carousel figures, 77, 85-86, 85
carvings, 26, 26-29
cane and whimsey carving, 61, 61
religious, 45-46, 45-47
scrimshaw, 91-95, 91-95
ship carving, 98, 98
stone miniatures, 117, 117
cast iron, see metal
ceramics, figural, 111-13, 111-15
chairs, 26, 31, 33
chalkware, 109-10, 109, 110
Chappell, William, 92
chests, 30, 34
dower chest, 30
kasten, 31
cigar store Indians, 82-85, 82
Claesen, Dirck, 111
Cobb, Nathan, 108
Collins, Zerubbabel, 22, 22
commercial art, 77
heart-in-hand lodge symbol, 85
shop signs and figures, 81-85, 81-86
trade cards, 88
Uncle Sam candy container, 86
Conger, John, 26
coverlets, 142, 142
crazy quilts, 130, 135
Crowell, A. Elmer, 108
crowns of thorns (woodwork), 62

daguerreotype, 7
Dare, Charles W.F., 86
decoys, 105-8, 105-8
Demuth, William, 85
Dentzel, Gustav, 86
Dentzel, William, 86
Dodge, Charles J., 85
dogs, whirligigs in shape of, 74
door knockers, 39
doorstops, 37, 42, 114, 117
dower chests, 30, 30
drawings, calligraphy, 51, 51-53
Drowne, 5hem, 66
ducks, decoys of, 105-8, 105-8
Durand, John, 18-21

eagles
in calligraphy drawings, 51
on coverlets, 142
pilot house eagles, 98
Schimmel's carving of, 42
sculptural, 85
weathervanes in shape of, 66, 69
whirligigs in shape of, 74
Earle, Alice Morse, 25
earthenware, 111, 113
embroidery on paper, 51

fabrics, 129
coverlets, 142, 142
hooked rugs, 135-41, 138-41
quilts, 129-35, 129-35
face jugs, 111-13
Field, Erastus Salisbury, 11, 21
figural art, 37-39, 37-44
carousel figures, 85-86
ceramics, 111-13, 111-15
Finlay, John and Hugh, 31
fish decoys, 108
floral rugs, 140
Foley, Edith, 129
fractur drawings, 4
frames
cast iron, 39 cast iron, 39 painted wood, 28-29 Frost, Edward Sands, 138 Frost, J.O.J., 101 furniture armchair, 26 iron, 39 painted wood, 30-33, 30-36

gameboards, 31, 34
Garcia, Fray Andres, 46
genre paintings, 18-21, 18-20
geometeic coverlets, 142
geometric rugs, 140
gingerbread prints, 26
glass, reverse paintings on, 58, 58
of naval battles, 98-100, 99
gravestone art, 22, 22-23
Guild, James, 10

Hancock, John, 91 Hicks, Edward, 18 Hidley, Joseph H., 18 history painting, 18-21 Hitchcock, Lambert, 33 hitching posts, 37 hobbies hitching posts, 37 hobbies calligraphy, 51 cane and whimsey carving, 61, 61 folk art as, 49 reverse paintings on glass, 58, 58 sandpaper paintings, 52 scissor cuttings, 52-54 scrimshaw, 91-95, 91-95 theorem painting, 50-51 tramp art, 62 Hofmann, Charles C., 62 hollow-cut Silhouettes, 17 Honeywell, M.A., 17 hooked rugs, 135-39, 138-41 horses hooked rugs, 135-39, 138-41 horses cane head in shape of, 61 carousel figures, 85-86 ship carvings in shape of, 98 weathervanes in shape of, 66, 66-68 household items, 25 carvings, 25-29, 26 figural art in metal, 37-39, 37-44 furniture, 30-33, 30-36 jagging wheel (pie crimper), 91 humans Jagging wheel 19, 110 ship carvings in shape of, 98 weathervanes in shape of, 68, 68 whirligigs in shape of, 74

Indians, see Native Americans

Kane, John, 11
kasten (chests), 31
King, William, 17
kitchen items
cast iron, 39
jagging wheel (pie crimper), 91
stove door, 37
stoves, 37
utensils, 26
Kright, Pichard, 98 Knight, Richard, 98

Limner, Payne, 10 Limner, Payne, 10 limners (portrait artists), 7-11 Lincoln, Abraham, 62 whirligigs in shape of, 72, 74 Loof, Charles I.D., 86 Lopez, George T., 45 Lopez, Jose Dolores, 46

MacMillan, Kirkpatrick, 105 MacReady, Dennis, 77 Mason, George, 10 match safes, 37-39 memorial paintings, 21, 21 mental panticings, 21, 21 metal figural art in, 37-39, 37-44 weathervanes made of, 65, 65-68 Miller, Lewis, 11 mill weights, 37, 42 miniatures, 105 chalkware, 109-10, 109, 110 decoys, 105-8, 105-8 figural ceramics, 111-13, 111-15 stone, 117, 117 wooden whimsies, 119, 119-27 mirrors wooden whimsies, 119, 119-27
mirrors
cast iron frames for, 39
reverse paintings on, 58, 100
models
of U.S.S. Constitution, 97
shadowbox models, 99
of ships, 97
Moses, Grandma (Anna Mary Robertson), 18, 129
mourning pictures, 21

Notice Americans (Indians) advertising aimed at, 77 canes carved by, 61 cigar store Indians, 82, 82-85 decoys made by, 105 weathervanes in shape of, 68, 68 whirligigs in shape of, 71 nautical art, 91 rope work, 97 sailors' souvenirs, 102-3, 102, 103 scrimshaw, 91-95, 91-95 ship carving, 98 ship's figureheads, 96, 98 ship models, 97, 97 ship paintings, 98-101, 99-101 needlecrafts embroidery on paper, 51 hooked rugs, 135-41, 138-41 memorial pictures, 21, 21 quilts, 129-35, 129-35 Nellis, Master Sanders K.G., 17 occupational weathervanes, 68-69

occupational weathervanes, 68-69 O'Kelley, Mattie Lou, 7, 18

genre paintings, 18-21, **18-20** memorial paintings, 21, **21** portraits, 7-11, 7-15 religious, 45-46, **45-47** portraits, 7-11, 7-15
religious, 45-46, 45-47
reverse paintings on glass, 58, 58
sandpaper paintings on glass, 58, 58
sandpaper paintings, 52, 52
ship paintings, 98-101, 99-101
shop signs as, 81
theorem painting, 50-51
Pantographs, 17
paperweights, 117
patriotic motifs
sculptural eagle, 85
on weathervanes, 69
on whirligigs, 71-74, 71, 72
Peale, Charles Wilson, 17
Perates, John, 46, 46
Peterson, Oscar, 108
Philips, David, 77
pictorial rugs, 141
picture frames
cast iron, 39
painted wood, 28-29
pieced quilts, 130
Pinney, Eunice, 21
portraits, 7-11, 7-15
posters, 77
pots, storage, 31
Prior, William Matthew, 7, 10, 17 posters, 77
pots, storage, 31
Prior, William Matthew, 7, 10, 17
public folk art, 77
architectural, 78, 78
shop signs and figures, 81-85, 81-89
puzzles, carved, 61

quilts, 129-35 album quilts, 129, 130 Amish quilts, 135 applique quilts, 133 crib quilt, 129 wreath quilt, 133

religious themes in chalkware, 109 in gravestone art, 22 in paintings and carvings, 45-46, 45-47 reredos (carved alter screens), 45, 45 retablos (painted panels), 45-46 Revere, Paul, 69, 81 Revere, Paul, 69, 81 reverse paintings on glass, 58, 58 of naval battles, 98-100, 99 Robertson, Anna Mary (Grandma Moses), 18, 129 Rockingham earthenware, 113 rolling pine 26 rolling pins, 26 roosters (cocks) Schimmel's carving of, 25 weathervanes in shape of, 65, 66 rope work, 97

sailors' souvenirs, 102, 102-3, 103
sailors' valentine, 102, 102
sand bottles, 103
sandpaper paintings, 52, 52
santeros (religious artisans), 45, 46
Scherenschnitte (scissor cuttings), 52-54, 53
Schimmel, William, 25, 42
scissor cuttings, 52-54, 53
scrimshaw, 91-95, 91-95
Seltzer, Christian, 30
shadowbox models, 99
ship paintings, 98-101, 99-101
ships
figureheads for, 96, 98, 98
models of, 97, 97
weathervanes in shape of, 69, 69
sse also nautical art
shop signs and figures, 81-85
cigar store Indians, 82
clockmakers, 81
guesthouse sign, 81
heart-in-hand lodge symbol, 85
resort sign ("Woodtop"), 86
show case, schrimshaw, 92
Silhouette, Etienne de, 17
silhouettes, 17, 17
Skillin, John, 98
Skillin, Simeon, Jr., 98
Skillin, Simeon, Jr., 98
Skillin, Simeon, Jr., 98
Skillin, Simeon, Jr., 98
Skillin, Simeon, 17, 117
stoneware, 111-13
ink well and sander, 34
water cooler, 27
Strachan, James, 77
straw work, 103
"Susan's Teeth" (scrimshaw), 95

textiles, see fabrics theorem painting, 50-51, **50**, **51** tinsel painting, 58 tip boxes, 82 Tolson, Edgar, 46 tombs and gravestones, **22** tovs toys ceramic, 111 sled, 25 whirligigs as, 71 trade cards, 88 trains, weathervanes in shape of, 69 tramp art, **27**, 62

Uncle Sam in architectural art, 78 candy container, 86 ship carvings in shape of, 98 weathervanes in shape of, 69 whirligigs in shape of, 71, 72 United States Pottery, 113 utensils, household, 26 jagging wheel (pie crimper), 91

Voght, Fritz G., 18, 55

Voght, Fritz G., 18, 55

wacky wood (whimsies), 119
walking sticks, 61, 61
Washington, George, 66, 142
chalkware, 109
whirligigs in shape of, 71-74
Waugh, Elizabeth, 129
weathervanes, 65-69, 65-69
whirligigs and, 33, 71-74, 71-75
Westervelt, A.B. & W.T., 65, 68
whale bone carving (scrimshaw), 91-95, 91-95
Wheeler, Charles "Shang," 108
whimsies, 61, 61, 119, 119-27
whirligigs, 33, 71-74, 71-75
Whiteman, Henry, 77
whitliging, 33, 71-74, 71-75
Whiteman, Henry, 77
whitliding, (carving), 61
Williams, William, 81
windmill weights, 37, 42
wind toys, zee whirligigs
wishing wells, 119
women
crafts as hobby for, 49
dower chests made for, 30, 30
mourning paintings by, 21
ship's figureheads in shape of, 98, 98
wood
armchair, 26
cane and whinsey carving, 61, 61 wood armchair, 26 cane and whimsey carving, 61, 61 carousel figures, 85-86, 86 carvings in, 26 chairs, 31 chests, 34 cigar holder, 39 clock face, 33 clock face, 33 decoys made of, 108 dower chest, 30 gameboards, 31, 34 painted furniture, 30-33 picture frame, 28-29 ship's figureheads, 98 tramp art. 62 ship's figureheads, 98 tramp art, 62 weathervanes, 65, 69 whimsies, 119, 119-27 whirligigs, 33, 71 wrought iron, see metal